Ernst Lehner

ALPHABETS &
ORNAMENTS

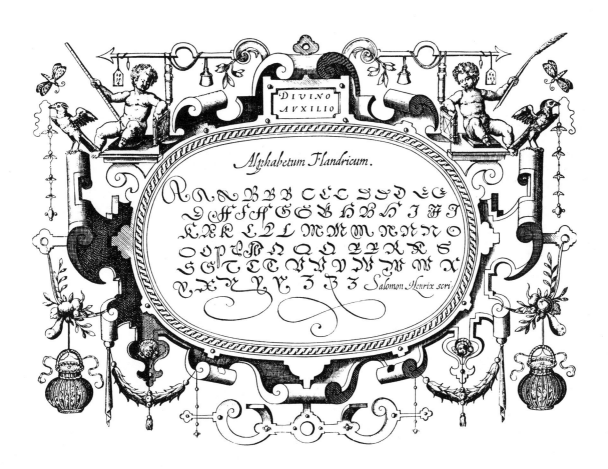

DOVER PUBLICATIONS, INC.
New York

Published in Canada by General Publishing Company, Ltd., 30 Lesmill Road, Don Mills, Toronto, Ontario.
Published in the United Kingdom by Constable and Company, Ltd., 10 Orange Street, London WC 2.

This Dover edition, first published in 1968, is an unabridged republication of the work originally published by The World Publishing Company in 1952. Several pages were printed in red and black ink in the original edition, and these plates are reproduced entirely in black in the present Dover edition.

Alphabets and Ornaments belongs to the Dover Pictorial Archive Series. Up to ten illustrations from this book may be reproduced on any one project or in any single publication, free, and without special permission. Wherever possible include a credit line indicating the title of this book, author, and publisher. Please address the publisher for permission to make more extensive use of illustrations in this book than that authorized above.
The republication of this book in whole is prohibited.

Standard Book Number: 486-21905-4
Library of Congress Catalog Card Number: 68-19170

Manufactured in the United States of America
Dover Publications, Inc.
180 Varick Street
New York, N. Y. 10014

ACKNOWLEDGMENT

I WANT TO express my sincere gratitude and appreciation to my friends and colleagues, and to the librarians, collectors and book dealers in Europe and in the United States of America, who provided me over the years with suggestions, advice, information, research material and prints which led to the compilation of this book. Only their untiring help and encouragement made it possible.

Because they are too numerous to be thanked individually, I beg each one of them to accept this acknowledgment as my personal recognition of my indebtedness to him.

To Miss Ruth Goldberg of New York go my special thanks for her most helpful and friendly collaboration.

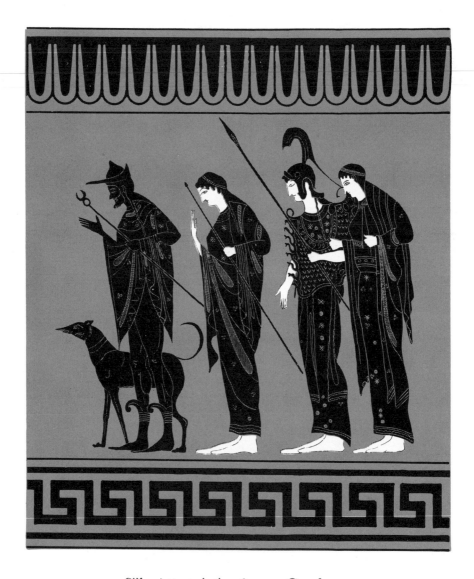

Silhouette painting from a Greek vase

LIST OF CONTENTS

Endpiece/GERMANY 1880

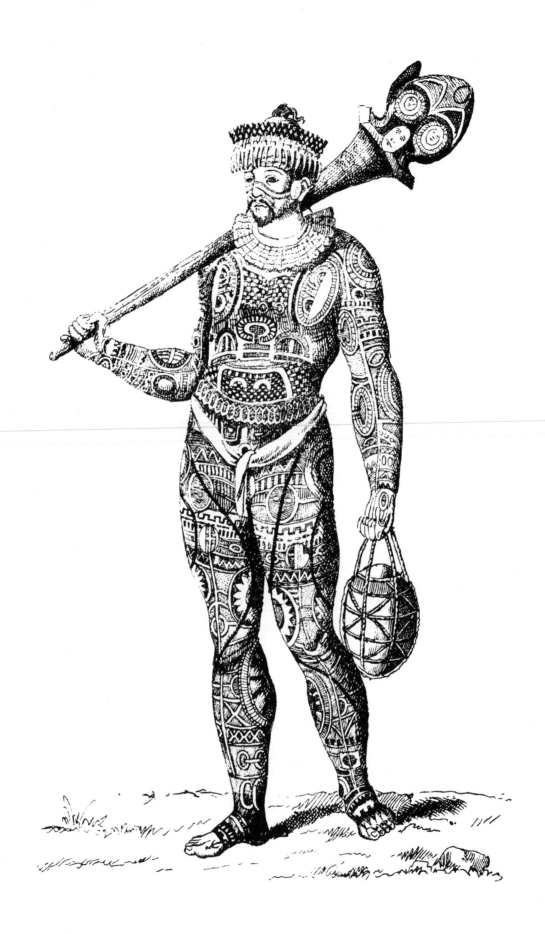

Tattoo of a Nukahiva priest, Marquesas Islands

INTRODUCTION

THE LUST to decorate and to embellish is part and parcel of the creative impulses of man. Somehow plain surfaces and clear outlines attract and intrigue the human eye, and man always endeavors to improve and beautify these challenging spaces and lines neglected by nature. This desire of man to ornament is not bound to any era, continent, race, cultural or educational standard. It has subconscious roots in every human being. We can observe it in the irresistible urge of small children everywhere to "decorate" any plain space or empty wall within their reach, and in the absent-minded doodling of grownups on pads and papers.

We can follow this urge to decorate from the dawn of human history right through all the ages and civilizations. From the plain wall sketches of the cave dwellers to the elaborate murals of our ocean liners. From the simple scratch designs on some of the crude implements of the Stone, Copper and Iron Ages to our own sophisticated and ornate table wares and household objects. From the little known art of decorative tattoo (developed from primitive scars of prehistoric times and still practiced by some African and Oceanian tribes) to the highly artistic ornaments of symbolic body decoration of Polynesia. From the war paint and battle finery of savage warriors to heraldic regalia and our military distinctions. From coarse grass and fiber tissues embellished with seashells, feathers and nutshells to beautifully ornamented fabrics, embroideries and laces.

Our information on ornamental art of early times is indirect and spotty, pieced together from some fragments of architectural designs, stone carvings and other archeologic odds and ends. Unfortunately man's work is as brittle and destructible as man himself. It is prey not only to the consuming forces of the elements of nature but also to the destructive furor of his fellow-man in wars and upheavals.

Our knowledge of decorative forms and expressions in antiquity is a little more intimate, thanks to the plentiful discoveries of archeologists at the sites of vanished cultures in Egypt, Nubia, Babylonia, Assyria, Phoenicia, Greece, Etruria, Rome, Persia, Media, India, the Far East, Central and South America. Wall carvings, tile pavements, mosaic incrustations, vase paintings, household objects, arms, and jewelry found in tombs, temples and other ruins give us a more than fleeting glance at the enormous development of applied art in these cultural periods.

We have gained a fair knowledge of ornamental art from the beginning of the Christian and Byzantine era throughout the Dark Ages, from paintings on wood panels, illuminated manuscripts and an impressive array of similar sources. Thorough and complete information on all these periods can be gained by the student of applied art from the many elaborate and excellent books on these special subjects by outstanding historians and scholars. The invention of paper in Europe in the fourteenth century, and of printing in the fifteenth century enabled our European forefathers to hand down to us a broad and complete picture of their decorative and ornamental designs in everyday use.

Artists, designers, craftsmen, printers, typographers, art students and amateurs who are seeking inspiration and a more intimate acquaintance with the decorative art of this period must spend a lot of time searching for manuscripts and incunabula, rare books

and atlases, design and pattern books of the old masters and craftsmen. Even contemporary books on these subjects, published only a few decades ago, already belong to the rare book class. It takes a good portion of bibliographic know-how to look for and to locate such rare volumes. They are mostly found in separate rare book departments of universities, museums, private and public libraries. These special collections are sometimes not accessible to the average reader, but only to the scholar, the bibliophile and the researcher.

The material reproduced in this book was selected and compiled by the author with one thought in mind: to give the reader the possibility of visualizing in chronological order the fantastic abundance of designs in some of the main groups of applied ornaments and decorations of the last five hundred years, without the necessity and strain of plowing through acres and acres of books and prints.

For the benefit of the interested student and amateur of applied art, an extensive bibliography on many subjects of decoration and ornament has been included in this book.

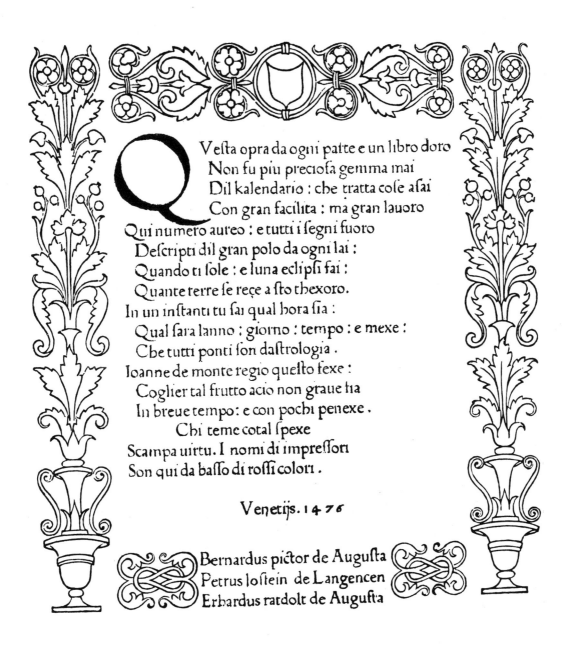

Qvesta opra da ogni parte e un libro doro
Non fu piu preciosa gemma mai
Dil kalendario : che tratta cose asai
Con gran facilita : ma gran lauoro
Qui numero aureo : e tutti i segni fuoro
Descripti dil gran polo da ogni lai :
Quando ti sole : e luna eclipsi fai :
Quante terre se rece a sto thexoro.
In un instanti tu sai qual hora sia :
Qual sara lanno ; giorno : tempo : e mexe :
Che tutti ponti son dastrologia .
Ioanne de monte regio questo fexe :
Coglier tal frutto acio non graue sia
In breue tempo: e con pochi penexe .
Chi teme cotal spexe
Scampa uirtu. I nomi di impressori
Son qui da basso di rossi colori .

Venetijs. 1476

Bernardus pictor de Augusta
Petrus lostein de Langencen
Erhardus ratdolt de Augusta

The first ornamented title page printed by Erhard Ratdolt / VENICE 1476

TITLE PAGES AND FRONTISPIECES

TITLE PAGES AND FRONTISPIECES

IN THE first twenty years of printing with movable type, books contained no title pages. Their low price as compared with the cost of handwritten manuscripts, and their novelty value, gave these volumes enough sales attraction. The outer appearance of a book was not the printer-publisher's concern. Books were bound individually according to the collector's or librarian's taste and solvency.

In these two short decades, the skill of printing spread like wildfire over Europe. In the year 1476, over one hundred offices printed books. They were being printed all the way from Naples to London, from Lyons to Cracow, from Saragossa to Rostock. Competition became really keen. In that year, Erhard Ratdolt of Venice designed the first ornamented title page, to give his *Calendarium* a more eye-appealing appearance. Such decorated title pages and frontispieces immediately became a necessary feature for every book. Throughout the following centuries these decorative title pages and frontispieces were designed by the most outstanding artists of their time.

In the last century the invention of new printing processes brought on much larger editions of books. Their appearance and bindings became the concern of the publishers. The make-up of the bindings was highly embossed and brightly gilded while decorative and ornamented title pages declined in popularity.

The thorough commercialization of book production in our century went one step further. The bindings became more or less uniform. The decorative sales appeal, completely detached from the book, took on the form of the book jacket.

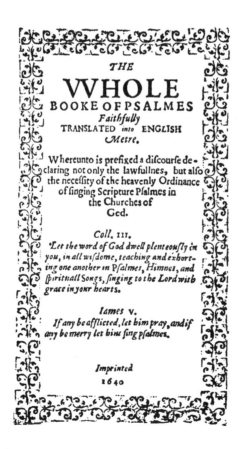

The first book printed in North America by Stephen Day / CAMBRIDGE 1640

Ad diuum Alfonfum Aragonum & utriuſq; Sicilię
regem iñ libros ciuiliũ belloru̅ ex Appinno Alexan‧
drino in latinũ traductos Pręfatio incipit feliciſſime.

Aithoru̅ regem ut ab Annco accepi‧
mus ſine munere ſalutare nemo po‧
teſt. Ego uero glorioſiſſime rex cum
tuam uirtutę̃ humanitatęq; cõſidero
tum cęteras naturę dotes:quibus in‧
ter ętatis noſtrę principes uel in pri‧
mis illuſtris es: ſublime ingenium :
ſummā caritatę̃: ſummā continentiā
nulla ratione adduci poſſum ut non

Anneus Seneca de
rege parcborum.

pluris apud te fidem meā eſſe exiſtimem q̃ ullas opes. Quip‧
pe cũ te indigentibus & ueluti e nauſtagio emerſis q̃q̃ ignotis
offerre uideam pias manus. Cęteɇ nec ſine munere ad te ueni
nec uacuis(ut aiunt)manibus tuā maieſtatē ſim adoraturus .
Nam cũ priores Appiani libros/Libycum: Syrium: Parthicũ
& Mithridaticũ Nicolao quinto ſu̅mo pontifici dum i huma‧
nis ageret e greco tranſtuliſſem/Reliquos ciuilium bellorum
cõmentarios:quę Senatus:popululq; romanus inuicem geſſit
nundũ editos aut perfectos a me ad quem potius mitterem q̃
ad te iuictiſſime princeps/Hiſpanię pariter & Italię noſtrę de

Nicolaus papa quin‧
Libycus. (tus.
Syrius.
Parthicus.
Mithridaticus.

Appiani Alexandrini ſopbiſte Romanoru̅ liber finit
qui Celticus inſcribaur. Traductio.P.Candidi.

Impreſſum eſt hoc opus Venetijs per Bernardũ picto‧
rem & Erhardum ratdolt de Auguſta una cum Petro
loſlein de Langencen correctore ac ſocio. Laus Deo.
.M. CCCC. LXXVII.

Ornamented title page printed by Erhard Ratdolt/VENICE 1477

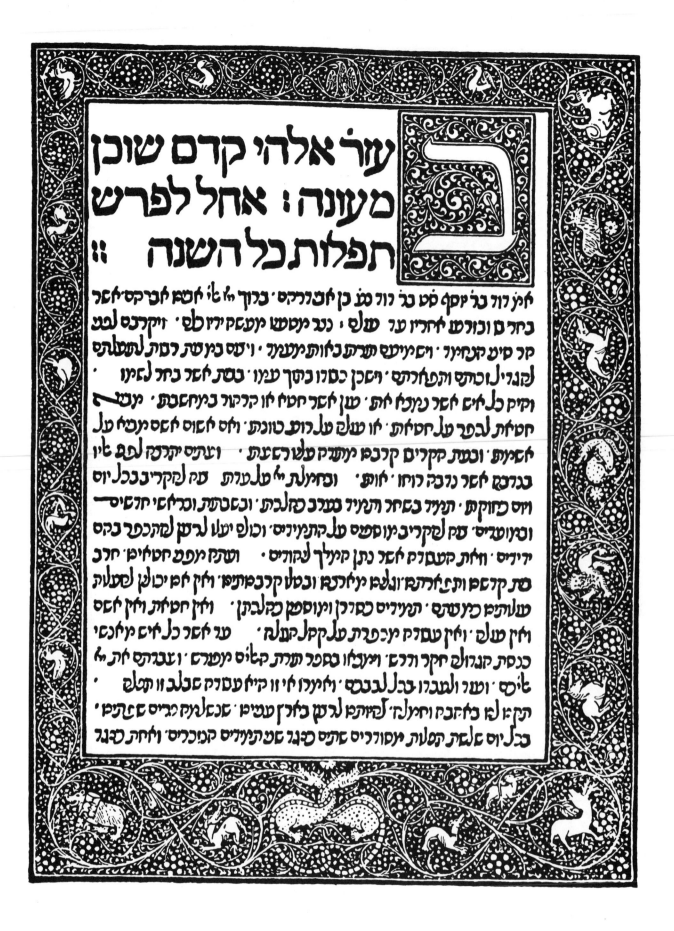

Ornamented Hebrew page printed by Elieser Toledano / LISBON 1489

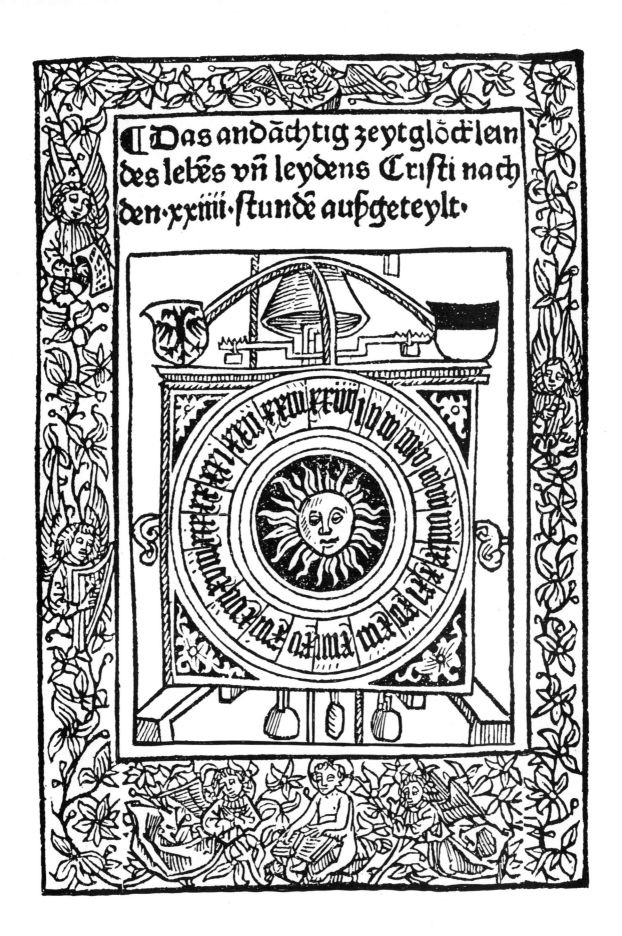

*Title page printed by Conrad Dinckmut/*ULM 1493

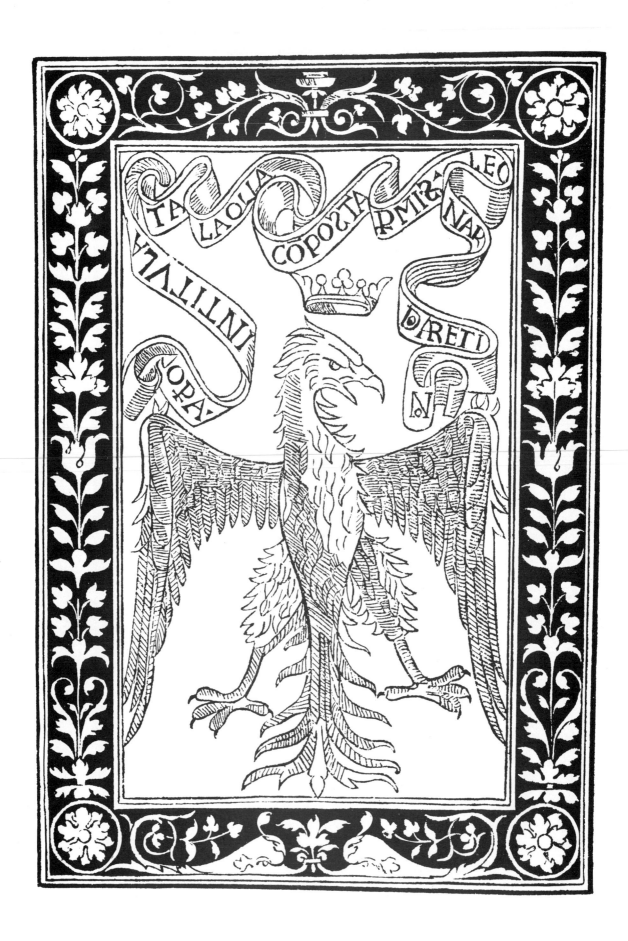

Frontispiece printed by Pelegrino de Pasquali / VENICE 1494

ОNÉЖЕВЬ ТРОЙЦН ПОКЛАНѦÉМІН
БГЬ БЛГОНЗВОЛН ЙСПЛЪ́ННТНСВО
Ю ЦРКВЬ, РАЗЛЙЧНЫМНКНѦГАМН
ВНДЕВЬ АЗЬВЬ АБГА БЛГО В ТРН
ЫН ЙБМЬХРАНИМН ГНЬГЮРГЬЦЬ
РНОЕВЫКЬ· ЦРКВЫ ПРАЗДНЫСТЫХ
КНЙГЪ, ГРЪХЬРАДН НАШНХ РАЗХЙ
ЩЕНІЕМЬ ЙРАЗДРАНІЕМЬ АГАРАНСКЫХЬ УЕДЬ · СЬЗРЪ
ВНОВАХЬ ПОСПЪШЕНІЕМЬ СТГОДХА, ЙЛЮБОВІЮКЬ БЖ
ТВНЫМ ЦРКВАМ · ЙНАПНСАХ СЙЮДШЕСПЪСНУЮКНѦГУ Ѡ̈С
МОГЛАСНЫКЬ· ВЬЙСПЛЪ́ННІЕСЛАВОСЛОВІЮТРІСЛНУНАѢГ
ОВЬ ѢДНСТВЪ ПОКЛАНѦÉМАГОБЖСТВА· МЛЮЖЕЮНІЕ
ЙСЬВЗРА́СТНЫЕ ЙСТАРІЕ, УЬ́ТОУЩЕЙ ЙЛНВЬСПЪ́ВАЮЩЕЙ
ЙЛНПН́ШУЩЕЛЮБВЕХВЪРАДНИСПРАВЛѦТН · НАСЖЕОУ́С
РДНЕПОТЪ́ЩАВШНХСЕНАСІЕД БЛОБЛСВЛѦ́ТН · ДА́ЙБОЙ
СЛА́ВЪЩЕ Ѡ̈ЦА ЙЗНЪ́ГОЖЕВЬСА́ СПАЙМЖЕВЬСА́· СТГОДХА
Ѡ̈НѢМЖЕВЬСА́ ЗДЪ́ОУ́ЛУНММЛ̈СТЬ ТА́МОЖЕ СЇНСВЪ
ТОМ Ѡ̈ЗАРЫМСЕ, ѦМІН· ПОВЕЛЪ́НІЕМ ГНА́МНГЮРГН
ЦЬРНОÉВНКН А́ЗЬ ХУРДАБЬ СЩÉНОЙНОКЬМАКАРІÉ, РСУ́КО
ДЕЛНСАХ СІÉ· ПРН́ ВСЕ Ѡ̈СЩÉННОМ МНТРОПОЛНТЕ ЗЕ́ТС
КОМКУ́Р ВАВУ́ЛЕ· ВЬЛЪ́ТО·ЗӒ КРГ СЛНЦ, Ӓ ·ЛУНЕ, Ѳ̈:·

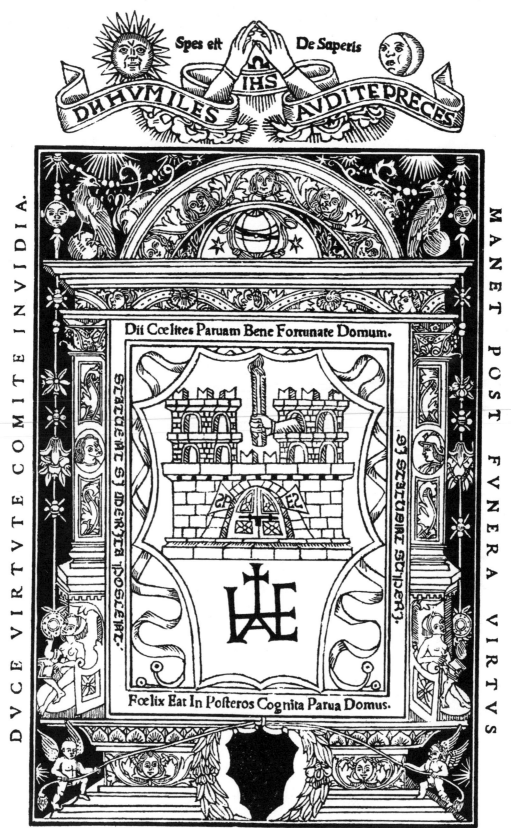

Frontispiece printed by Bernardinus Vercellensis / VENICE 1495

The first German law book printed by Hans Schönsperger / AUGSBURG 1496

Actum hoc nonū et infrascri
ptum beate Marie virginis
psalterū ad honorē omipotē
tis dei ad eusdē beatē Marie
virginis celestis et terrestris
glose Impatricis Illustrissi
mi friderici tcij Impatoris
ꞇ maximi Maximiliani glori
osissimi nostri regis ab earun
dem Illustrissimaꝛ regiaruꝛ
maiestatū huillimo Cappella
no Hermāno Mitzschewitz
ex Brandeburgēsi Margia
Trebbinensi vtriusꝗ Inris psul tu magno Cir
ca Oderam franckfordensꝪ ciuitatis ꝓthono
tario ad teucroꝛ cōtentōꝛ denoue legis dulcissi
mis mirabilibꝰ diuini amoris flore vberrie refer
tis ꝓfectū Annodomini Millesimoquadringē
tesūnooctuogesimo Mono Illustrissimo Iimpa
tori friderico ex Lunenborch delatū Et Anno
Monagesimosecūdo in mense Septēbri ad Il
lustrissimas cesarias regiasꝗ manꝰ pñcialiꝭ pre
sentatꝭ Mutu regio cesario iussu Ab illustrissi
ma Romana Friderici Iimpatoris tercij Can
cellaria examinatū Cesareo sumptu ad impmē
dum ꝓmissum Msic et in Tzenna Cistterciensis
oꝛdis deuoto claustro subpñcipatu domni. dñi
Micolai abbatis spiritualis patris ac domni dō
m sui graciosi singularꝭ in huius glose vginis
laudibꝰ sui et tociꝰ Cistersiensis oꝛdinis dulcis
sime patronisse deuoti ad alti celsi sacri diui pij

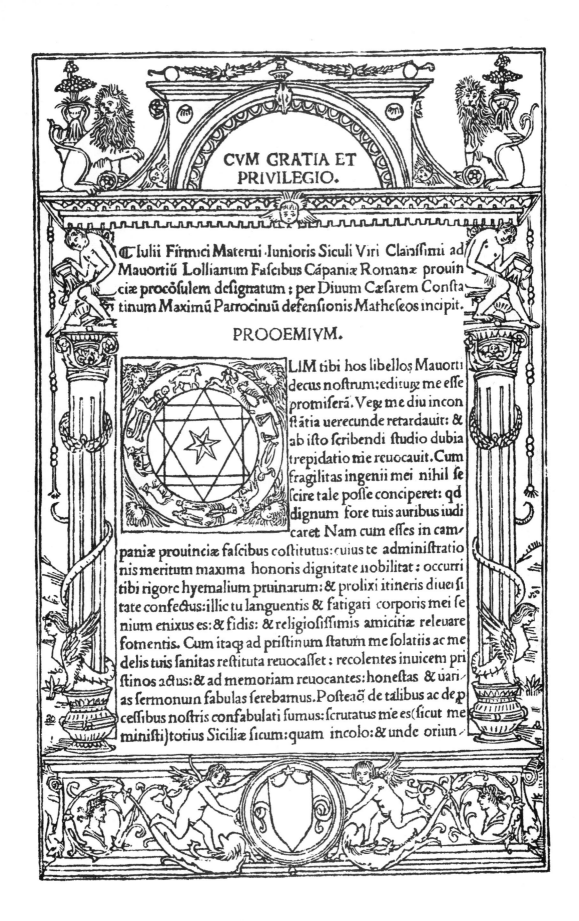

CVM GRATIA ET
PRIVILEGIO.

Iulii Firmici Materni Iunioris Siculi Viri Clarissimi ad
Mauortiū Lollianum Fascibus Cāpaniæ Romanæ prouin
ciæ procōsulem designatum; per Diuum Cæsarem Consta
tinum Maximū Patrociniū defensionis Matheseos incipit.

PROOEMIVM.

LIM tibi hos libellos Mauorti
decus nostrum: editurg me esse
promiserā. Verg me diu incon
stātia uerecunde retardauit: &
ab isto scribendi studio dubia
trepidatio me reuocauit. Cum
fragilitas ingenii mei nihil se
scire tale posse conciperet: qd
dignum fore tuis auribus iudi
caret Nam cum esses in cam
paniæ prouinciæ fascibus costitutus: cuius te administratio
nis meritum maxima honoris dignitate nobilitat: occurri
tibi rigore hyemalium pruinarum: & prolixi itineris diuersi
tate confectus: illic tu languentis & fatigati corporis mei se
nium enixus es: & fidis: & religiosissimis amicitiæ releuare
fomentis. Cum itaq ad pristinum statum me solatiis ac me
delis tuis sanitas restituta reuocasset: recolentes inuicem pri
stinos actus: & ad memoriam reuocantes: honestas & uari
as sermonum fabulas serebamus. Posteaq de talibus ac de p
cessibus nostris confabulati sumus: scrutatus me es (sicut me
ministi) totius Siciliæ sicum: quam incolo: & unde oriun

Ornamented title page printed by Johannes Winterburger / VIENNA 1497

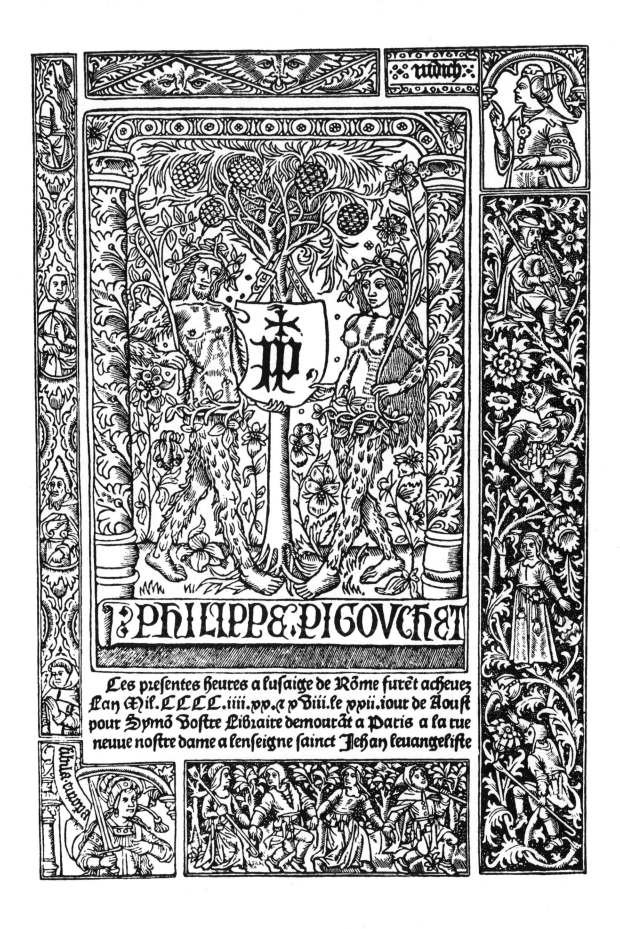

Frontispiece printed by Philippe Pigouchet / PARIS 1498

Ornamented title page by Nicolo and Dominico Gesú / VENICE 1500

Ornamented title page printed by Zorzi de Rusconi / VENICE 1501

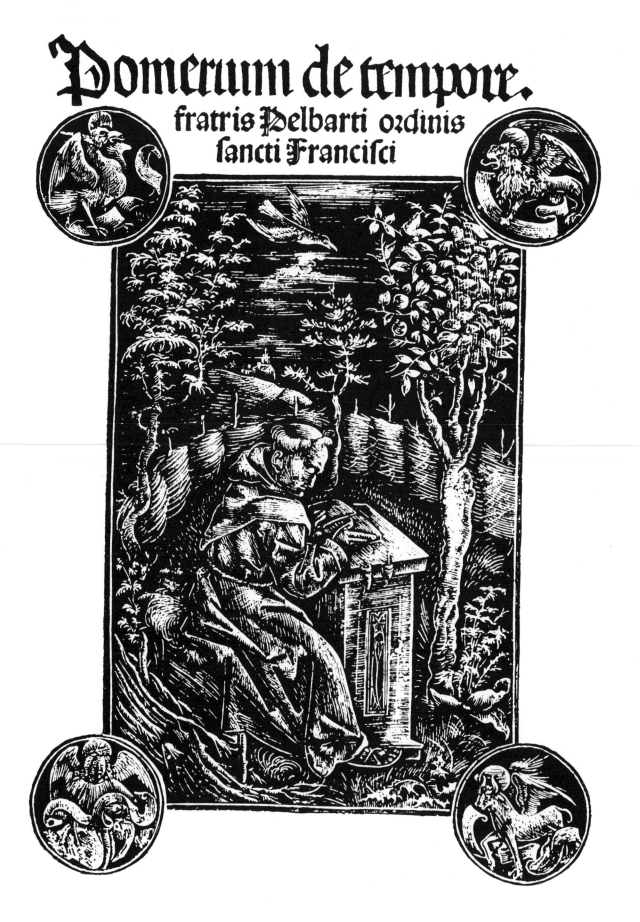

Pomerium de tempore.

fratris Pelbarti ozdinis sancti Francisci

Title page printed by Johann Othmar / AUGSBURG 1502

Frontispiece printed by Stephanus Baland / LYONS 1505

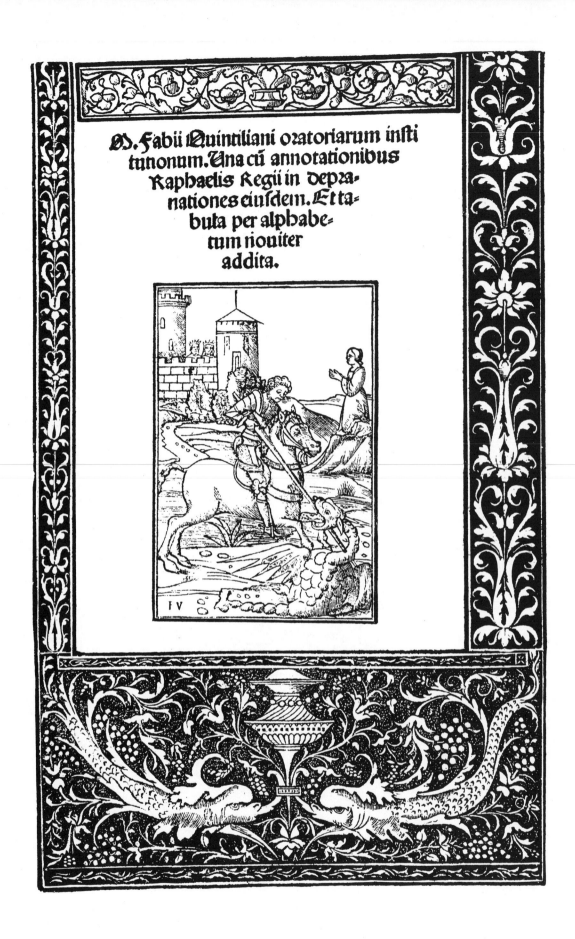

Ornamented title page printed by Johannes de Rusconibus / VENICE 1512

· 34 ·

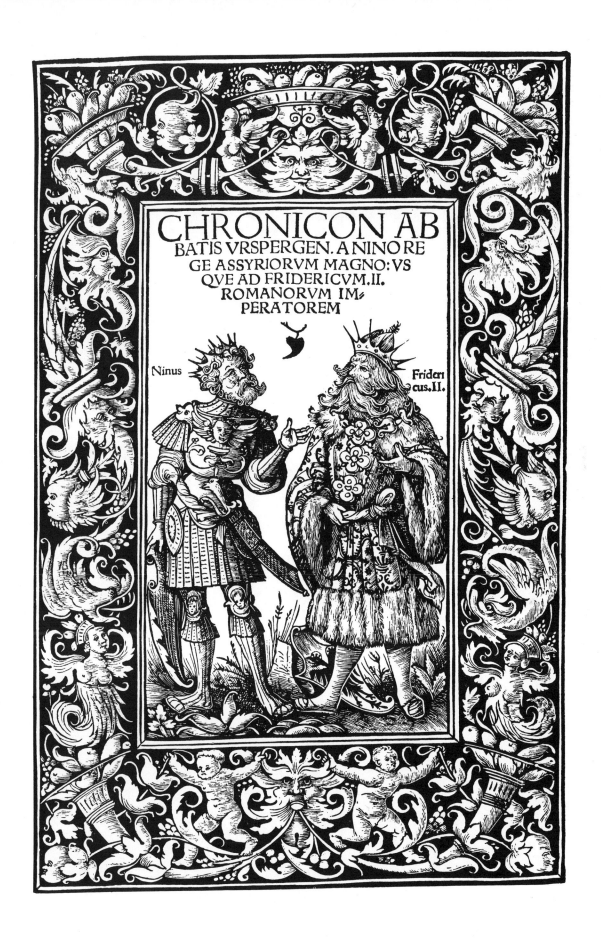

Title page designed by Daniel Hopfer / AUGSBURG 1515

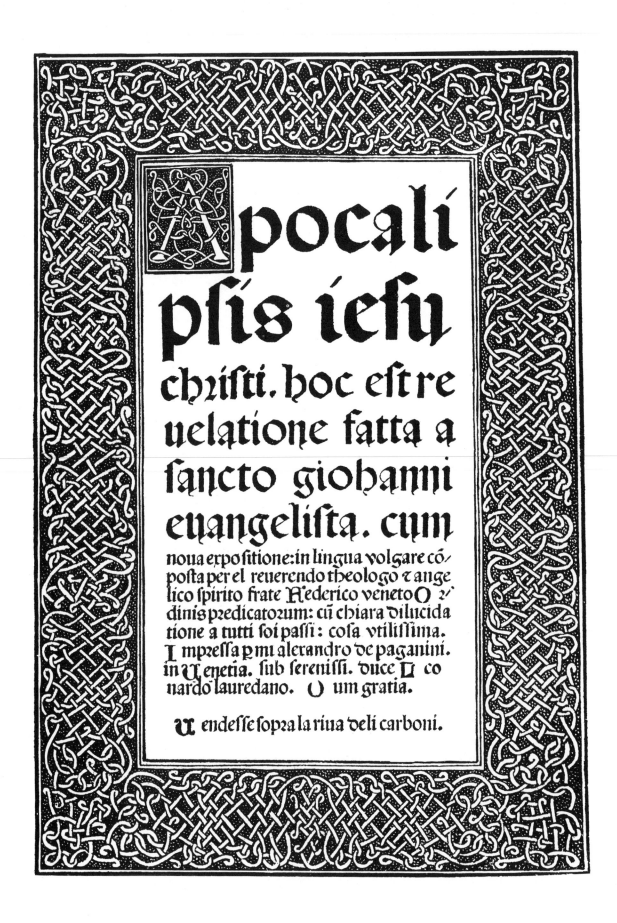

Apocalipsis iesu christi. hoc est re uelatione fatta a sancto giohanni euangelista. cum noua erpositione:in lingua volgare cóposta per el reuerendo theologo ⁊ angelico spirito frate Federico veneto Ordinis predicatorum: cũ chiara dilucidatione a tutti soi passi: cosa vtilissima. Impressa p mi alerandro de paganini. in Venetia. sub serenissi. duce Leonardo lauredano. Cum gratia.

Vendesse sopra la riua deli carboni.

Ornamented title page printed by Alessandro Paganino / VENICE 1515

·36·

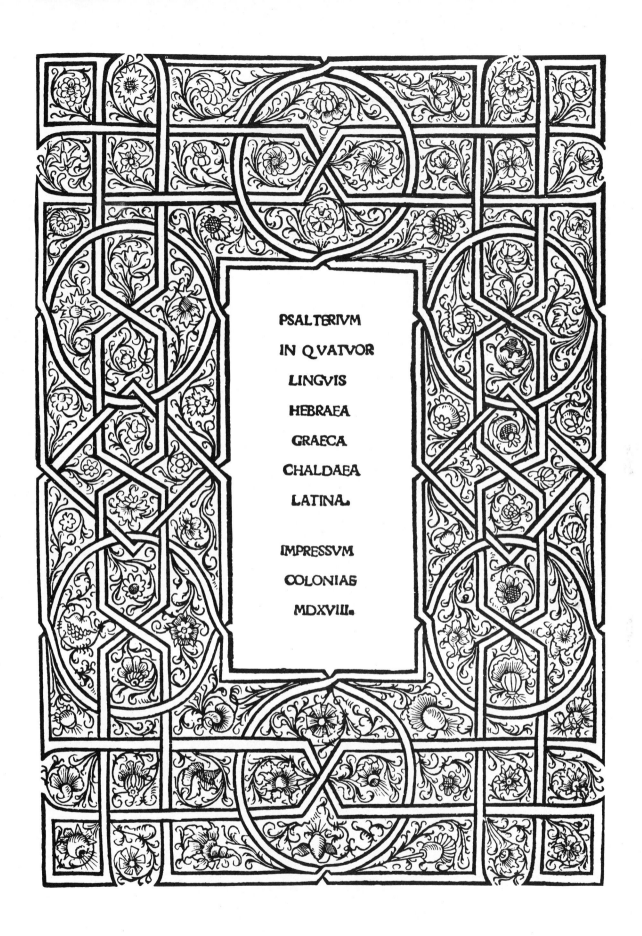

PSALTERIVM
IN QVATVOR
LINGVIS
HEBRAEA
GRAECA
CHALDAEA
LATINA.

IMPRESSVM
COLONIAE
MDXVIII.

Ornamented title page from a Psalterium/COLOGNE 1518

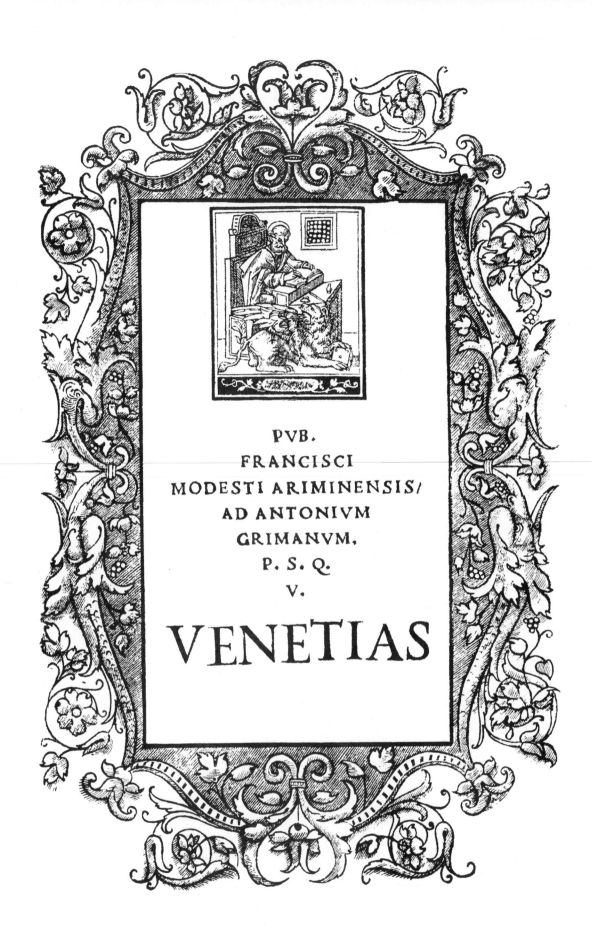

PVB.
FRANCISCI
MODESTI ARIMINENSIS/
AD ANTONIVM
GRIMANVM.
P. S. Q.
V.

VENETIAS

*Ornamented title page printed by Bernardinus de Vitalis/*VENICE 1521

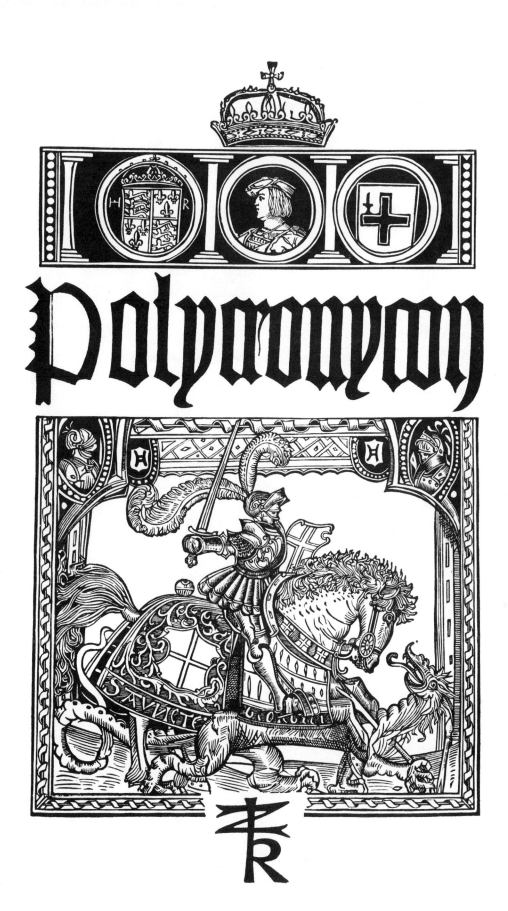

Title page printed by Peter Treveris / LONDON 1527

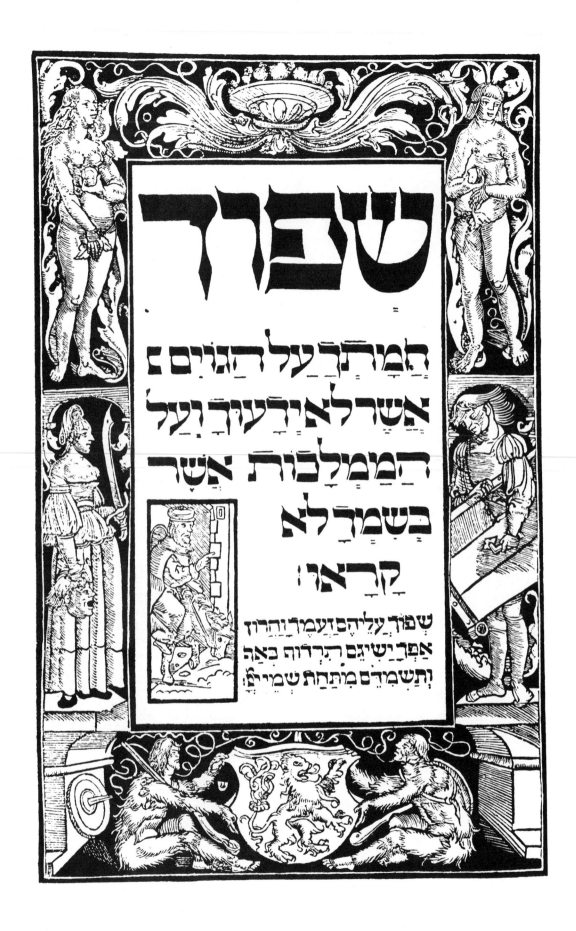

Hebrew title page printed by Gerson Cohen / PRAGUE 1527

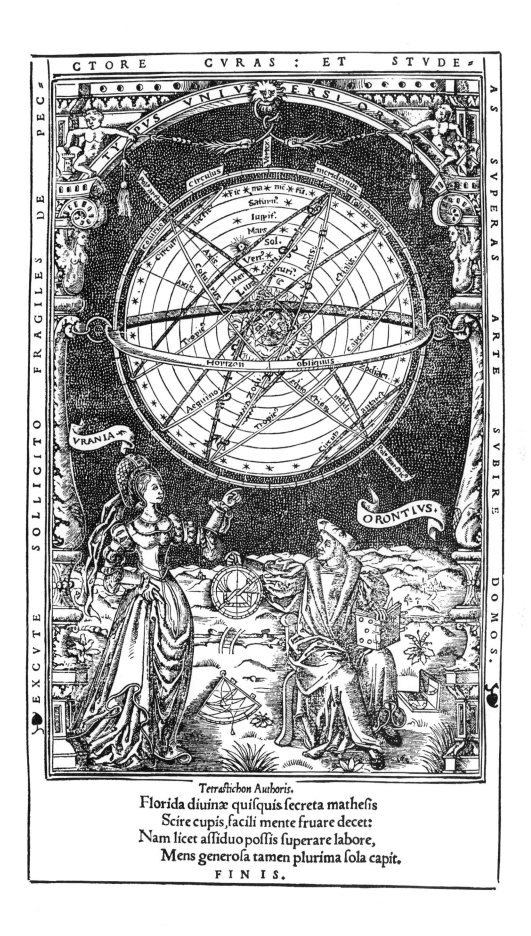

End page from the first mathematical book by Oronce Finé / PARIS 1530

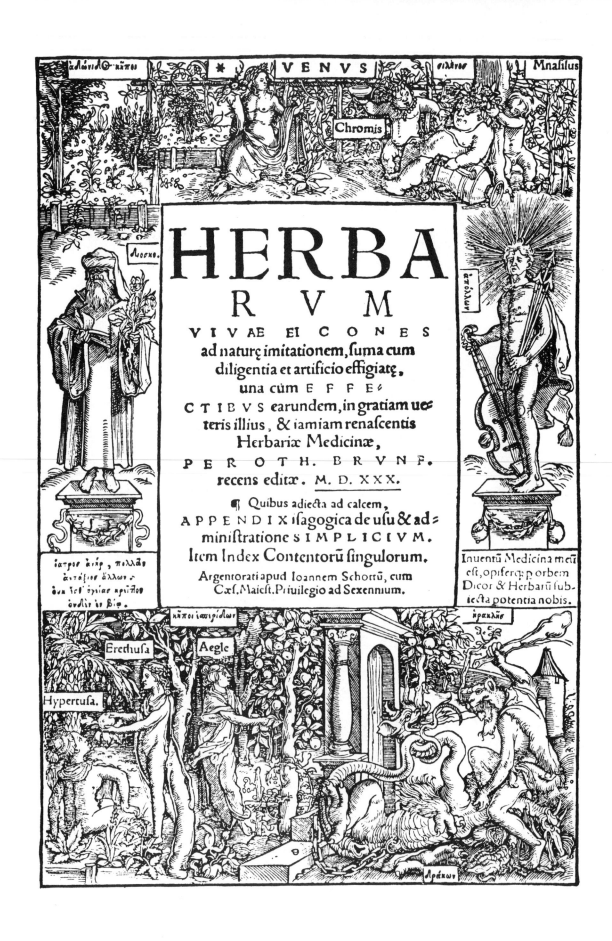

*Title page designed by Hans Weiditz/*STRASBOURG 1530

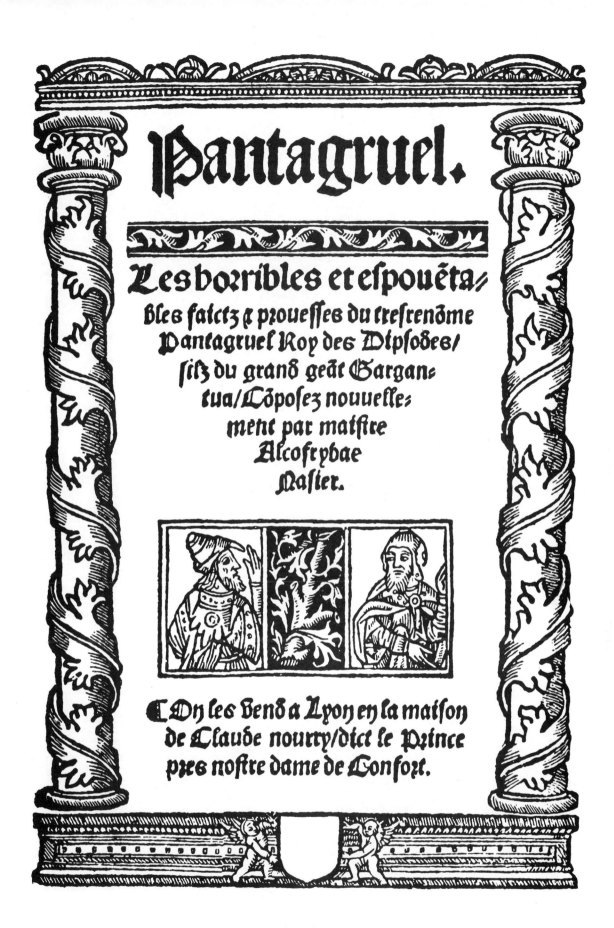

Pantagruel.

Les horribles et espouëta/
bles faictz & prouesses du tresrenõme
Pantagruel Roy des Dipsodes/
filz du grand geãt Gargan-
tua/Cõposez nouelle:
ment par maistre
Alcofrybae
Masier.

¶On les vend a Lyon en la maison
de Claude nourry/dict le Prince
pres nostre dame de Confort.

Ornamented title page printed by Claude Nourry/ LYONS 1532

· 43 ·

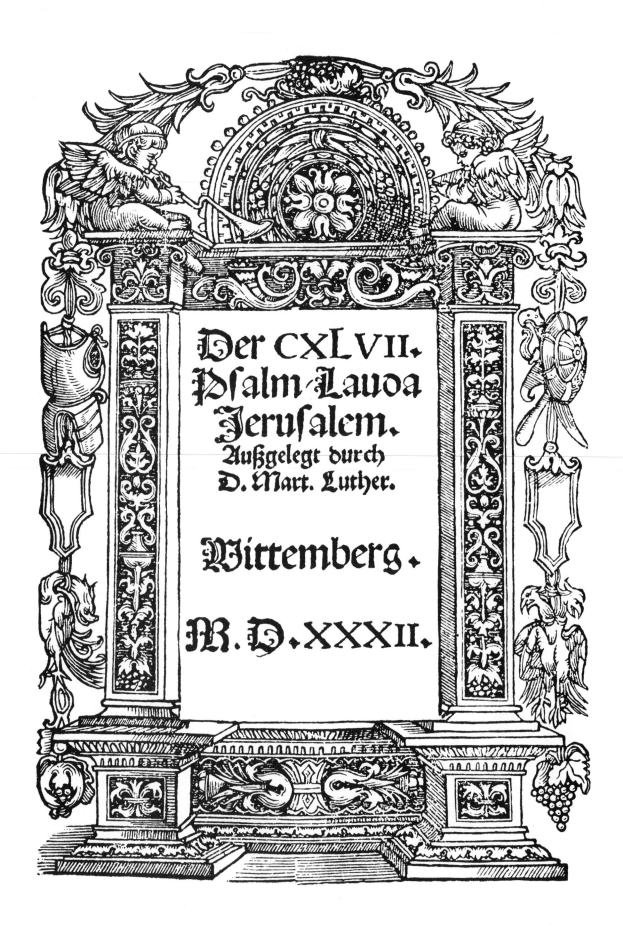

Der CXLVII.
Psalm Lauda
Jerusalem.
Außgelegt durch
D. Mart. Luther.

Wittemberg.

M.D.XXXII.

Ornamented title page printed by Fridrich Peypus / NUREMBERG 1532

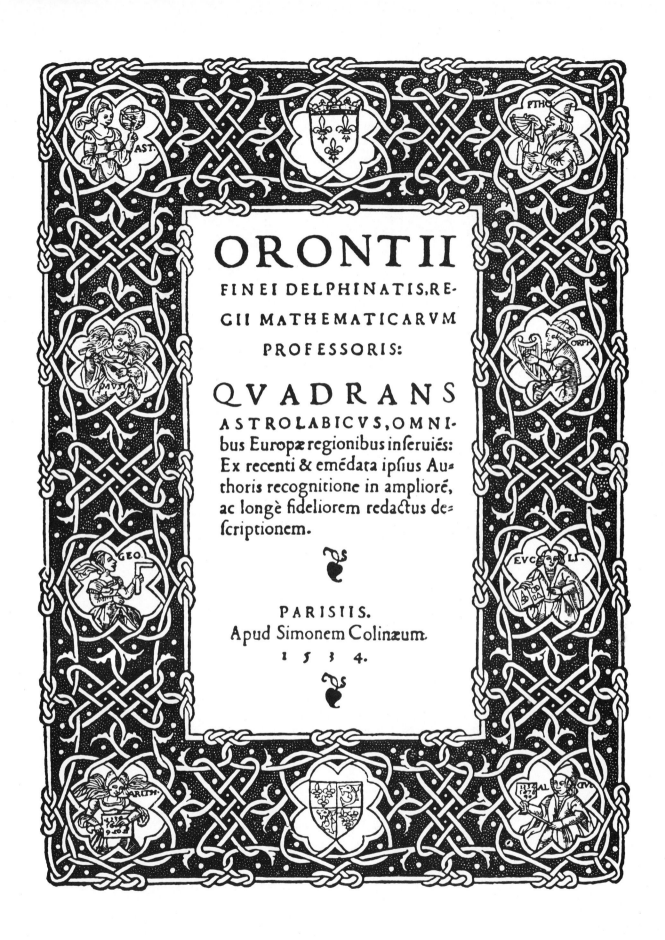

ORONTII

FINEI DELPHINATIS, REGII MATHEMATICARVM PROFESSORIS:

QVADRANS

ASTROLABICVS, OMNI-
bus Europæ regionibus inferuiés:
Ex recenti & emédata ipfius Au-
thoris recognitione in amplioré,
ac longè fideliorem redactus de-
fcriptionem.

PARISIIS.
Apud Simonem Colinæum.
1534.

Ornamented title page designed by Oronce Finé / PARIS 1534

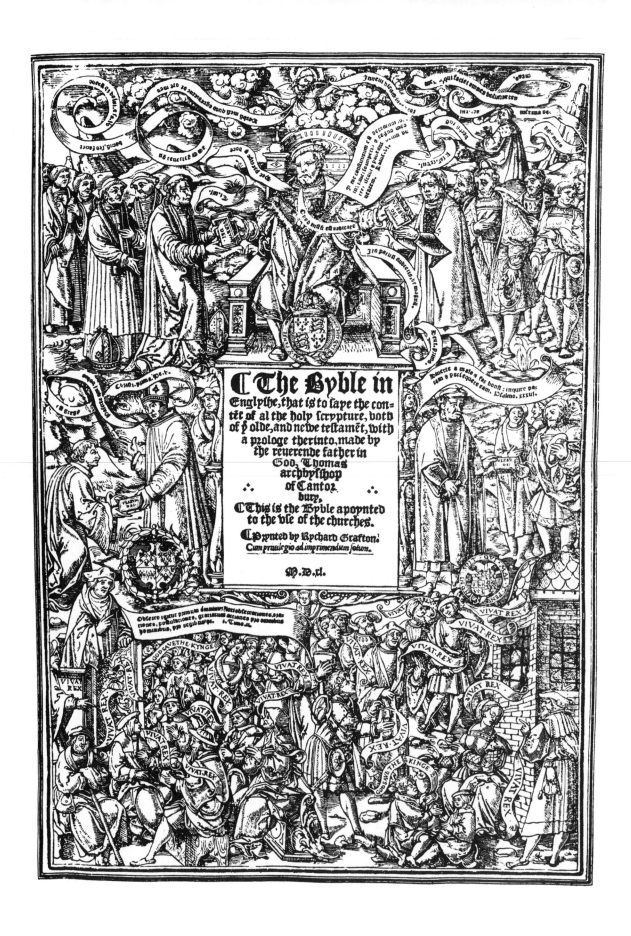

Title page printed by Rychard Grafton/ LONDON 1540

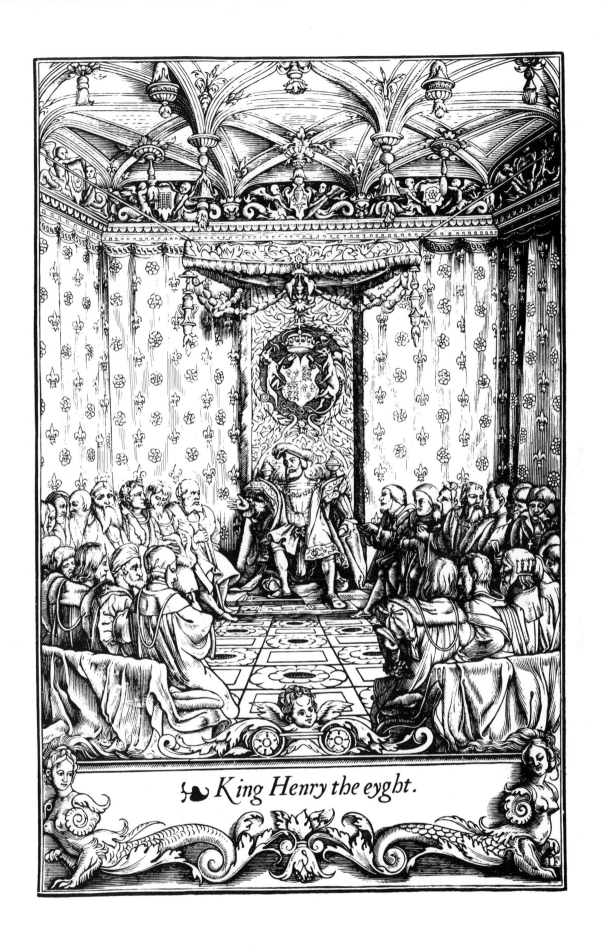

King Henry the eyght.

End page printed by Rychard Grafton / LONDON 1548

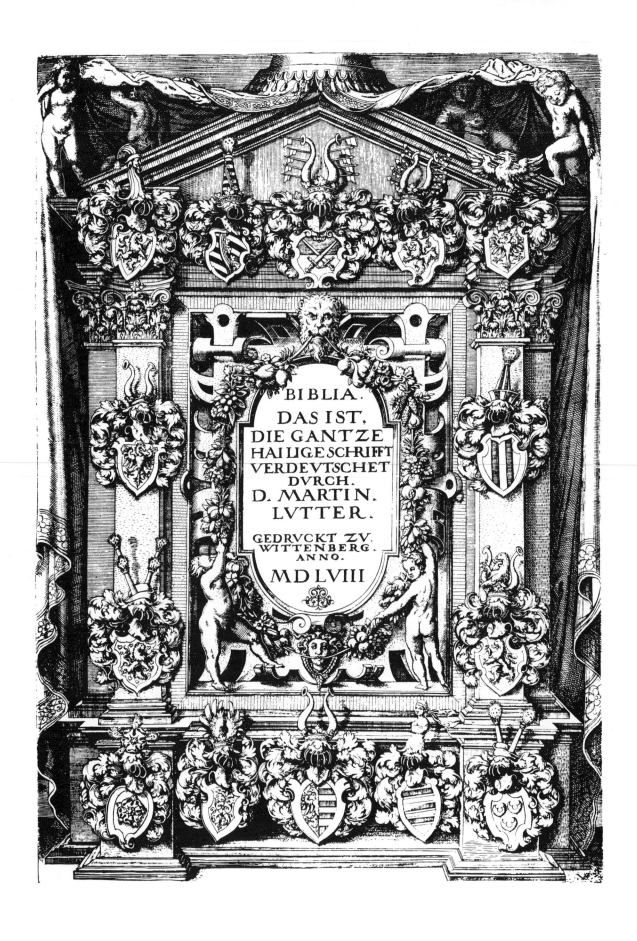

Title page designed by Virgil Solis / WITTENBERG 1558

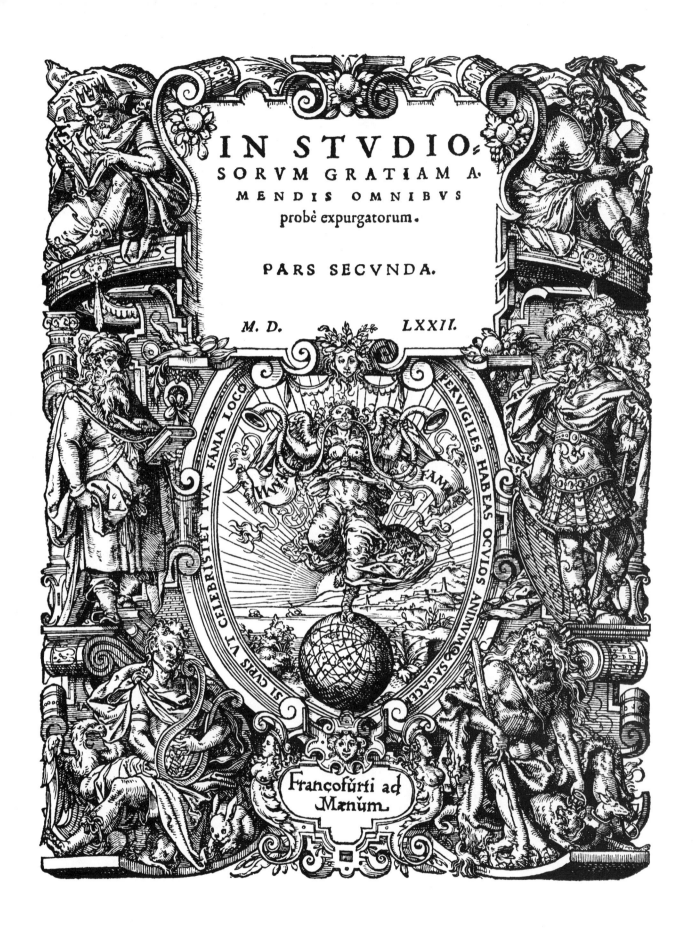

IN STVDIO-
SORVM GRATIAM A.
MENDIS OMNIBVS
probè expurgatorum.

PARS SECVNDA.

M. D. *LXXII.*

Francofůrti ad
Mænům.

Title page designed by Jost Amman/FRANKFORT O.M. 1570

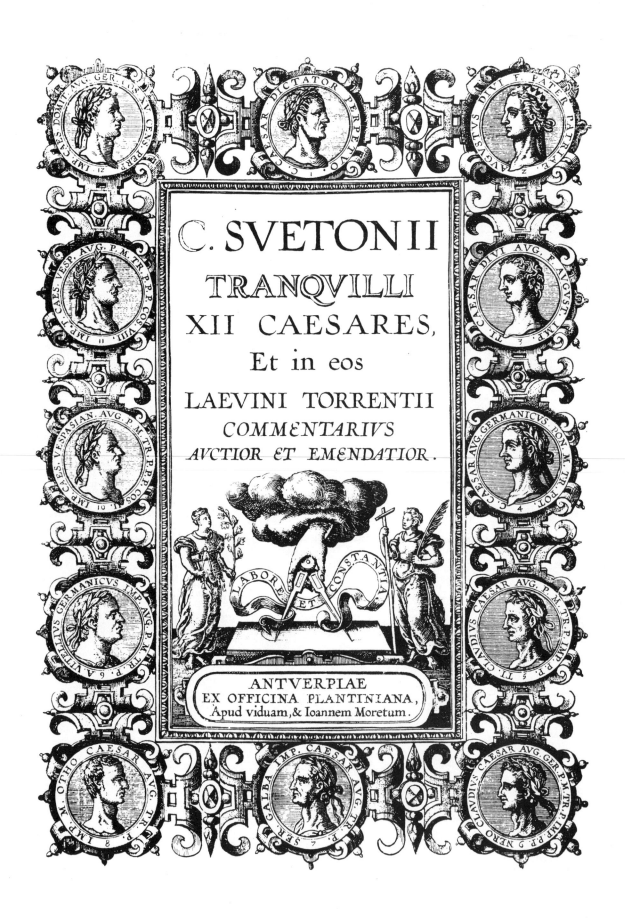

C. SVETONII

TRANQVILLI
XII CAESARES,
Et in eos
LAEVINI TORRENTII
COMMENTARIVS
AVCTIOR ET EMENDATIOR.

LABORE ET CONSTANTIA

ANTVERPIAE
EX OFFICINA PLANTINIANA,
Apud viduam,& Ioannem Moretum.

Title page printed by Christoph Plantin / ANTWERP 1578

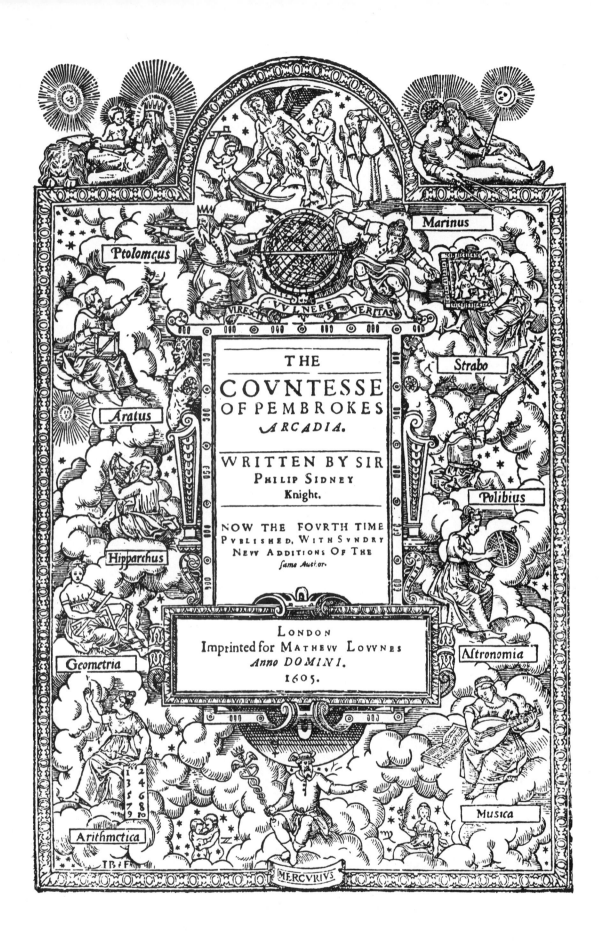

Ptolomeus · Marinus · Strabo · Polibius · Astronomia · Musica · Arithmetica · Geometria · Hipparchus · Aratus

VIRESCIT VVLNERE VERITAS

THE
COVNTESSE
OF PEMBROKES
ARCADIA.

WRITTEN BY SIR
PHILIP SIDNEY
Knight.

NOW THE FOVRTH TIME
PVBLISHED, WITH SVNDRY
NEW ADDITIONS OF THE
same Author.

LONDON
Imprinted for MATHEW LOVVNES
Anno DOMINI.
1605.

MERCVRIVS

Title page printed for Mathew Lownes / LONDON 1605

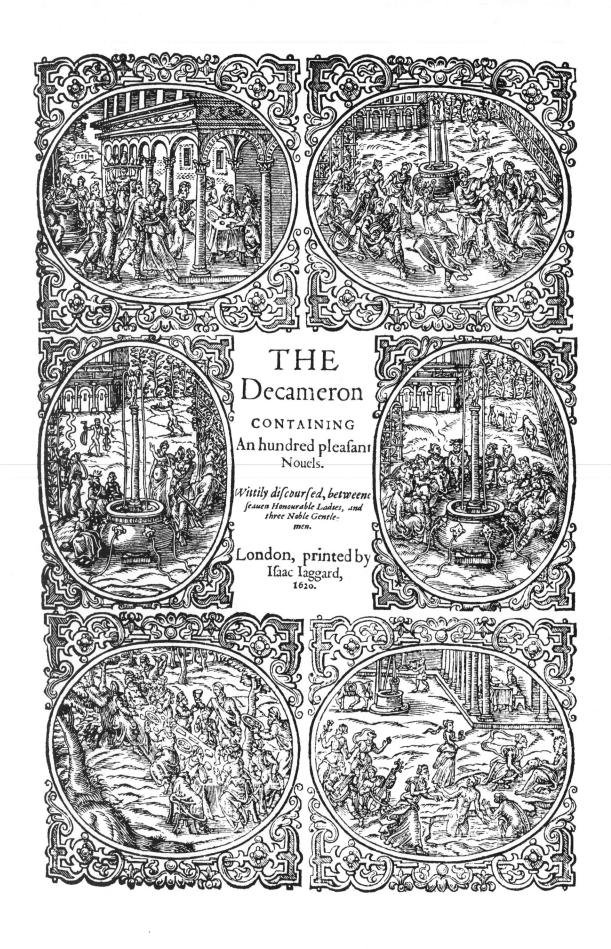

THE
Decameron
CONTAINING
An hundred pleasant
Nouels.

Wittily discoursed, betweene
seauen Honourable Ladies, and
three Noble Gentle-
men.

London, printed by
Isaac Iaggard,
1620.

Title page printed by Isaac Iaggard / LONDON 1620

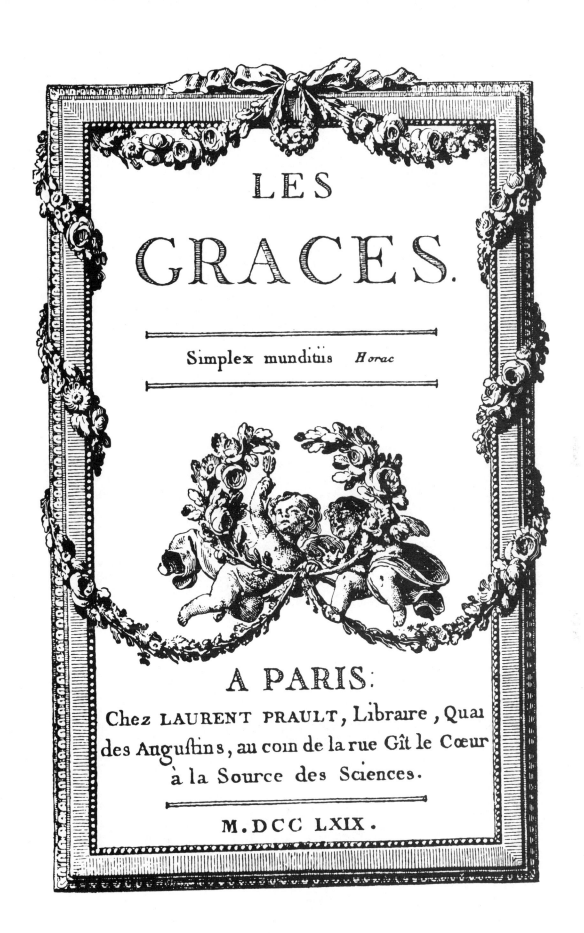

LES
GRACES.

Simplex munditiis *Horac*

A PARIS:
Chez LAURENT PRAULT, Libraire, Quai
des Augustins, au coin de la rue Gît le Cœur
à la Source des Sciences.

M.DCC LXIX.

Title page designed by Jean-Michel Moreau the Younger / PARIS 1769

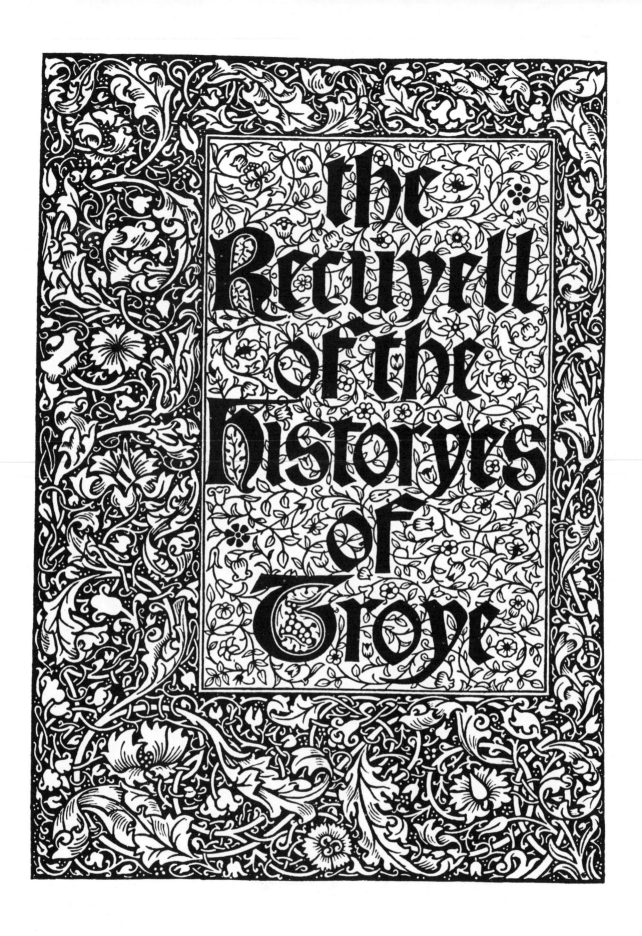

Title page designed by William Morris, Kelmscott Press / HAMMERSMITH 1892

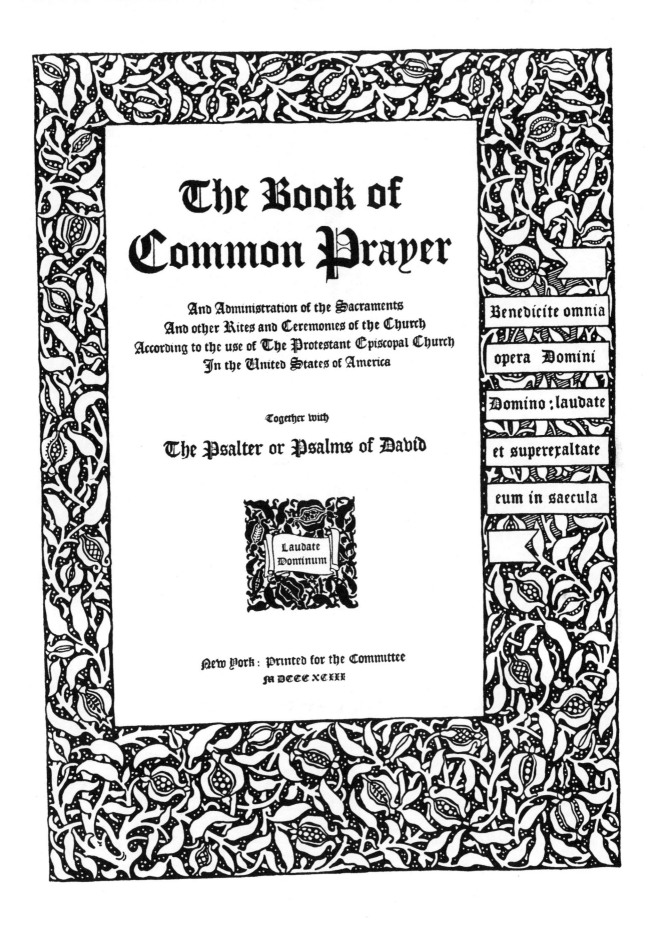

The Book of Common Prayer

And Administration of the Sacraments
And other Rites and Ceremonies of the Church
According to the use of The Protestant Episcopal Church
In the United States of America

Together with

The Psalter or Psalms of David

Laudate
Dominum

Benedicite omnia

opera Domini

Domino : laudate

et superexaltate

eum in saecula

New York : Printed for the Committee
M DCCC XCIII

Title page designed by Bertram G. Goodhue, De Vinne Press / NEW YORK 1893

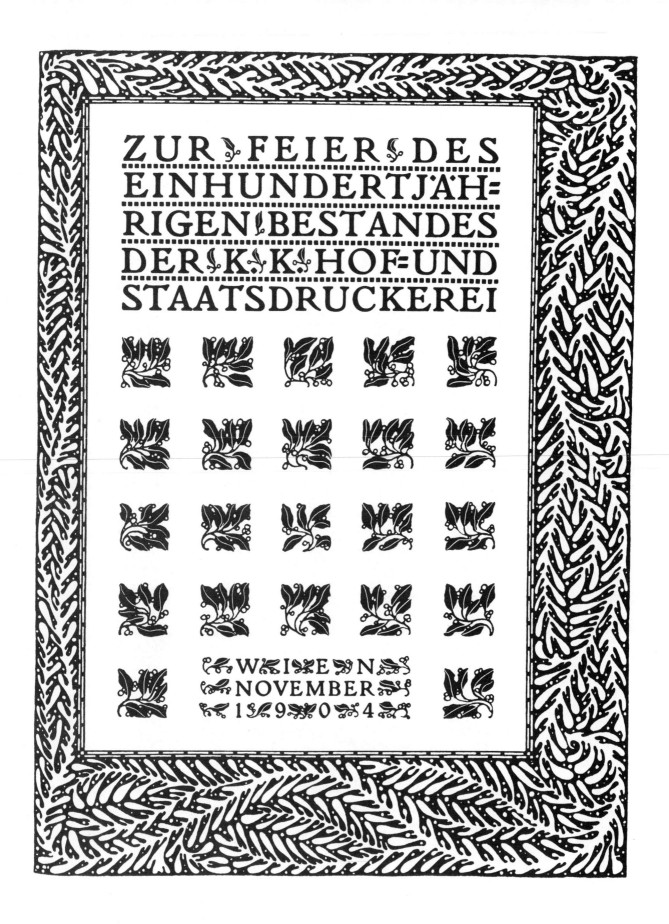

Title page designed by Koloman Moser, Staatsdruckerei / VIENNA 1904

LETTERS & ALPHABETS

Initial B from a manuscript / TOLEDO 11TH CENTURY

LETTERS AND ALPHABETS

LETTERS AND ALPHABETS

Dᴜʀɪɴɢ ᴛʜᴇ fifth and the sixth centuries, monastic scribes for the early church began to give the first letter on the first page of their manuscripts a greater prominence. These enlarged letters were called "Initials" from the Latin *initialis* meaning "beginning."

In the many ecclesiastic and worldly manuscripts of the following centuries, these initials became larger and more ornamented; embellished with pictorial décor and miniature illustrations; adorned with designs in gold and illuminated with brilliant colors. Such initials were used not only as the first letter of a manuscript but also at the beginning of divisions, chapters, paragraphs and even sentences. Through the extensive use of these elaborately ornamented initials in medieval times, they became an integral part of early book decoration.

When Johannes Gutenberg designed his Bible, he had to take into consideration that his printed books must compete with these manuscripts of rich décor. Ornamented initials were accepted as an absolutely necessary and indispensable feature of a well-made and attractive book. So Gutenberg and his successors used the movable ornamented initial in their printed works in an outstanding way and with excellent results.

From this time on throughout the last five hundred years, nearly every known and unknown woodcutter, engraver, writing master, illustrator, type designer, punch-cutter and printer made his contribution to the uncountable multitude of ornamented initials and alphabets.

Initial K from a manuscript / ɢᴇʀᴍᴀɴʏ 12ᴛʜ ᴄᴇɴᴛᴜʀʏ

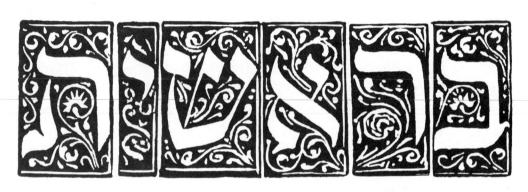

Ornamented Hebrew letters by Joshua Salomon Soncino / CREMONA 1483

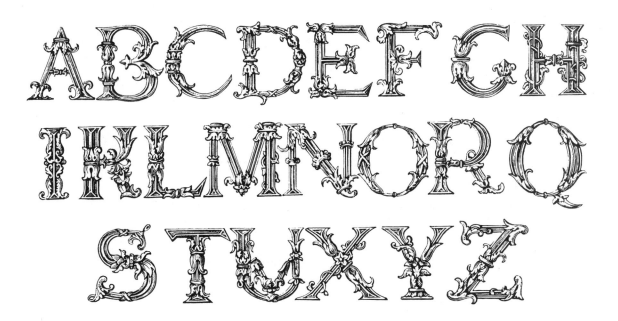

Ornamented alphabet / ENGLAND 1490

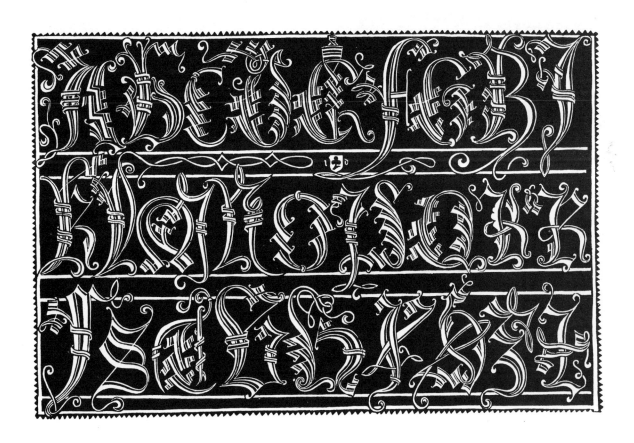

Ornamented alphabet / GERMANY 15TH CENTURY

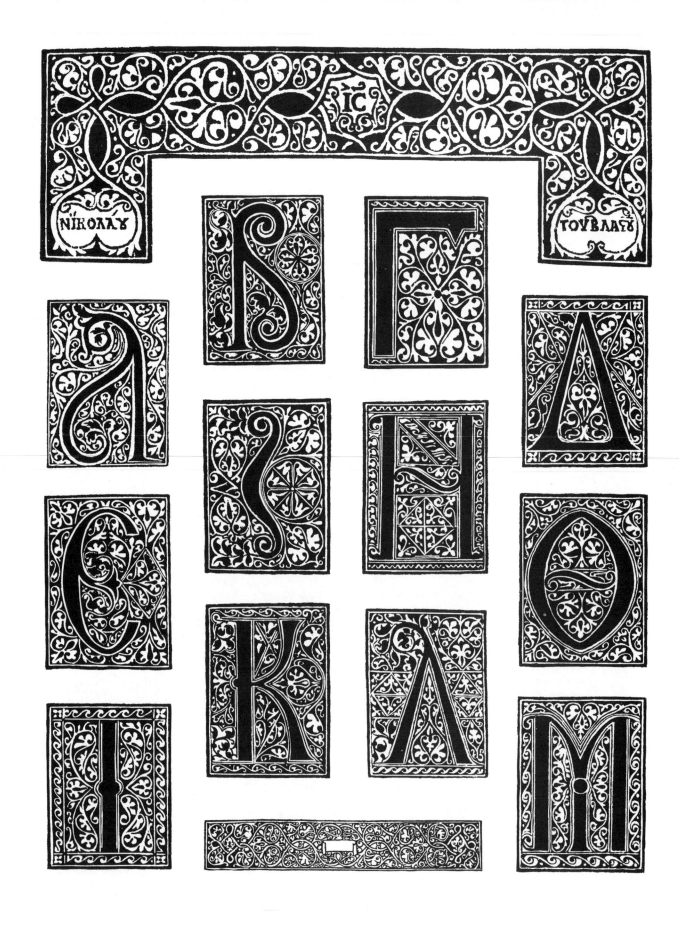

Greek initials by Zacharias Callierges / VENICE 1499

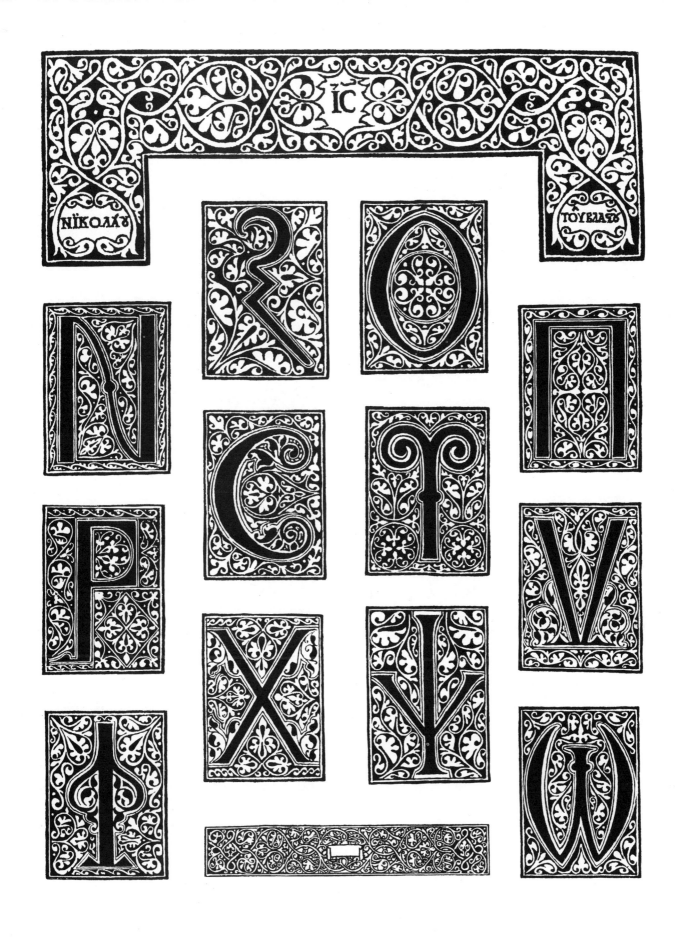

Greek initials by Zacharias Callierges / VENICE 1499

Initials from incunabula / PARIS-LYONS 1485–1499

Initials from incunabula/PARIS-LYONS 1485–1499

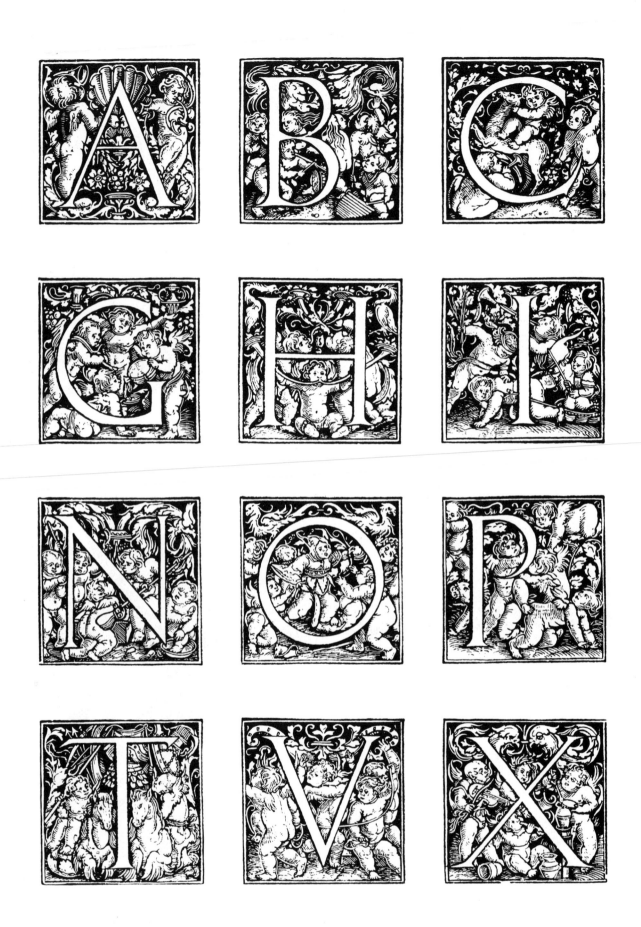

Children alphabet by Hans Weiditz/AUGSBURG 1521

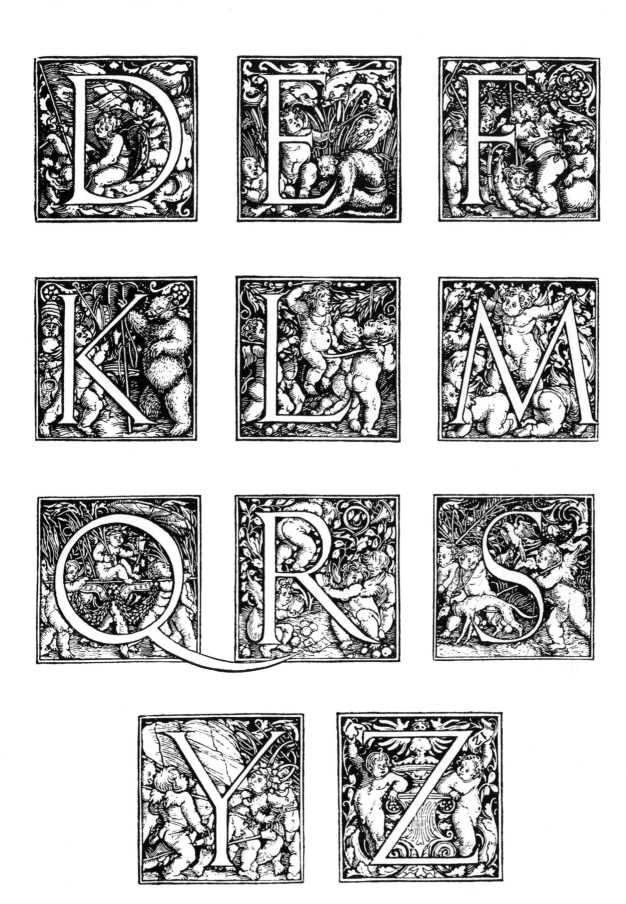

Children alphabet by Hans Weiditz/AUGSBURG 1521

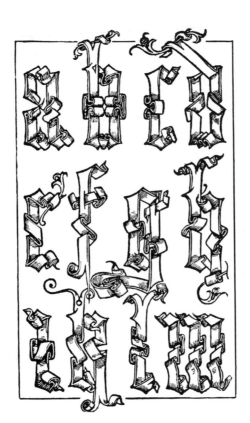

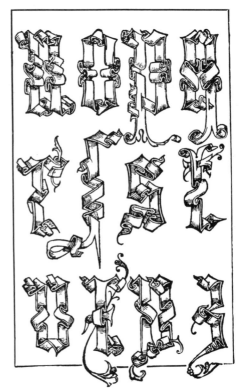

Ribbon alphabet by Ludovico Vicentino / VENICE 1533

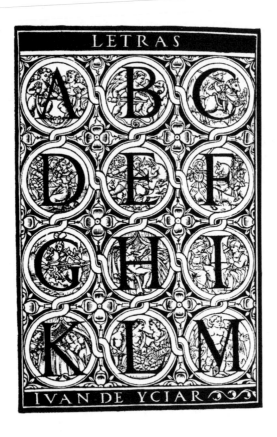

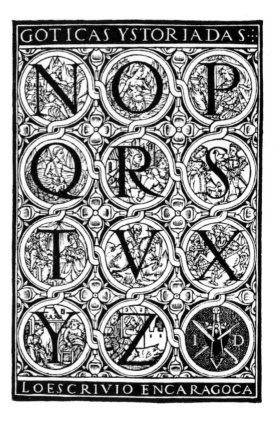

Ornamented alphabet by Juan de Yciar / SARAGOSSA 1550

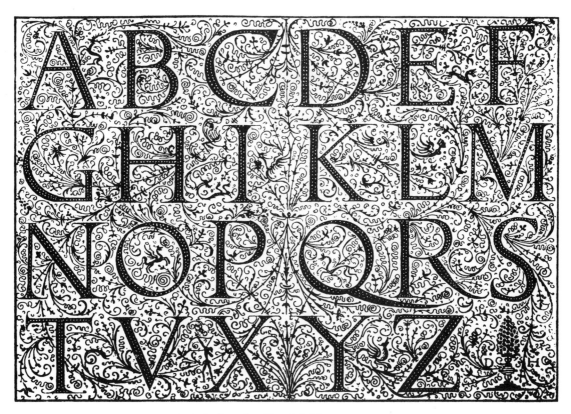

Ornamented alphabet by Daniel Hopfer / NUREMBERG 1549

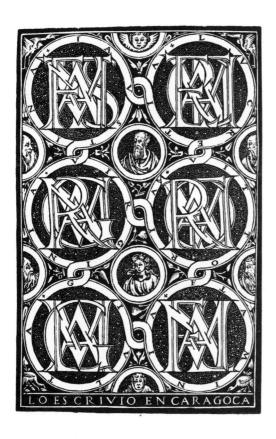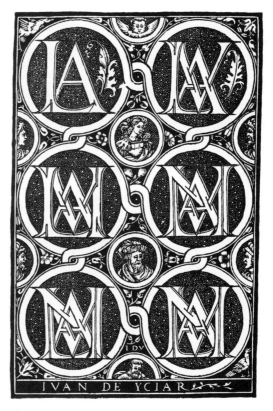

Monograms by Juan de Yciar / SARAGOSSA 1550

Initials by Juan de Yciar / SARAGOSSA 1550

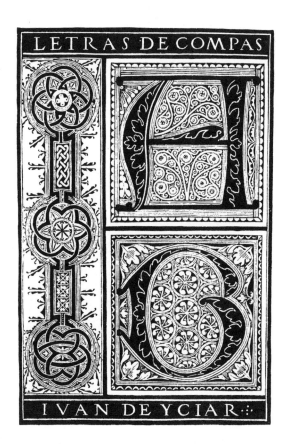

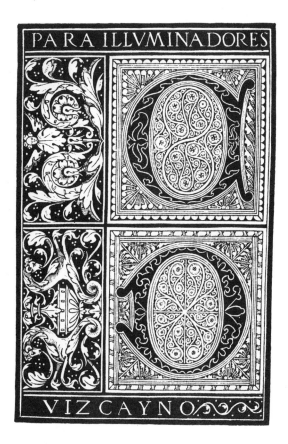

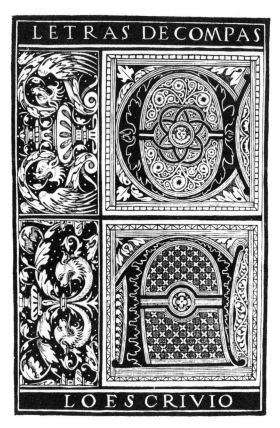

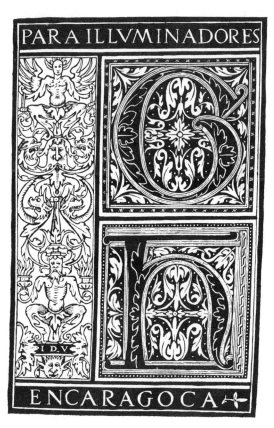

Initials by Juan de Yciar / SARAGOSSA 1550

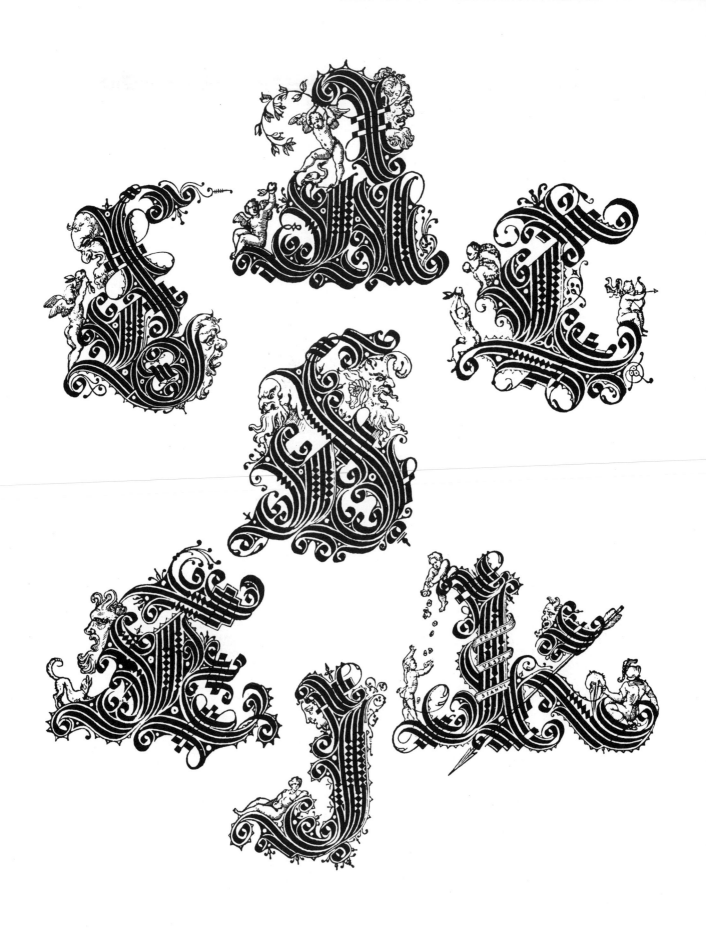

Calligraphic initials by Amphiareo Vespasiano / VENICE 1554

Alphabet by Giovanni Francesco Cresci/ROME 1569

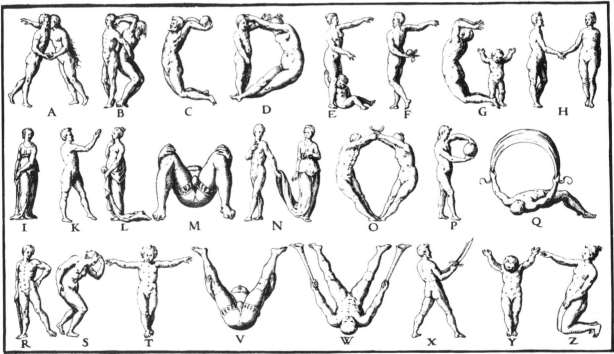

*Human alphabet by Jo. Theodor and Jo. Israel De Bry/*FRANKFORT O.M. 1596

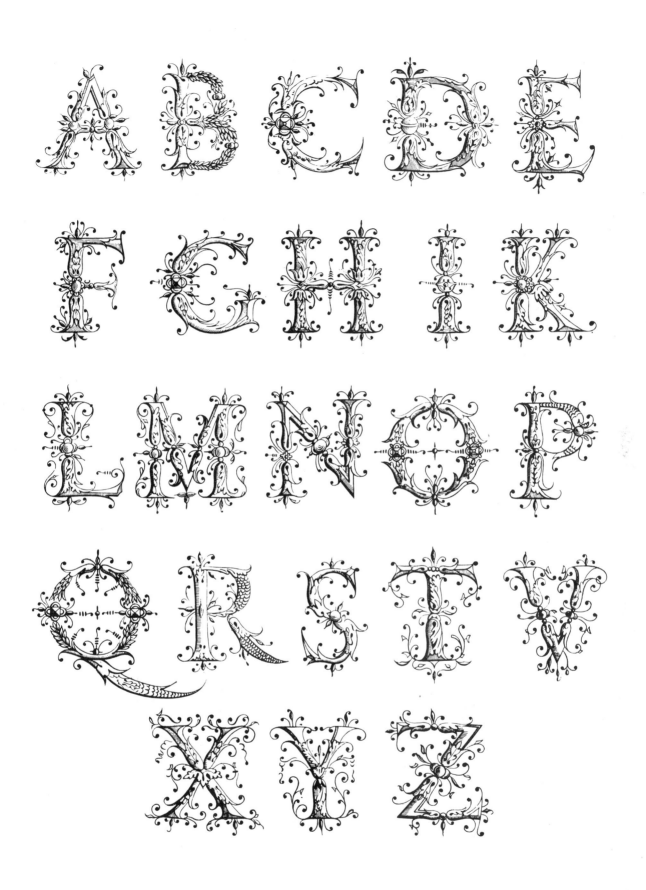

Ornamented alphabet / ITALY 16TH CENTURY

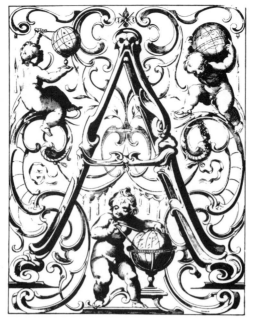

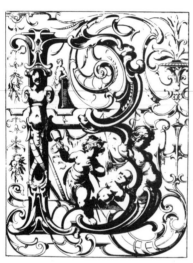

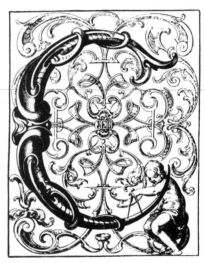

Initials by Lucas Kilian / AUGSBURG 1627

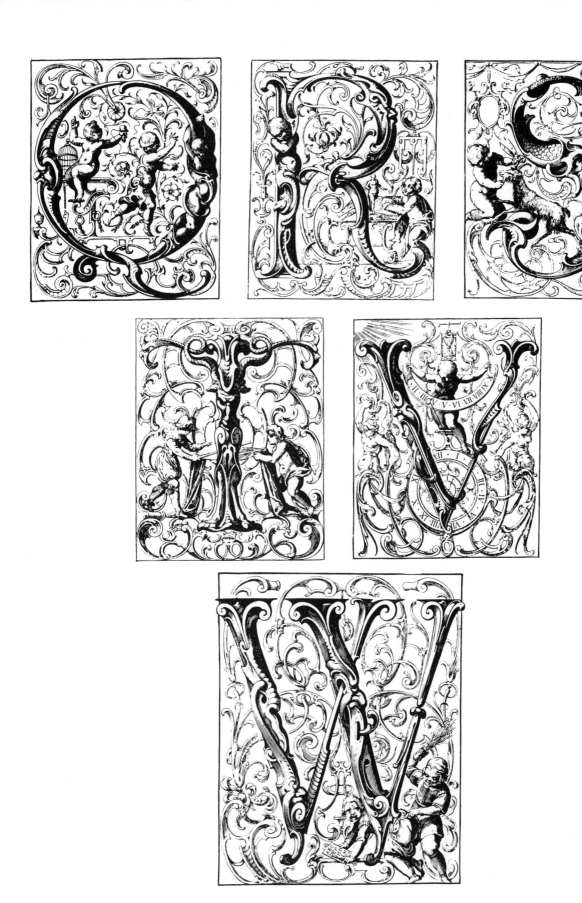

Initials by Lucas Kilian / AUGSBURG 1627

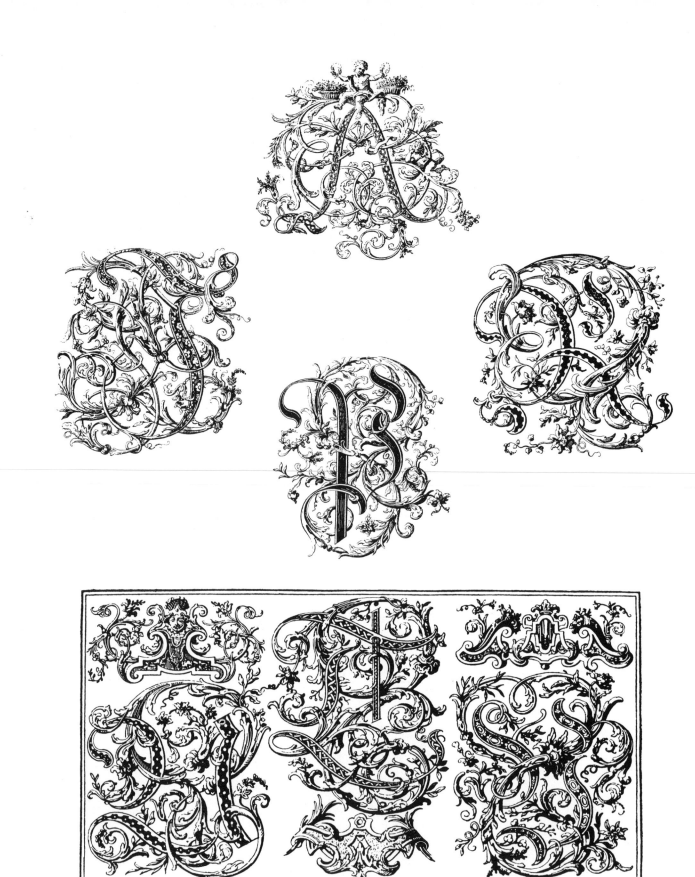

Initials by Johann Daniel Preisler / NUREMBERG ABOUT 1700

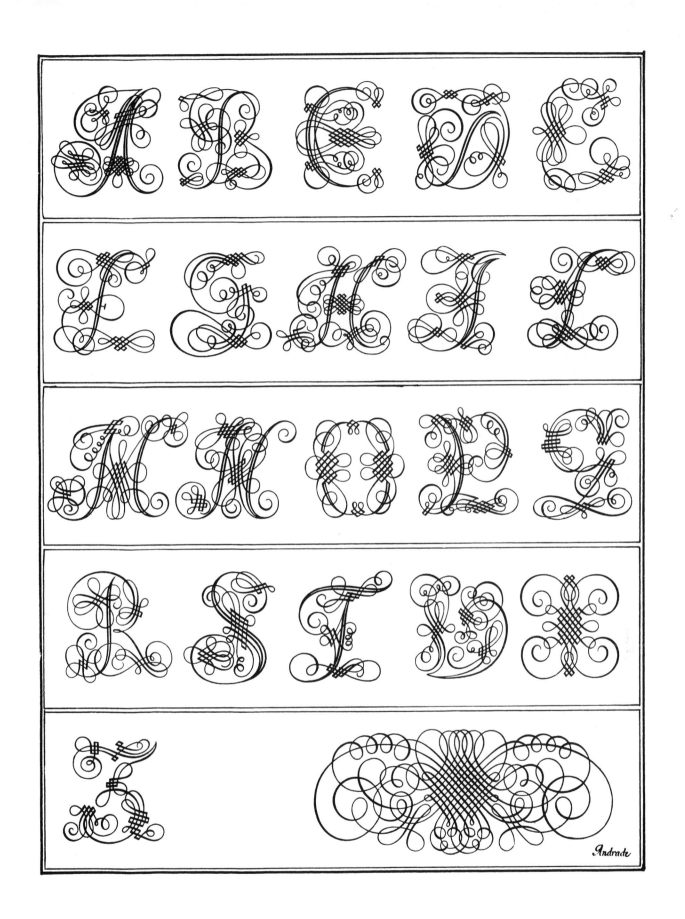

Calligraphic alphabet by Mánoel Andrade de Figueiredo / LISBON 1722

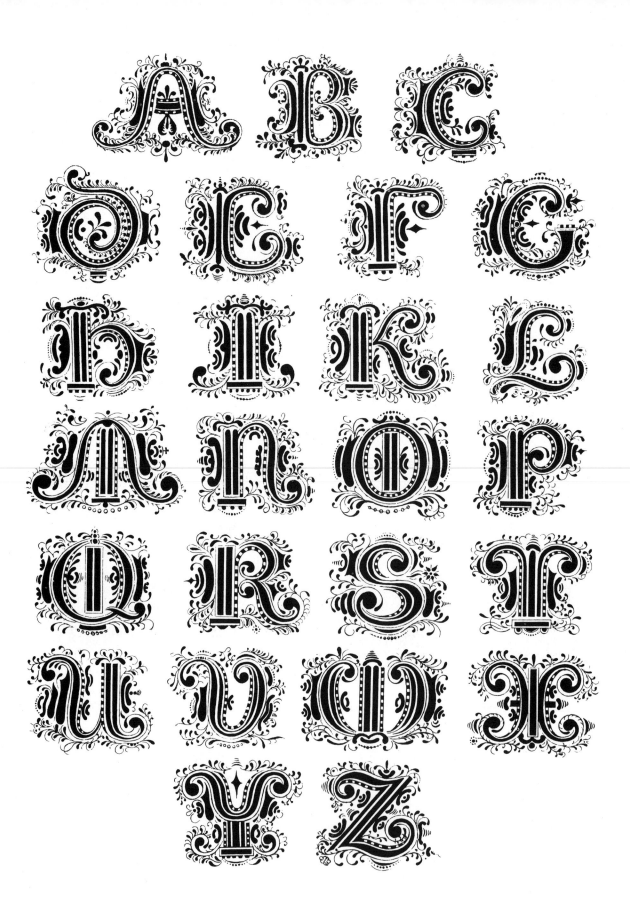

Ornamented alphabet / AUSTRIA 18TH CENTURY

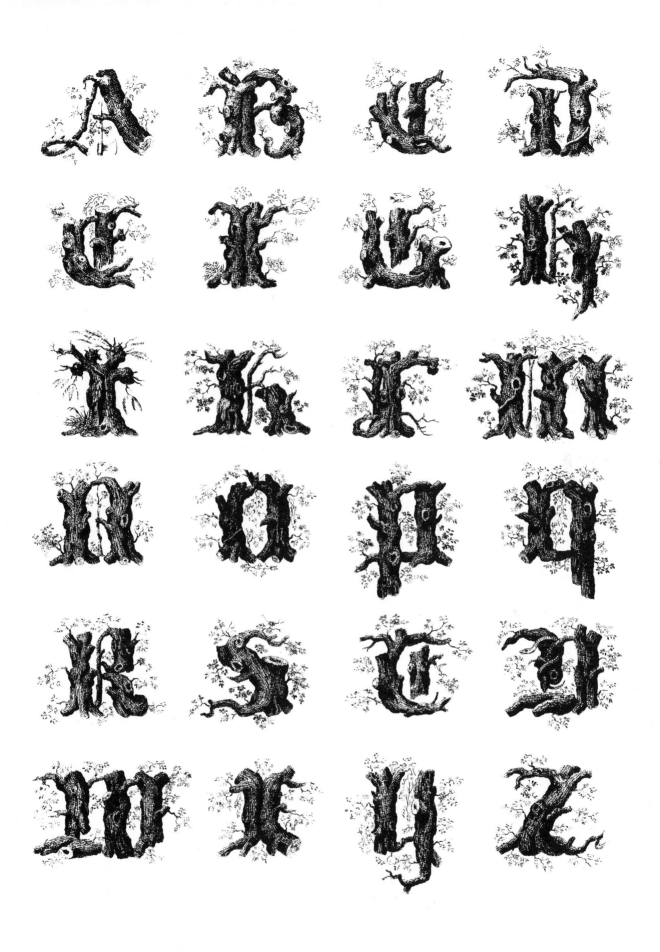

Wood alphabet by Joseph Balthazar Silvestre / PARIS 1843

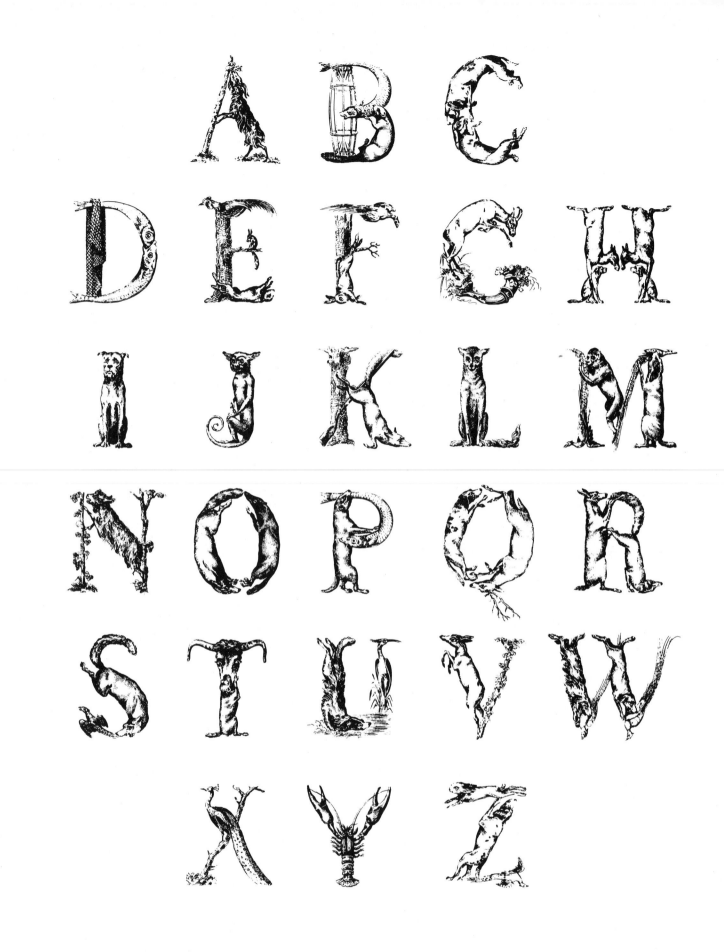

Animal alphabet by Joseph Balthazar Silvestre / PARIS 1843

Fleurons & Borders

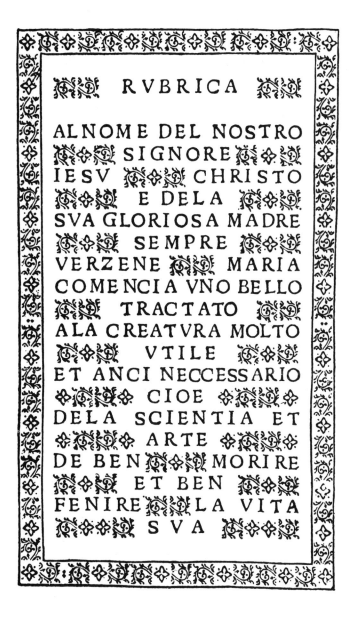

The first "Fleurons" printed by Giovanni and Alberto Alvise / VERONA 1478

FLEURONS AND BORDERS

FLEURONS AND BORDERS

THIRTY YEARS after Johannes Gutenberg invented movable printing type, two printers in Verona named Giovanni and Alberto Alvise designed movable ornaments called "Flowers" or "Fleurons." Their first book with flower decorations and borders, *Arte de ben Morire*, was printed in 1478. This book created an uproar of indignation among their fellow printers, because contemporary craftsmen and critics predicted that this infamous commercialization of book décor would eventually lead to the complete decay of the art of printing and book decoration.

Contrary to that prediction, the design of flowers and borders became, in the following centuries, a subtle and highly esteemed art in itself. All leading type-founders and punch-cutters made their special contributions to the art of movable ornaments.

In the eighteenth century, the casting of flowers reached an all-time peak. Well known type designers and founders, like Louis René Luce and Pierre-Simon Fournier, Jr., in Paris, Johann Thomas Trattner in Vienna, Johannes Enschedé in Haarlem, William Caslon, Jr., in London, and many others were vying for the laurel with their artistic flower and border designs.

The nineteenth century brought on a flood of flower specimens, good and bad, artistic and commercial, new creations and crude imitations. And so at the turn of the century, after almost 450 years, the prediction of the critics in Verona became a near reality. The art of book décor and printing, with the exception of the work of a few bibliophilistic diehards, was drowned in commercialization.

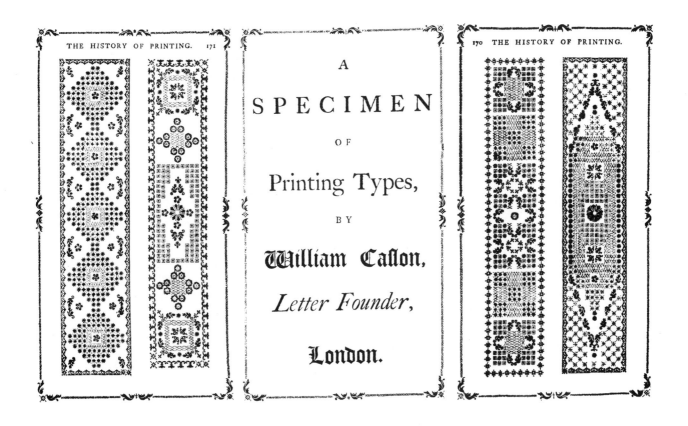

*Typographic ornaments by William Caslon, Jr./*LONDON 1771

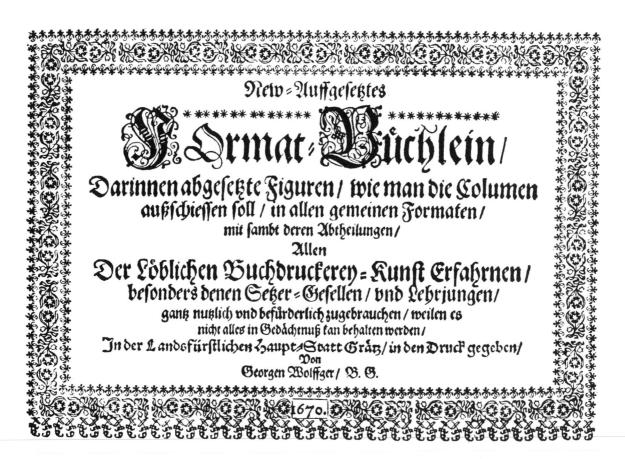

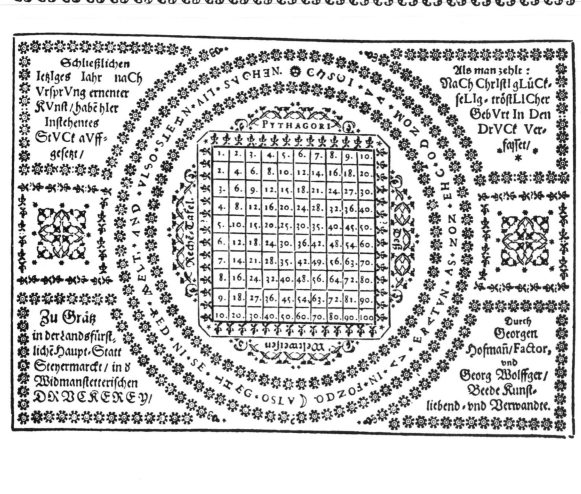

Typographic borders by Georg Wolffger / GRAZ 1670

Typographic ornaments by Georg Wolffger / GRAZ 1670

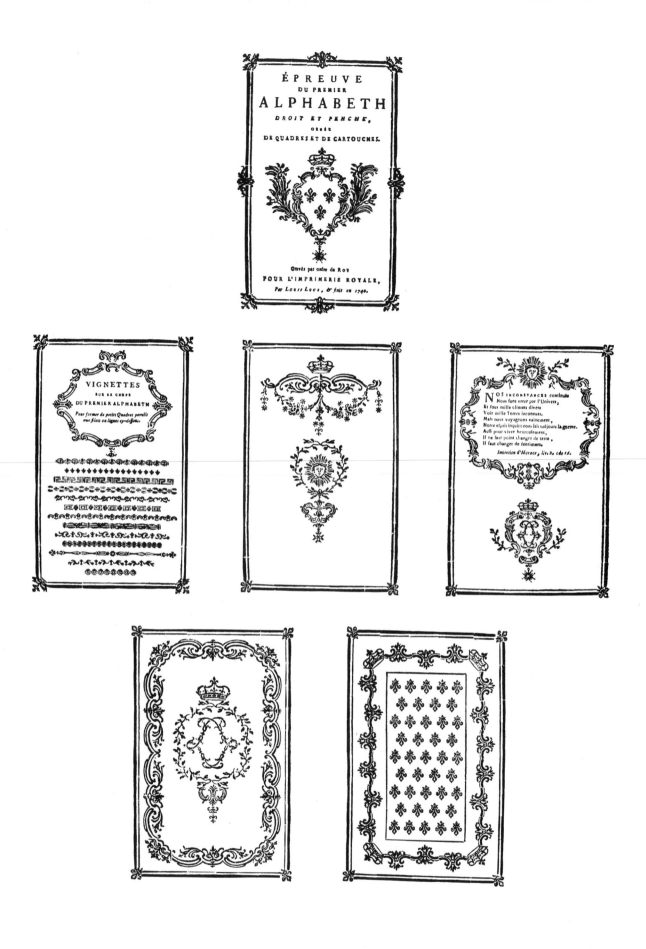

Typographic borders and ornaments by Louis René Luce / PARIS 1740

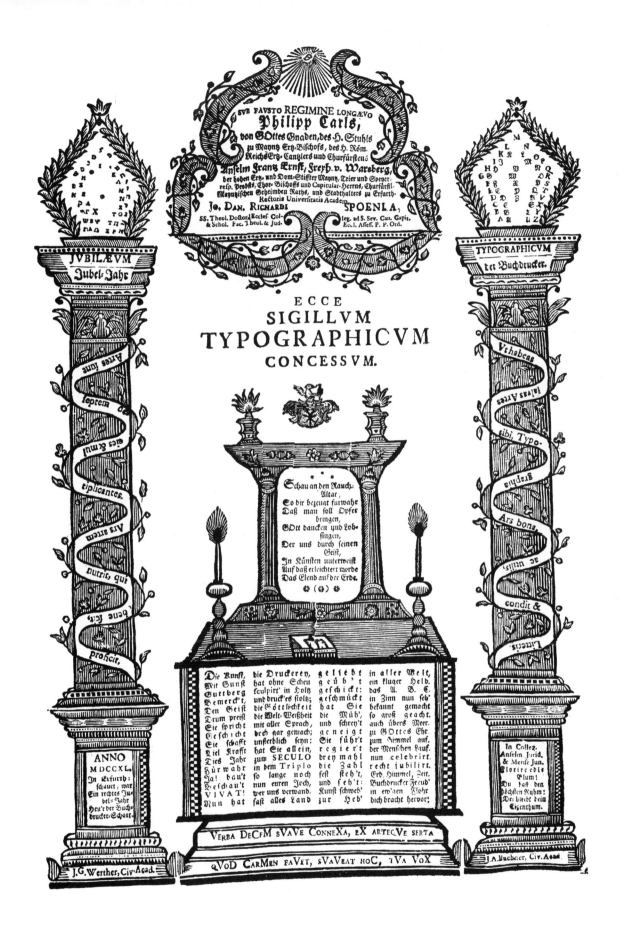

Typographic anniversary broadside/ERFURT 1740

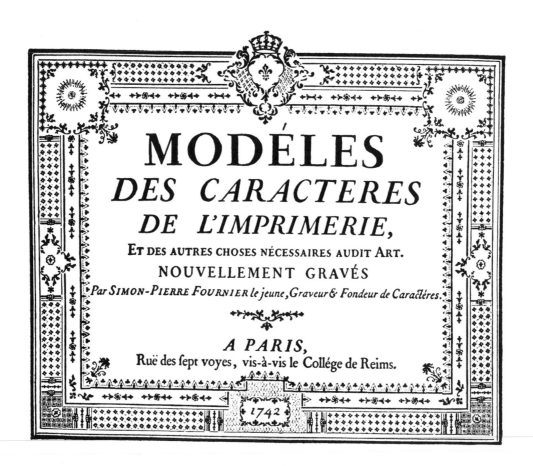

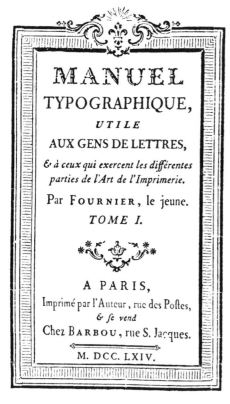

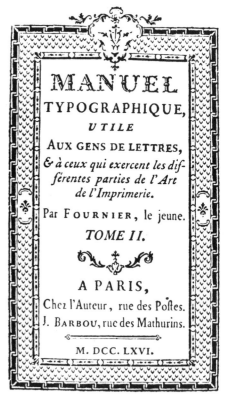

Title pages by Pierre-Simon Fournier, Jr./PARIS 1742–1766

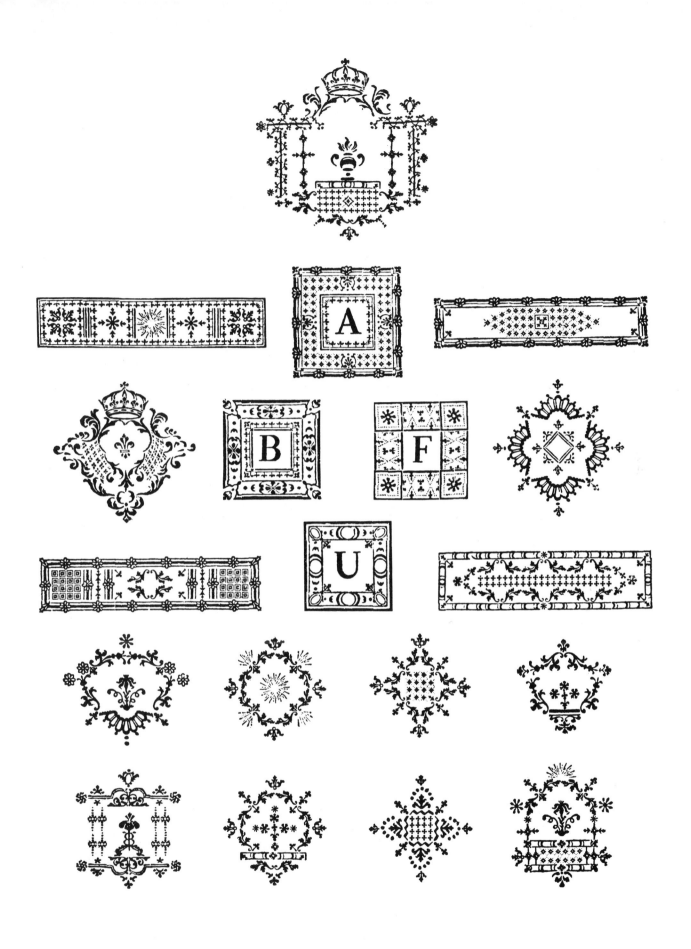

*Typographic ornaments by Pierre-Simon Fournier, Jr./*PARIS 1742

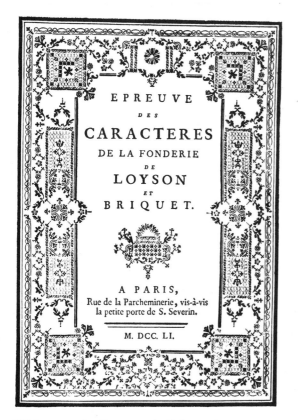

Title page by Loyson & Briquet / PARIS 1751

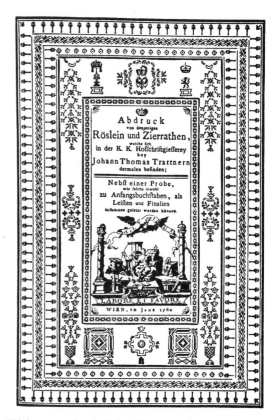

Title page by J. Th. Trattner / VIENNA 1760

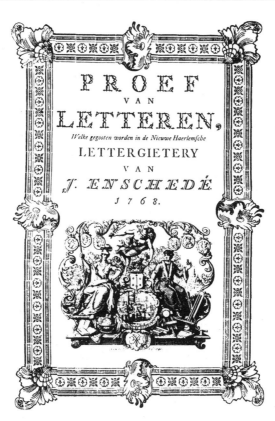

Title page by Johannes Enschedé / HAARLEM 1768

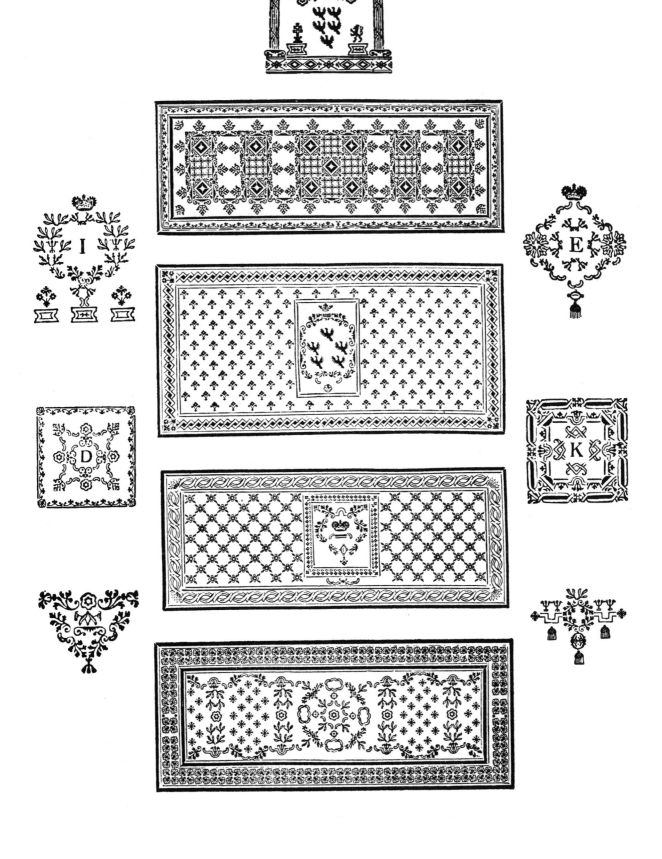

Typographic ornaments by Johann Thomas Trattner / VIENNA 1760

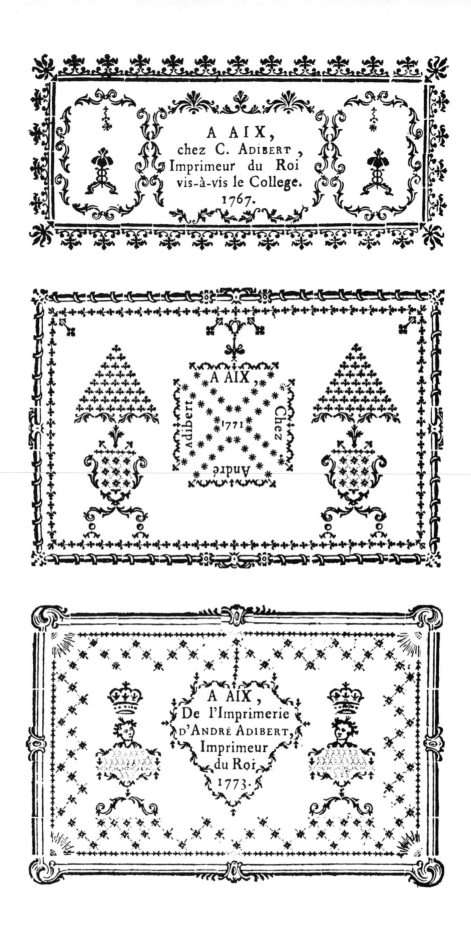

Typographic colophons by C. & A. Adibert / AIX 1767–1773

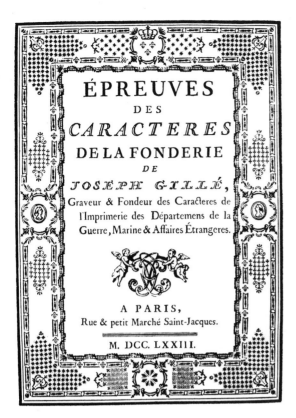

Title page by Joseph Gillé / PARIS 1773

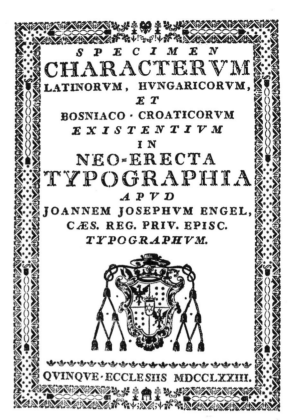

Title page by J. J. Engel / PECS–FÜNFKIRCHEN 1773

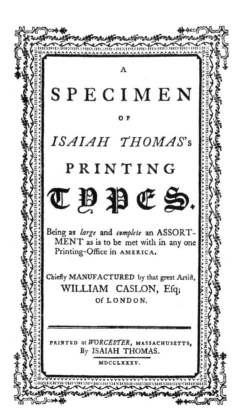

Title page by Isaiah Thomas / WORCESTER, MASS. 1785

Typographic ornaments (First Empire) / PARIS 1810–1819

Typographic borders (Restauration) / PARIS 1820–1829

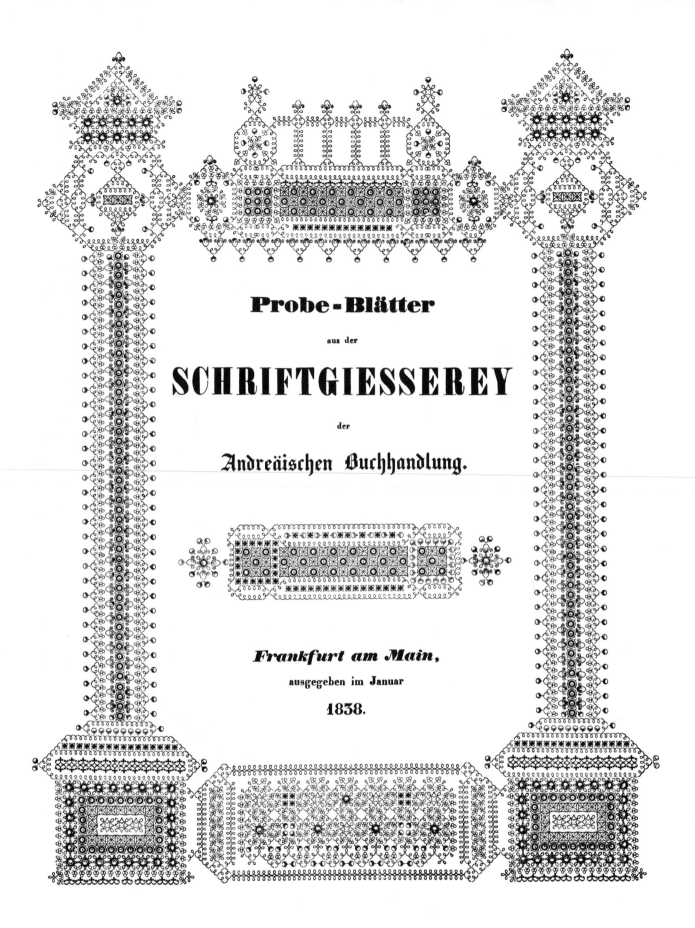

Probe-Blätter

aus der

SCHRIFTGIESSEREY

der

Andreäischen Buchhandlung.

Frankfurt am Main,

ausgegeben im Januar

1838.

Typographic border by Andreäische Buchhandlung/ FRANKFORT O.M. 1838

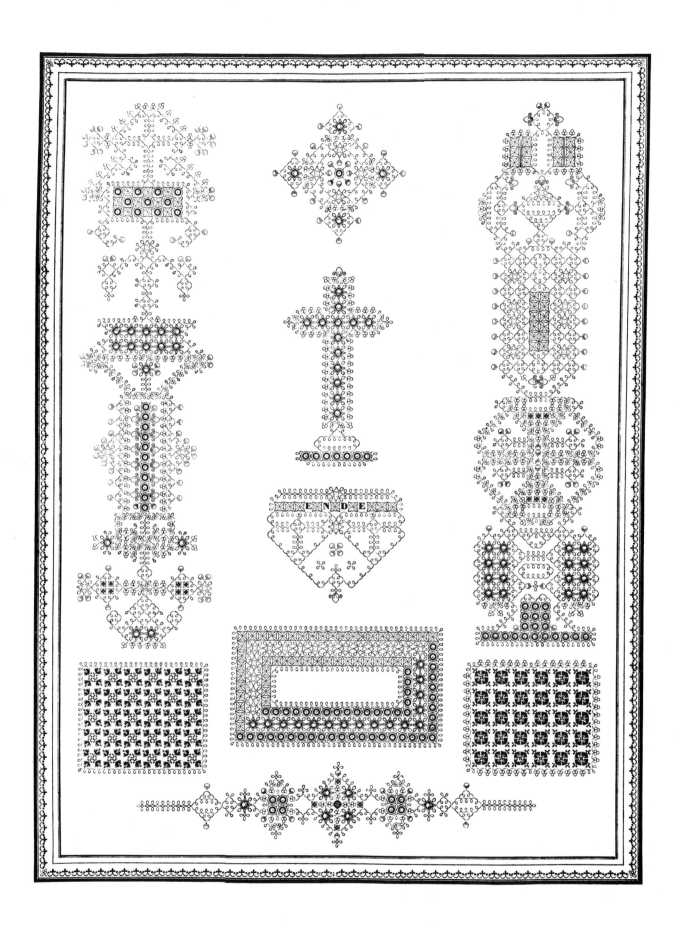

Typographic ornaments by Andreäische Buchhandlung / FRANKFORT O.M. 1838

Schriftschneiderei
und
Schriftgiesserei

A. Beyerhaus
Berlin.

Typographic borders by A. Beyerhaus / BERLIN 1840

Typographic borders (Louis Philippe) / PARIS 1840–1849

Typographic borders (Cathedral) / PARIS 1840–1849

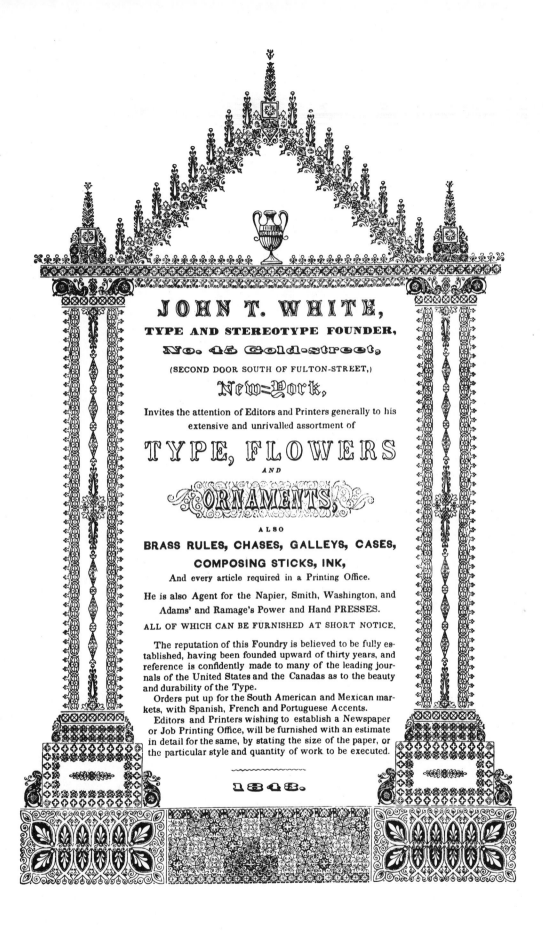

JOHN T. WHITE,

TYPE AND STEREOTYPE FOUNDER,

No. 45 Gold-street,

(SECOND DOOR SOUTH OF FULTON-STREET,)

New-York,

Invites the attention of Editors and Printers generally to his
extensive and unrivalled assortment of

TYPE, FLOWERS

AND

ORNAMENTS,

ALSO

BRASS RULES, CHASES, GALLEYS, CASES,
COMPOSING STICKS, INK,

And every article required in a Printing Office.

He is also Agent for the Napier, Smith, Washington, and
Adams' and Ramage's Power and Hand PRESSES.

ALL OF WHICH CAN BE FURNISHED AT SHORT NOTICE.

The reputation of this Foundry is believed to be fully es-
tablished, having been founded upward of thirty years, and
reference is confidently made to many of the leading jour-
nals of the United States and the Canadas as to the beauty
and durability of the Type.

Orders put up for the South American and Mexican mar-
kets, with Spanish, French and Portuguese Accents.

Editors and Printers wishing to establish a Newspaper
or Job Printing Office, will be furnished with an estimate
in detail for the same, by stating the size of the paper, or
the particular style and quantity of work to be executed.

1843.

Title page by John T. White / NEW YORK 1843

Typographic borders (Second Empire) / PARIS 1860–1869

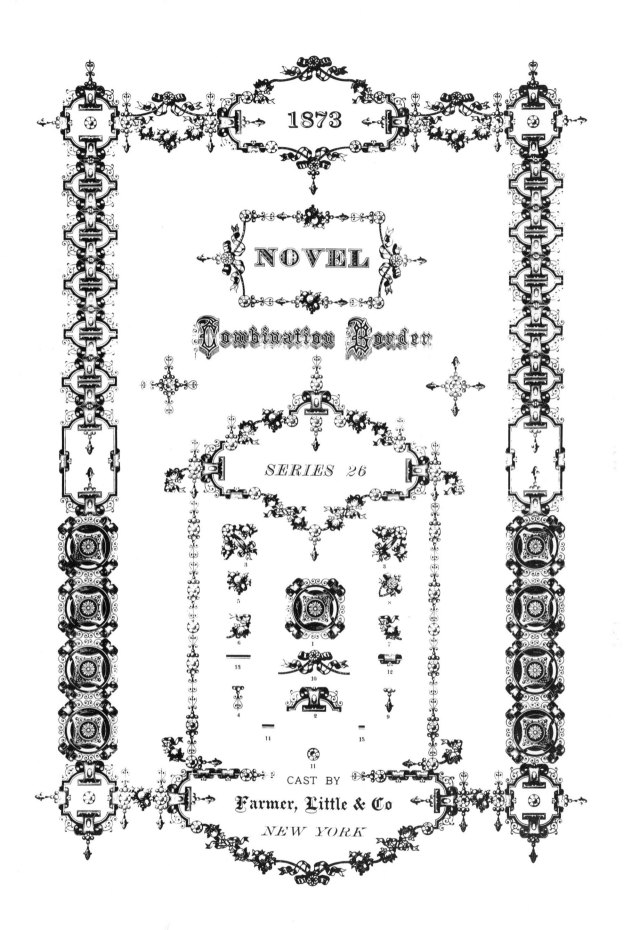

Typographic border by Farmer, Little & Co. / NEW YORK 1873

Typographic borders (Second Renaissance) / BERLIN 1870–1890

Headpieces & Vignettes

Calligraphic endpiece from a manuscript / PARIS 15TH CENTURY

HEADPIECES AND VIGNETTES

HEADPIECES AND VIGNETTES

HEADPIECES, endpieces and vignettes, as well as flowers and initials, played an important part in the decoration of printed books. Headpieces were put at the beginning of a book and its chapters; endpieces, called tailpieces or *cul-de-lamp*, were used at the end of the book or at its divisions; vignettes or emblems were scattered throughout a book wherever the typographer wanted to use a decorative spot.

To determine the exact origin of most of these decorations, it would be necessary to check such designs contained in every rare book in every library and collection all around the globe. It would be necessary to check their publishing dates and places as well as their printers. It would be an impossible task.

The fact that the same design was sometimes used simultaneously or only a few years apart in the most distant locations, makes it impossible to pinpoint the exact time and origin of most of these decorations. The type-founders who originated this kind of book ornament sold and resold such cuts to faraway places. Not even the specimen books of the early foundries give absolute proof of origin, because it was customary for type-cutters and printers to include in their specimen books their whole stock, without reference to their own or foreign make or time of design.

The assignment of most of these decorations to a certain artist, printer or country is partly guesswork, based in many instances only on special style elements, make-up or technical considerations.

Headpieces and vignettes by Aldus Manutius/VENICE 1495–1499

Vignettes by Hans Holbein the Younger / LONDON 1529

Headpieces by Ivan Fedorov / MOSCOW-OSTROG 1564–1580

Head- and endpieces / PARIS 1630–1650

Head- and endpieces / PARIS 1650–1670

Headpieces by Vicentii Ursini/NAPLES 1681

Head- and endpieces by Johann Ernst Adelbulner / NUREMBERG 1730

Head- and endpieces / VIENNA 1740–1750

Head- and endpieces by Sigmund Calles / VIENNA 1750–1760

Endpieces and vignettes by L'Imprimerie Royale / PARIS 1760–1789

Head- and endpieces by L'Imprimerie Nationale / PARIS 1792–1799

Vignettes by J. Ritchel von Hartenbach, Jr./ERFURT 1836

*Vignettes by J. Ritchel von Hartenbach, Jr./*ERFURT 1836

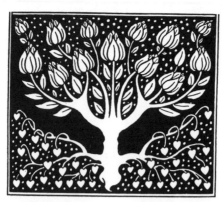

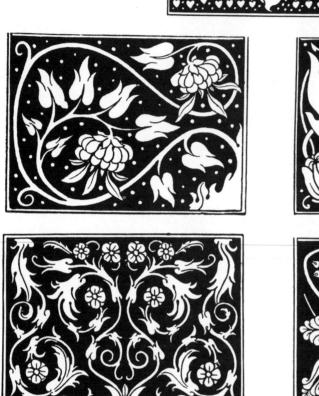

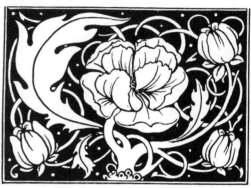

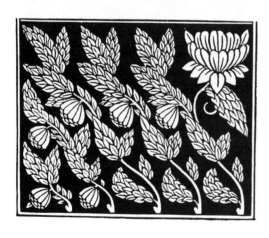

Vignettes by Aubrey Beardsley, Kelmscott Press/HAMMERSMITH 1891–1895

SILHOUETTES & SHADOW FIGURES

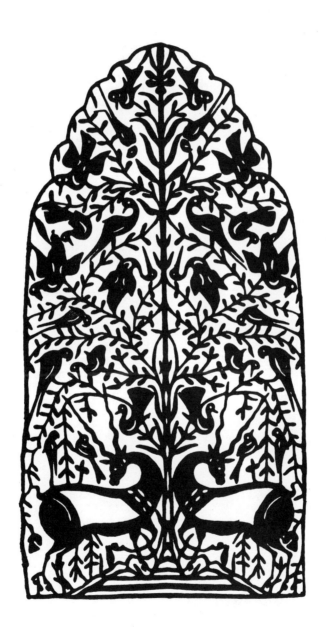

Silhouette / INDIA

SILHOUETTES AND SHADOW FIGURES

SILHOUETTES AND SHADOW FIGURES

SINCE TIMES of old, human beings were intrigued by an unbelievable bodiless phenomenon around them, the shadow. Everywhere black shadows waxed and waned, painting grotesque shapes and figures on everything. No wonder that the creative mind of man used light and shadow as an artistic and decorative medium.

Shadow art is not an expression of a single period, a definite territory or a certain people. Shadow painting and shadow decoration came and went throughout all ages and all continents, like the medium itself, anywhere and everywhere.

The use of shadow art is evidenced in applied art from all four corners of the globe. We see it in Egyptian hieroglyphs and Etruscan vase paintings. In tribal symbols and decorations in Africa, North and South America. In shadow puppets in the Far and Middle East. In silhouette portraits and wall paintings, shadow figures and ornaments for lanterns and light shades, pottery and basket décor. In Russian Tula silver and Moresque metal etching, and scores of other objects.

The expression "Silhouette" is comparatively new. It was coined in France in 1759 for cheap and easily produced articles after the name of the French minister of finance of that time, Étienne de Silhouette. The term was used in mockery of his stern and unpopular economy laws.

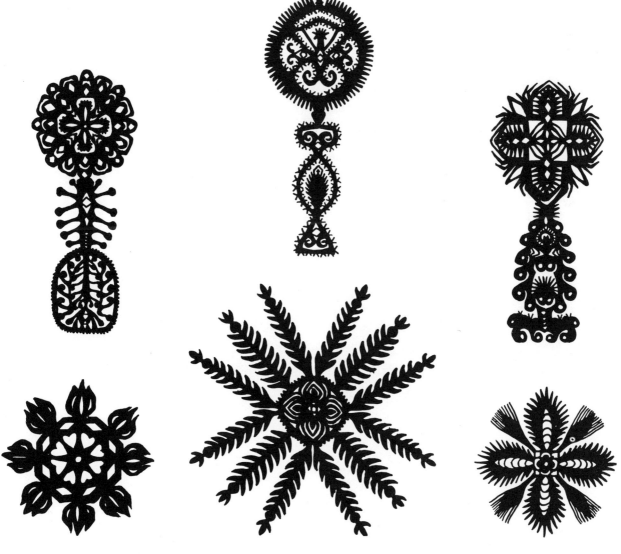

Silhouettes, peasant art/RUSSIA

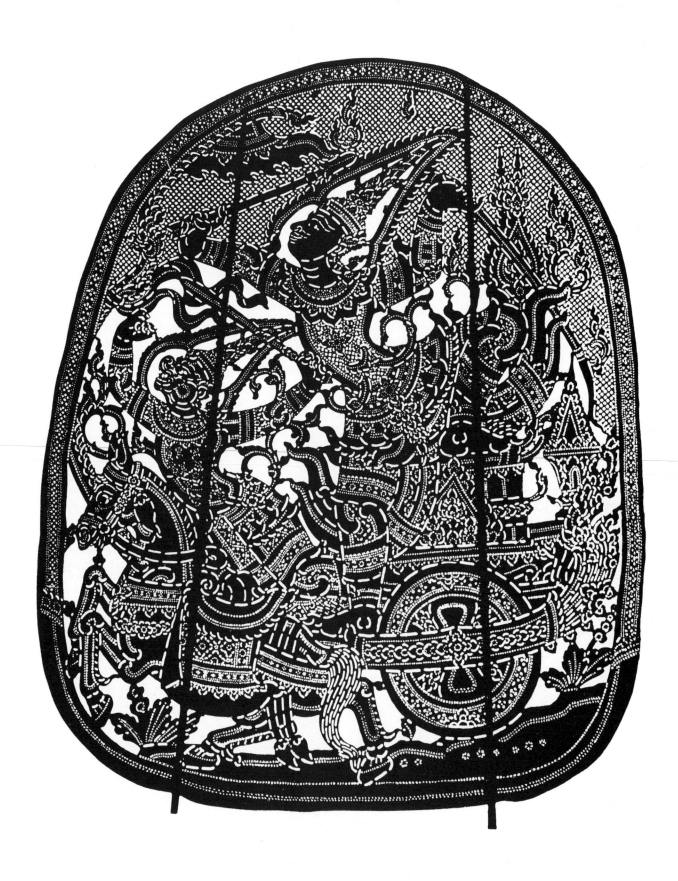

Shadow play picture / SIAM

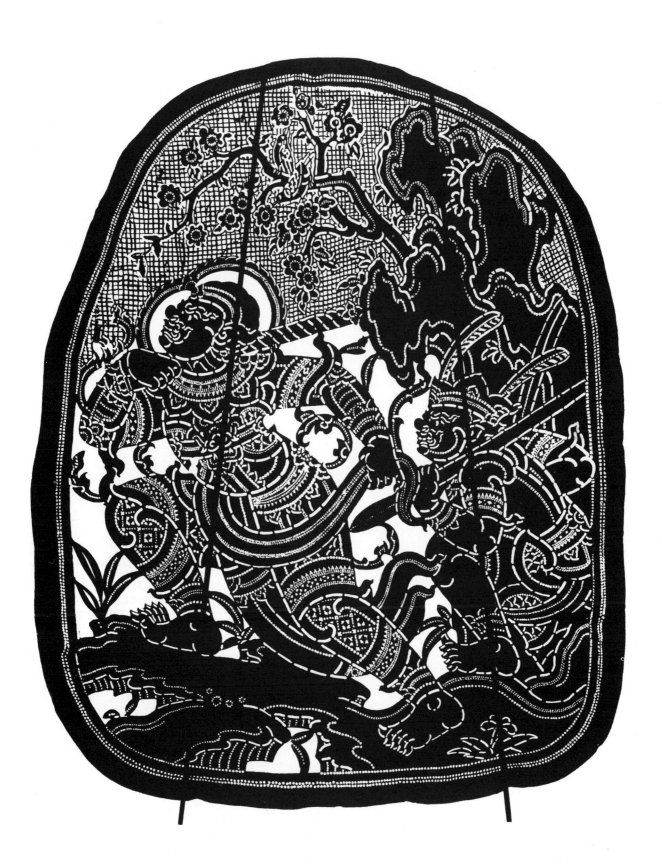

Shadow play picture / SIAM

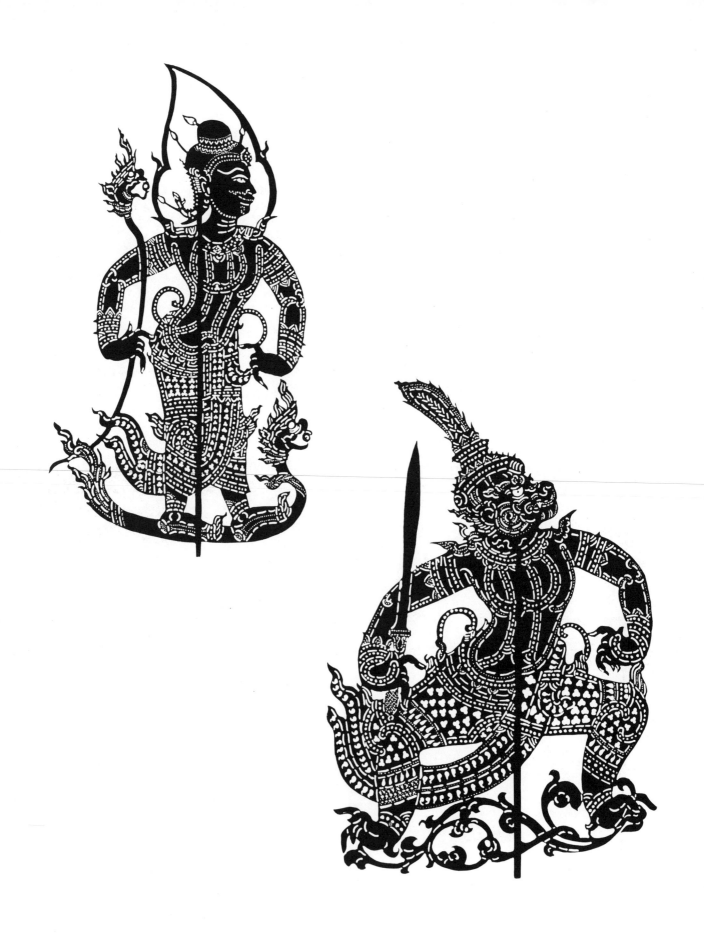

Shadow play figures / SIAM

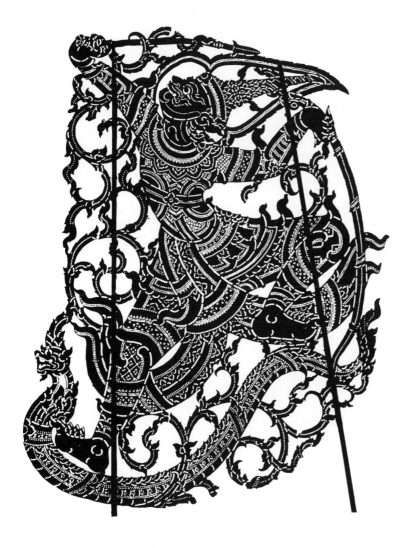

Shadow play figures/SIAM

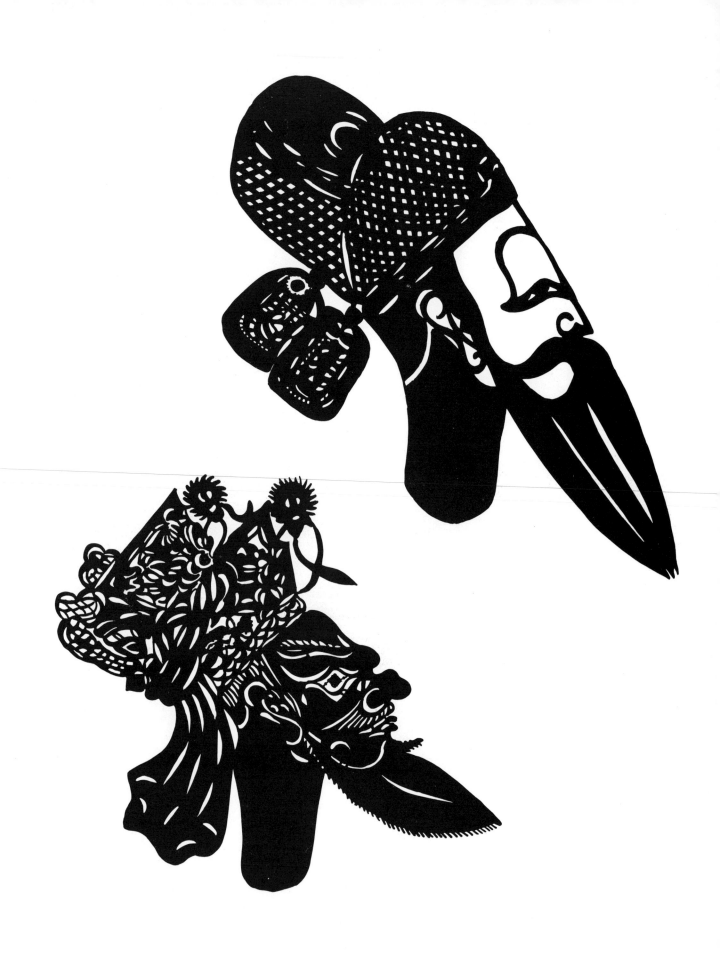

Heads from shadow puppets/CHINA

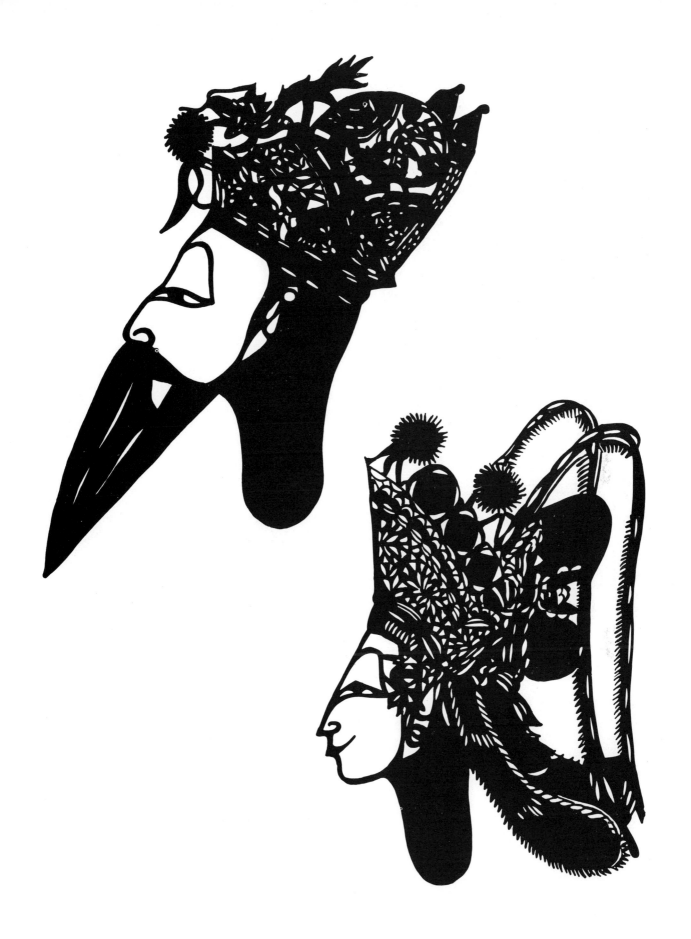

Heads from shadow puppets / CHINA

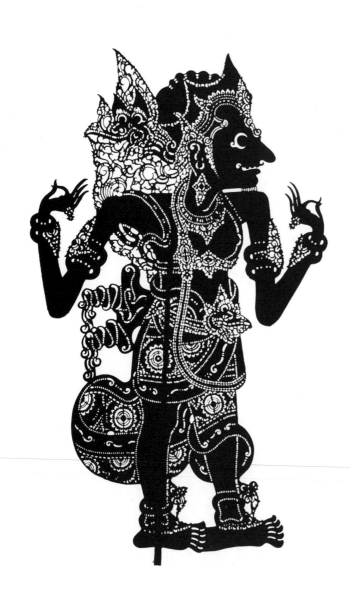

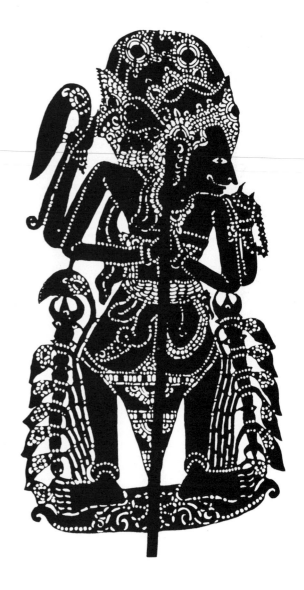

Shadow puppets / BALI

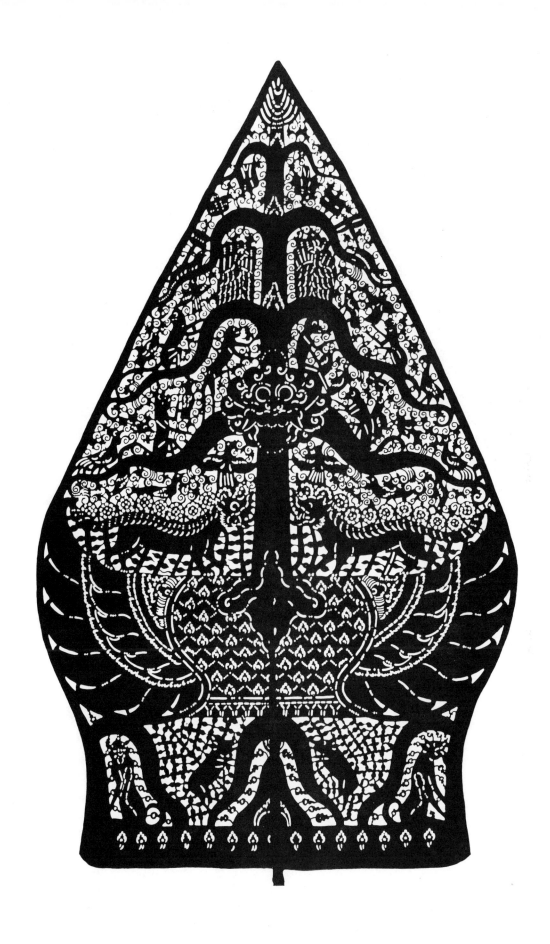

Intermission sign from a shadow play / JAVA

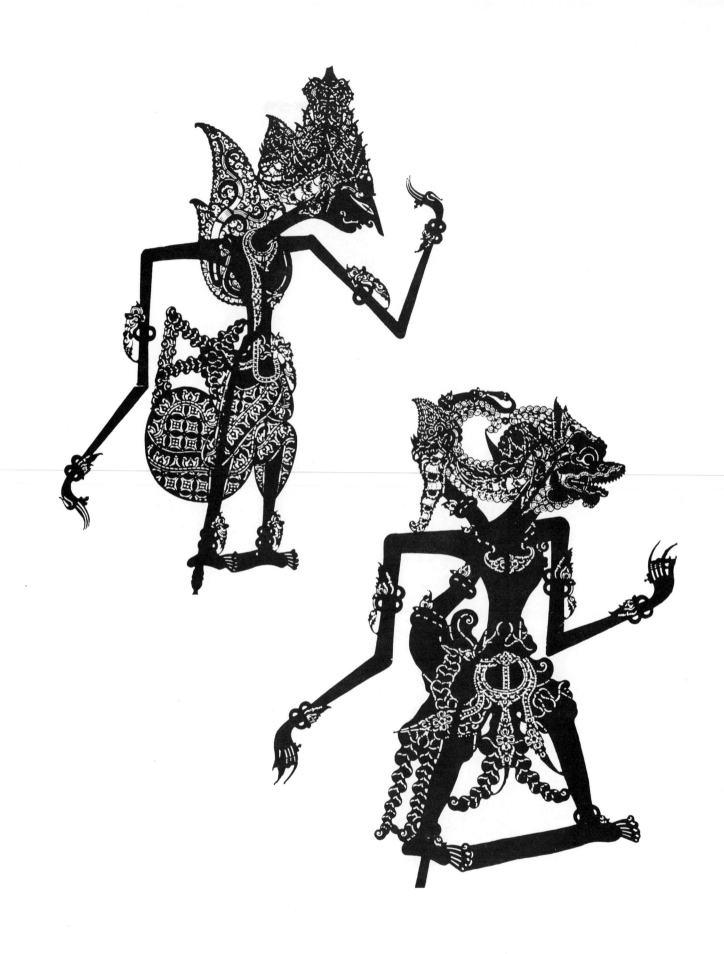

Shadow puppets / JAVA

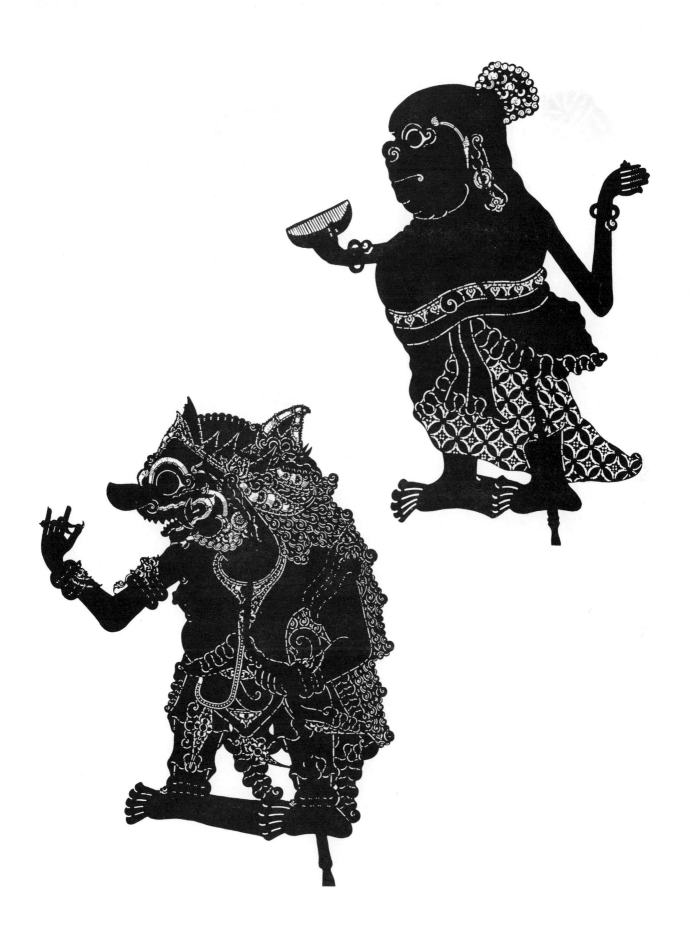

Shadow puppets / JAVA

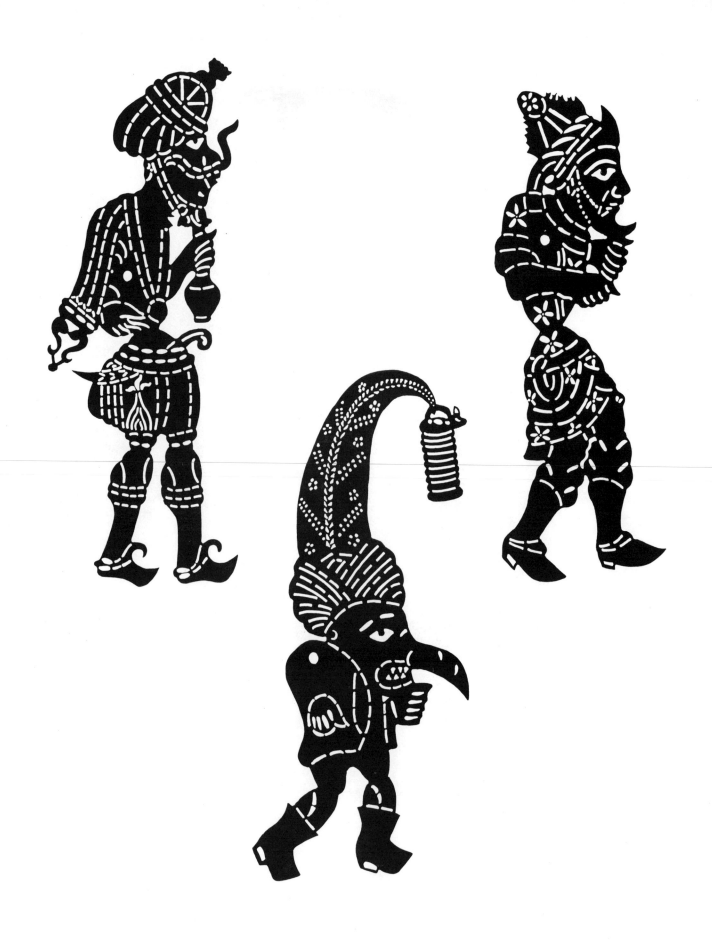

Shadow puppets / TURKEY

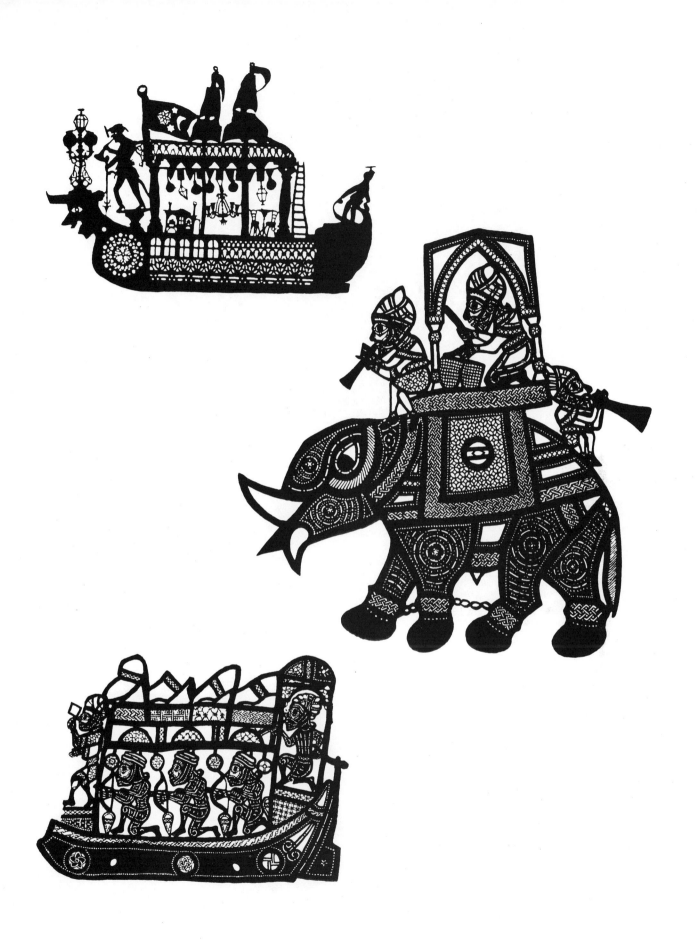

Shadow play figures, Mameluke / EGYPT 14TH CENTURY

Lantern silhouettes/CHINA

Lantern silhouettes / CHINA

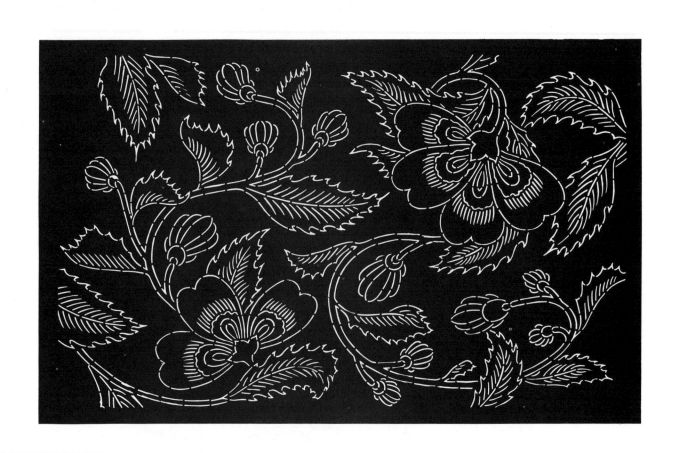

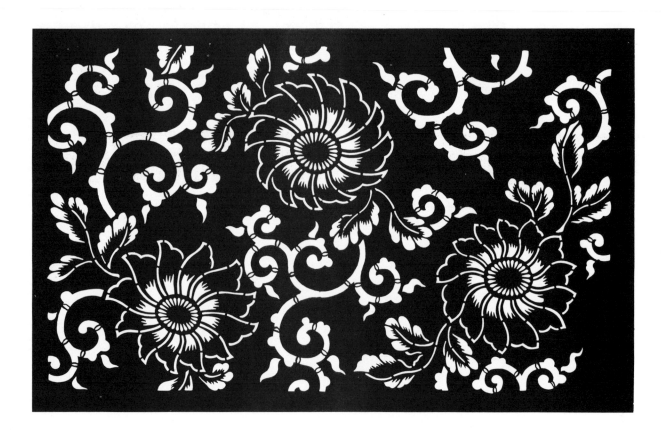

Stencils for silk printing / JAPAN

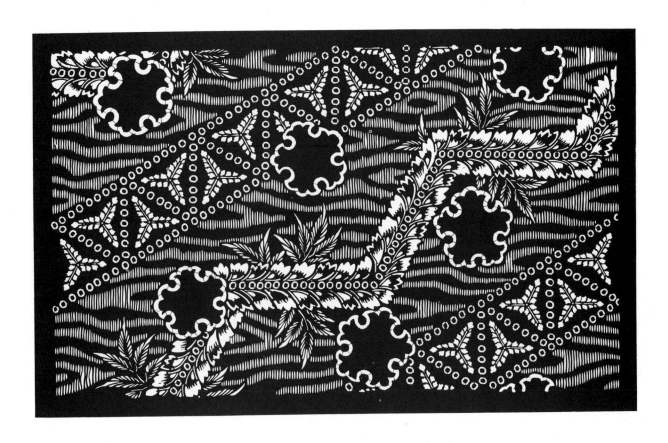

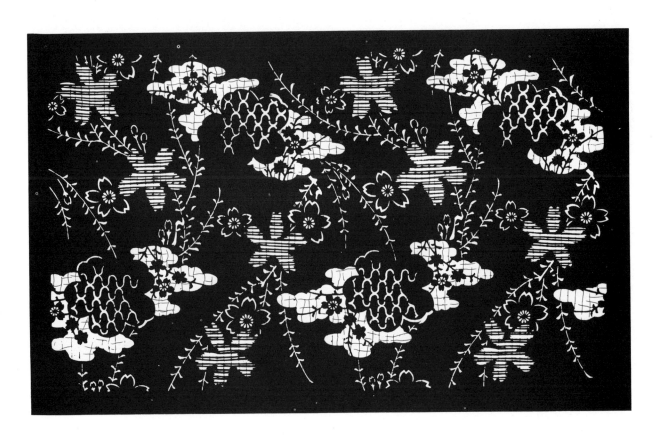

Stencils for silk printing / JAPAN

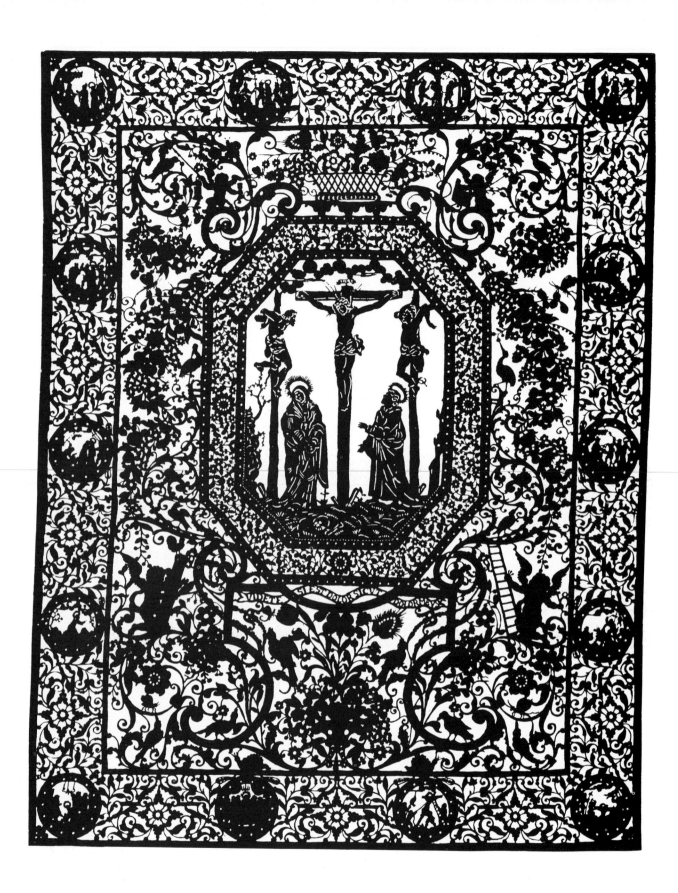

Silhouette "Calvary" / HOLLAND ABOUT 1700

Silhouettes, peasant art / ITALY 18TH CENTURY

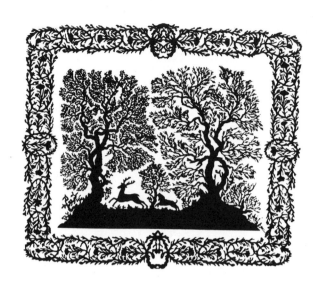

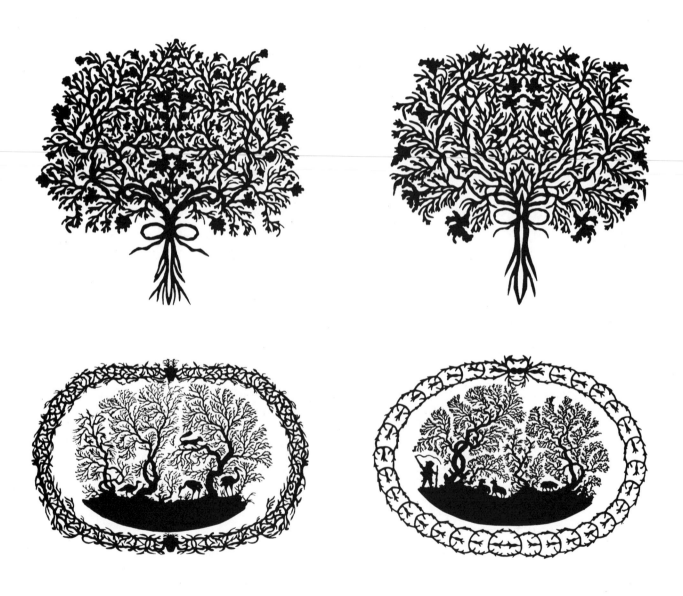

Silhouettes / VIENNA 18TH CENTURY

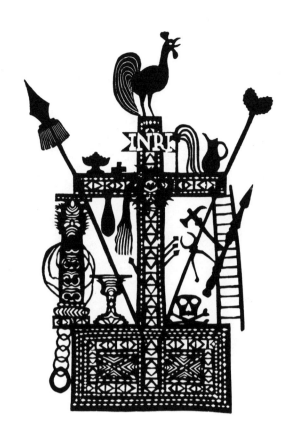

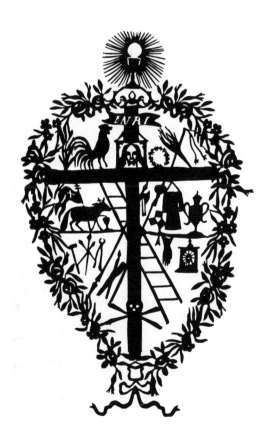

Silhouettes, monks art / GERMANY 19TH CENTURY

Silhouettes by Jean Jacob Hauswirth/BASEL 1860

APPLIED ORNAMENTS &

PATTERN BOOKS

Calligraphic ornament from a manuscript/ENGLAND 12TH CENTURY

APPLIED ORNAMENTS AND PATTERN BOOKS

APPLIED ORNAMENTS AND PATTERN BOOKS

ONE OF the most astounding misconceptions, found in discussions with contemporary artists and craftsmen, is the belief that the roots of regional decoration and the core of epochal styles are in the so-called "peasant art" of that special territory or period. This is an absolutely false derivation, contrary to the true occurrences.

In bygone times, peasants were serfs. Theirs and their women's hands were heavy from hard work. Their personal chattels were nil, and their shapeless garments were made from coarse fabrics. They had no skill in handicrafts and no possessions of their own worthy of embellishment.

The designing of objects of applied art—wood carvings, table ware, household implements, fashion accessories, jewelry, etc.—was the domain of leading artists and artisans. Spinning, weaving, embroidering, pearl-stitching, lace-making, etc., were the prerogatives and pastimes of the ladies of the ruling and well-to-do upper crust. The use of certain materials and fabrics, weaves and colors, lace and jewelry was an exclusive right of certain families, castes or office holders.

Only after the peasants became free men on their own land did they copy the styles and designs of their former masters and so they developed an art of their own, always far behind the contemporary style of their time and surroundings. The basic forms and designs of contemporary peasant art can be found in the pattern and model books of the leading artists and craftsmen of many centuries ago.

Center pieces by Aldus Manutius / VENICE 1499

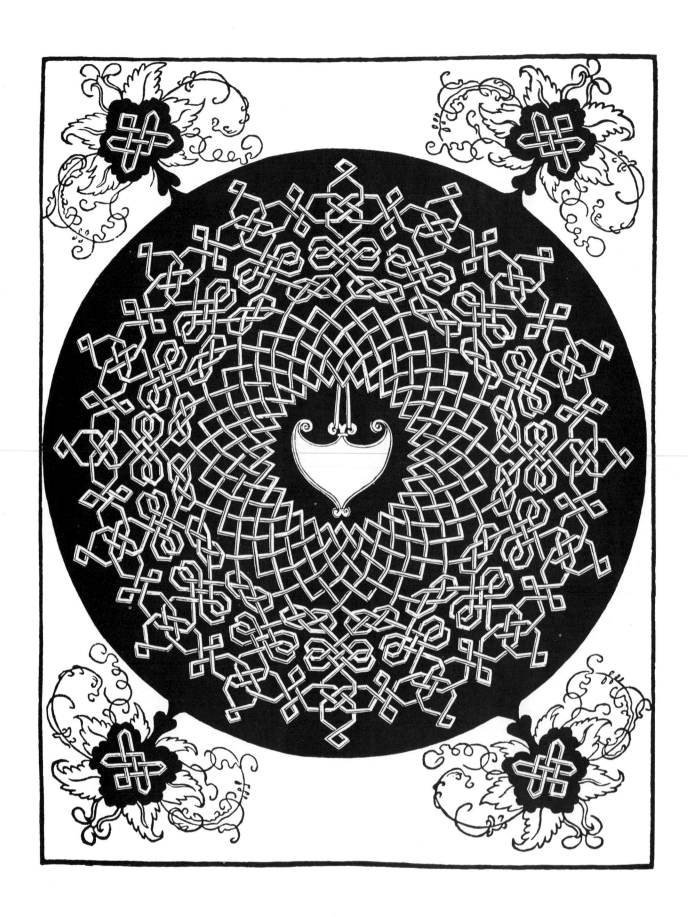

Needlepoint pattern by Albrecht Dürer / NUREMBERG 1505

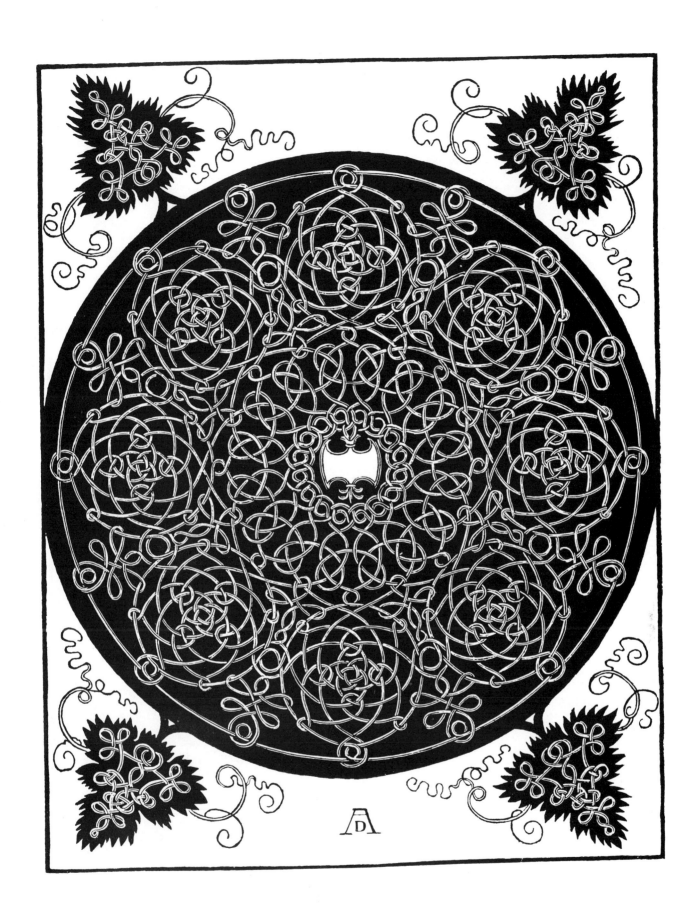

Needlepoint pattern by Albrecht Dürer / NUREMBERG 1505

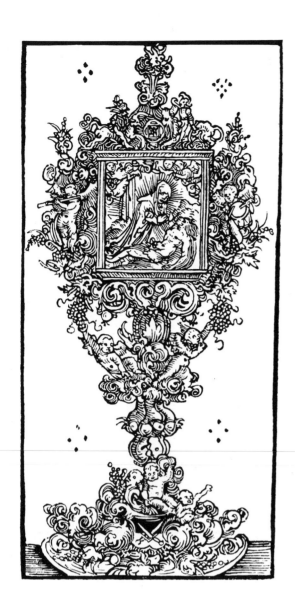

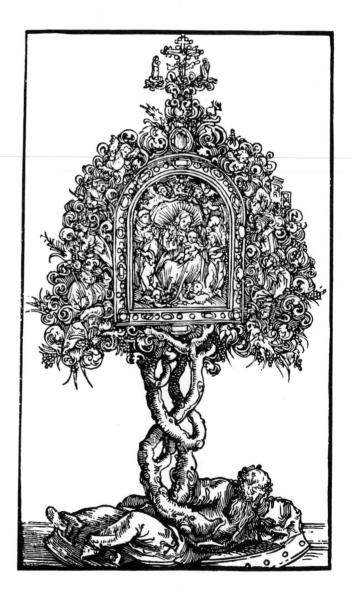

Monstrances by Lucas Cranach / WITTENBERG 1509

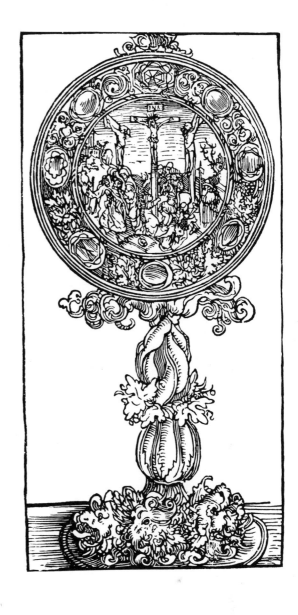

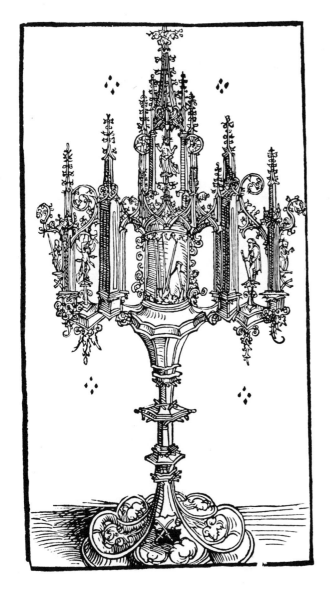

Monstrances by Lucas Cranach / WITTENBERG 1509

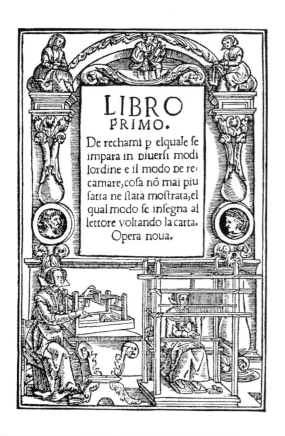

Lace designs by Alessandro Paganino / VENICE 1518

E auertiffe con el difegno infieme ti appoftiamo vn poftilo belliffi-
mo e vago a locchio cofa non mancho va tenerfe cara che effo vi
fegno: laqual cofa va noi fono ftata con grandiffima fatica com-
pofta e ordinata a tua vtilita e pochiffima fpefa. Vale

Lace designs by Alessandro Paganino / VENICE 1518

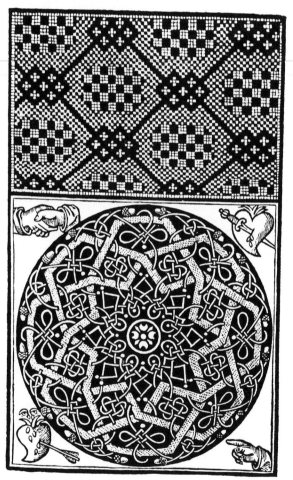

Embroidery and lace designs by Nicolo Zoppino/VENICE 1529

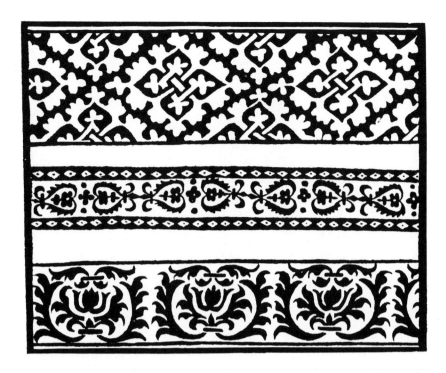

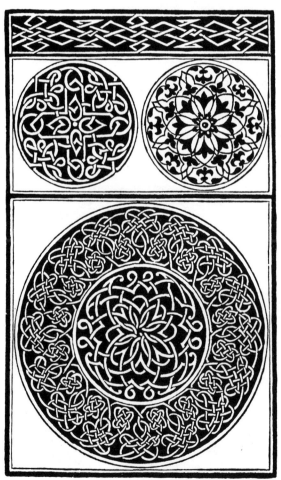
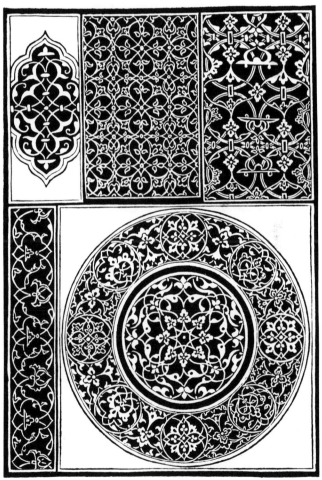

Embroidery and lace designs by Nicolo Zoppino / VENICE 1529

La fleur de la science de Pourtraicture

Et patrons de broderie. Facon arabicque/et ytalique.
Cum priuilegio regis.

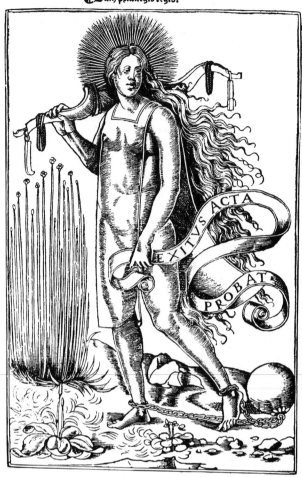

Embroidery designs by Francisque Pellegrin/ PARIS 1530

Embroidery designs by Francisque Pellegrin / PARIS 1530

· 159 ·

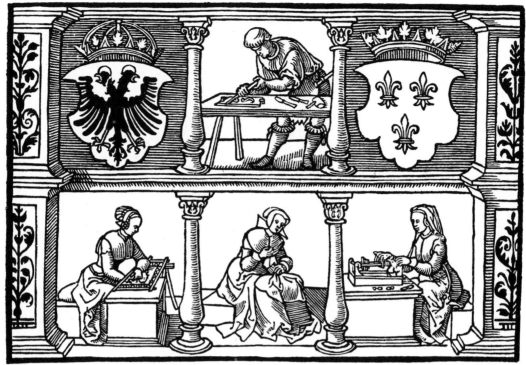

Eyn newe kunstlich moetdelboech alle kunstner

zo brauchen fur snytzeller/wapensticker perlensticker.etc. vnd ouch fur Jonferen vnd frauwen/ernstlich vff das neuwes gefondē allē den genē die vff kunstē verstāt habent. Gedruckt zo Cöllen, durch Peter Quentel. Jm iar, M..D.XXXJJ .im Bramaent.

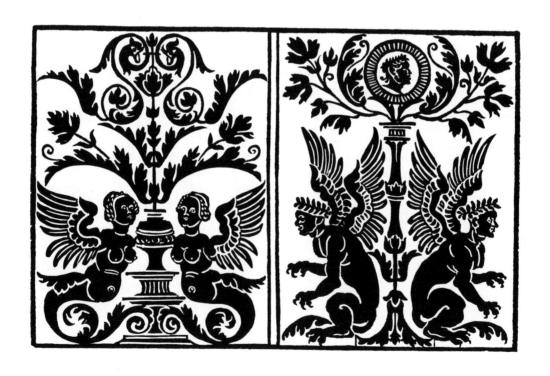

Embroidery designs by Peter Quentel/COLOGNE 1532

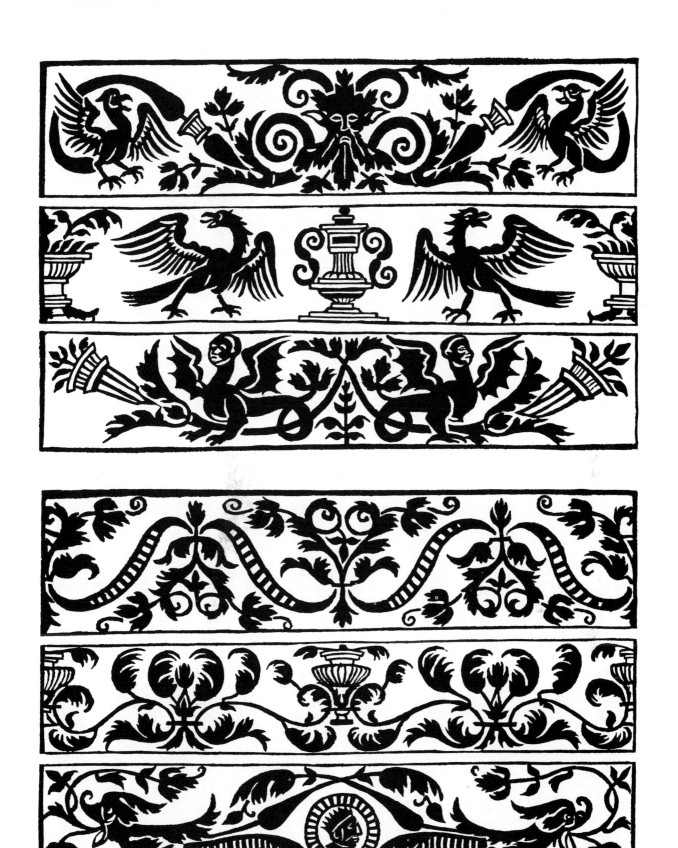

Embroidery designs by Peter Quentel/COLOGNE 1532

Lace design by Giovanni Andrea Vavasore / VENICE 1532

Lace designs by Mattheo Pagan / VENICE 1543

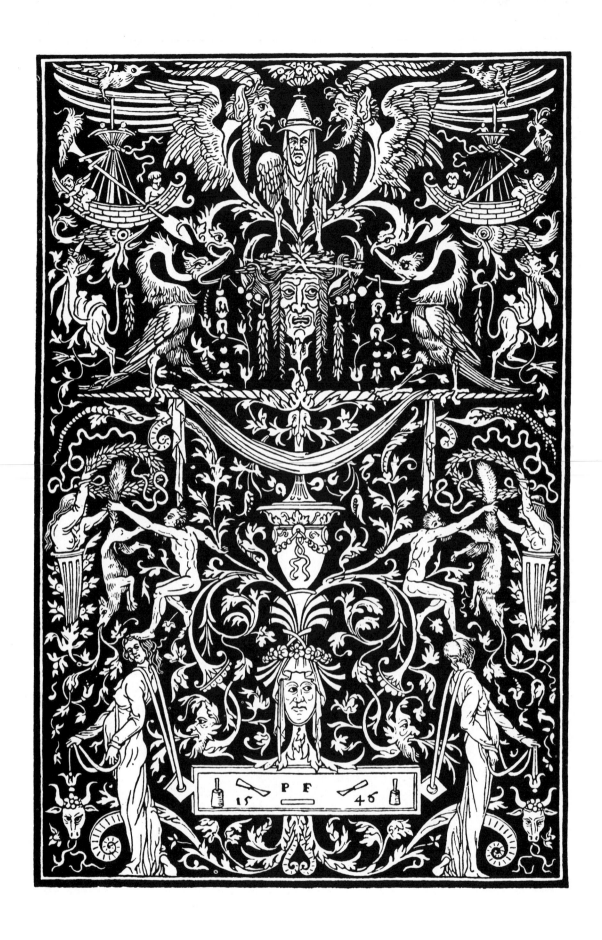

Metal etching designs by Peter Flötner / ZURICH 1546

Metal etching designs by Peter Flötner / ZURICH 1546

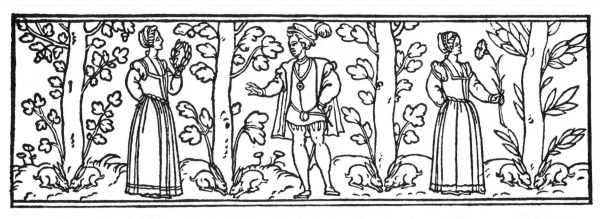

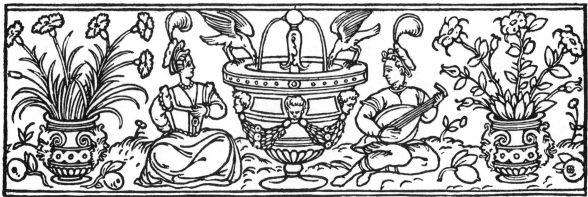

Embroidery designs by Giovanni Ostaus / VENICE 1567

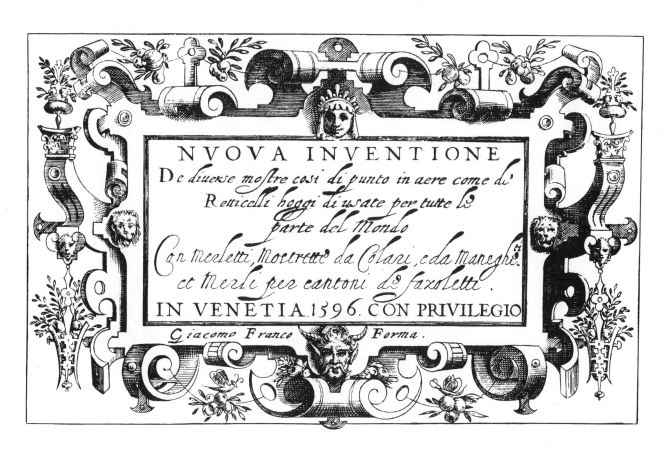

NVOVA INVENTIONE
De diuerse mostre cosi di punto in aere come di'
Retticelli hoggi di usate per tutte le
parte del Mondo
Con merletti, Mostrette da Colani, e da Maneghe,
et Merli per cantoni de fazoletti.
IN VENETIA. 1596. CON PRIVILEGIO
Giacomo Franco Forma.

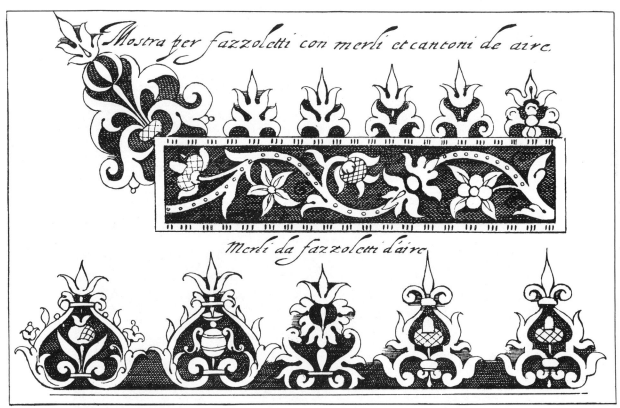

Mostra per fazzoletti con merli et cantoni de aire.

Merli da fazzoletti d'aire

Lace designs by Giacomo Franco / VENICE 1596

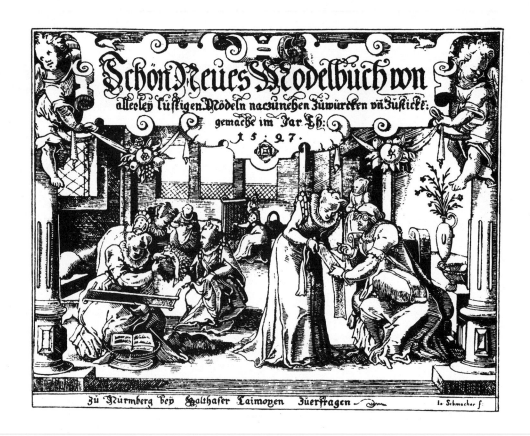

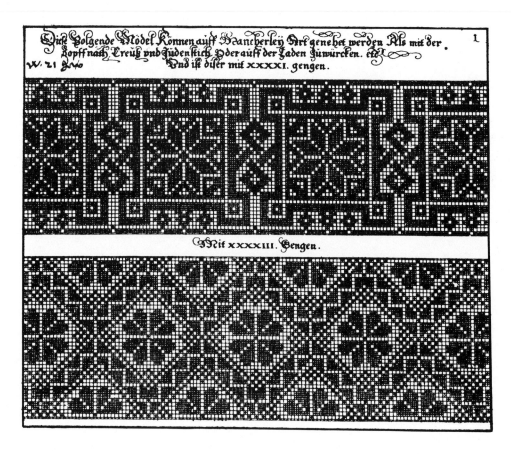

Lace designs by Hans Sibmacher / NUREMBERG 1597

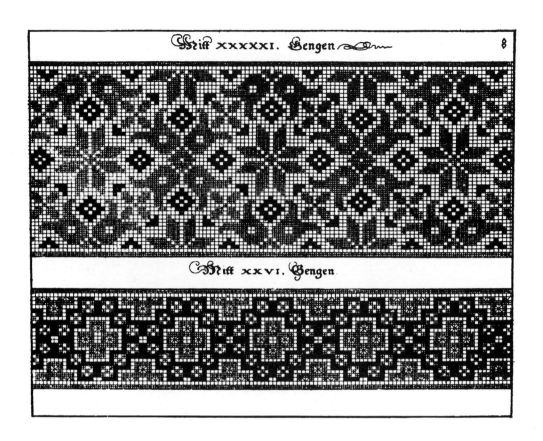

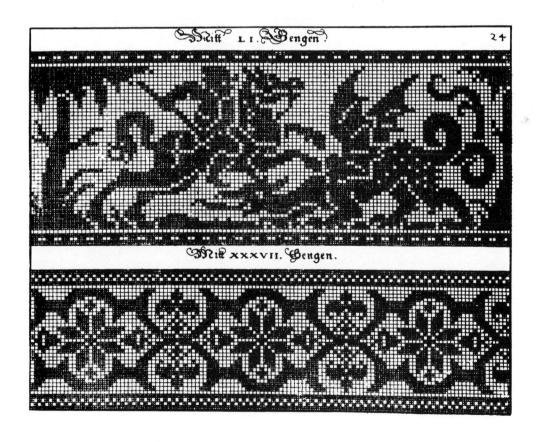

Lace designs by Hans Sibmacher / NUREMBERG 1597

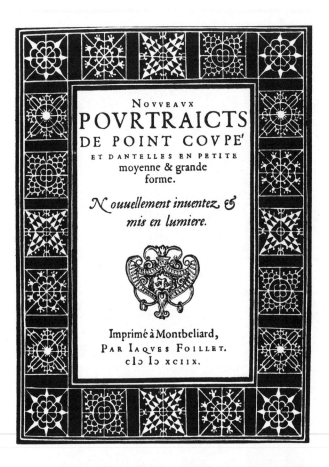

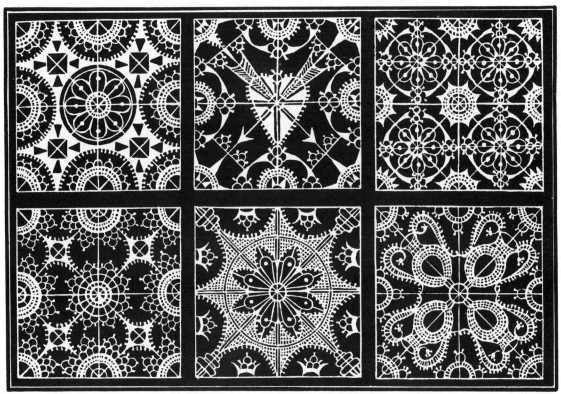

Lace designs by Iaques Foillet / MONTBELIARD 1598

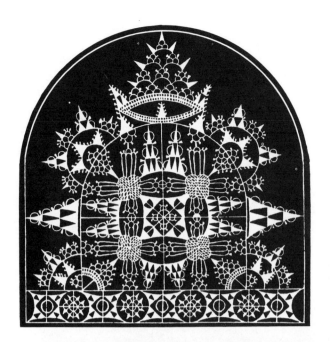
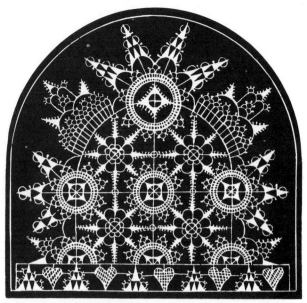
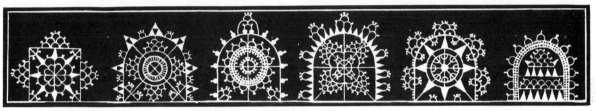
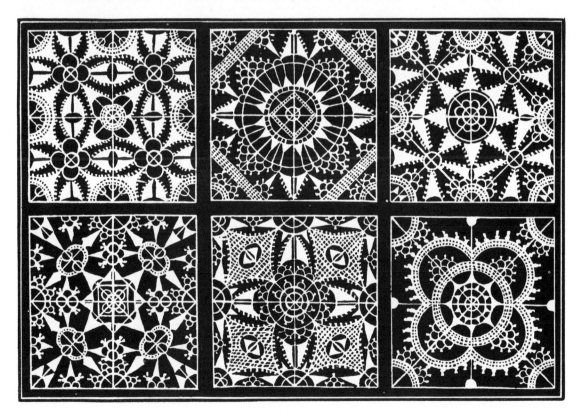

Lace designs by Iaques Foillet / MONTBELIARD 1598

Trois Dieux furent parreins du troisiesme Henry,
Iupiter, Mars, Phebus; cette perle Lorraine,
Vne triple Deèsse eut pour triple marreine,
Palas, Venus, la grace au chef tousiours fleury.

Peintre a fin que ton art imite la Nature,
Au tableau de ce Roy dont l'honneur touche aux Cieux,
Pein sur son chef Pallas, sur ses léures Mercure,
Mars dessus son visage, & l'amour dans ses yeux.

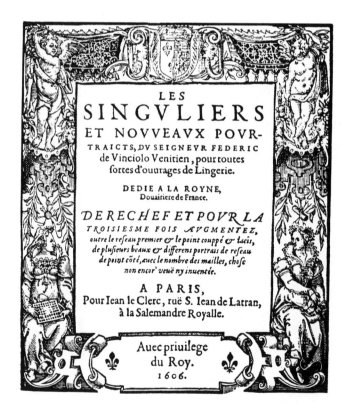

LES
SINGVLIERS
ET NOVVEAVX POVR-
TRAICTS, DV SEIGNEVR FEDERIC
de Vinciolo Venitien, pour toutes
sortes d'ouurages de Lingerie.

DEDIE A LA ROYNE,
Douairiere de France.

DE RECHEF ET POVR LA
TROISIESME FOIS AVGMENTEZ,
outre le reseau premier & le point couppé & lacis,
de plusieurs beaux & differens portraits de reseau
de point côté, auec le nombre des mailles, chose
non encor' veuë ny inuentée.

A PARIS,
Pour Iean le Clerc, ruë S. Iean de Latran,
à la Salemandre Royalle.

Auec priuilege
du Roy.
1606.

Lace designs by Federic de Vinciolo / PARIS 1606

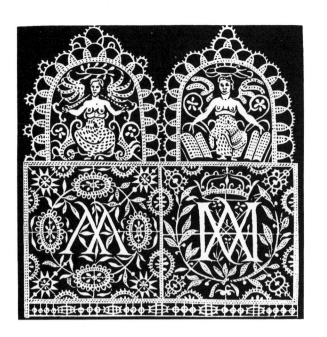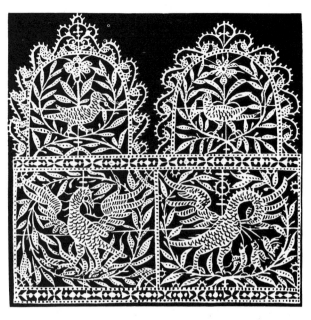

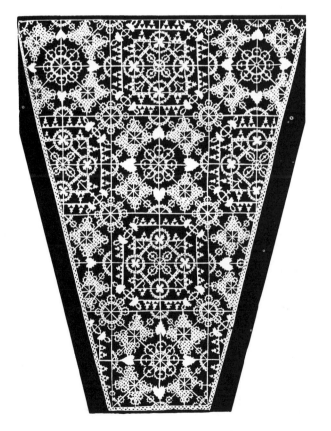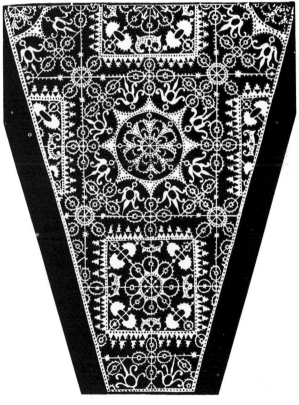

Lace designs by Federic de Vinciolo / PARIS 1606

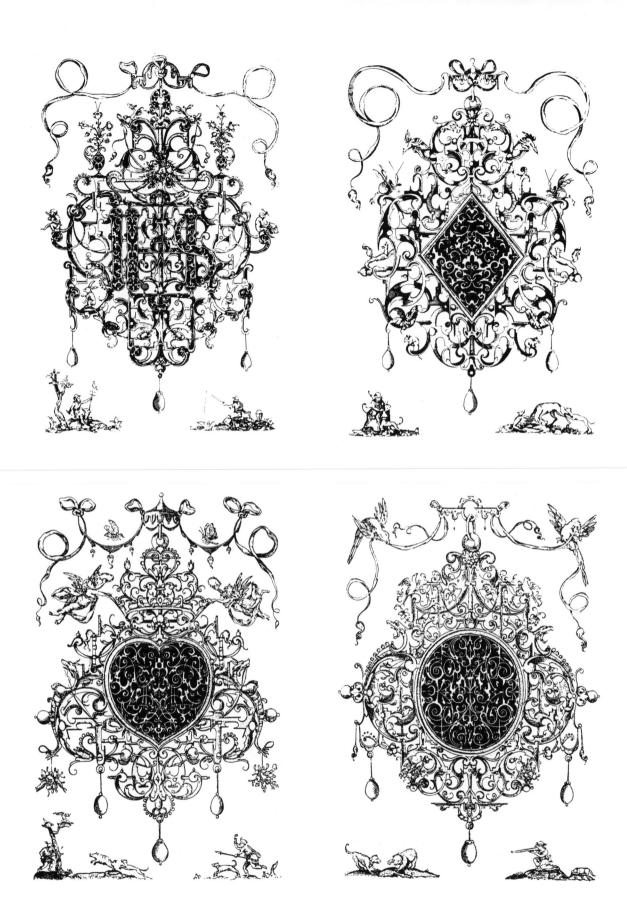

Designs for earrings / HOLLAND 1609

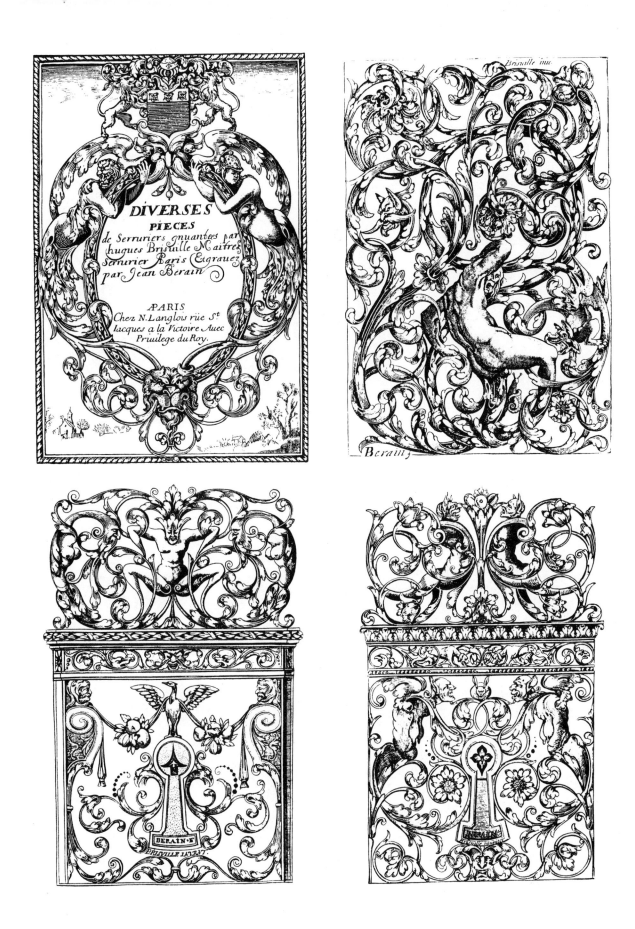

Wrought iron work designs by Hugues Brisville / PARIS 1663

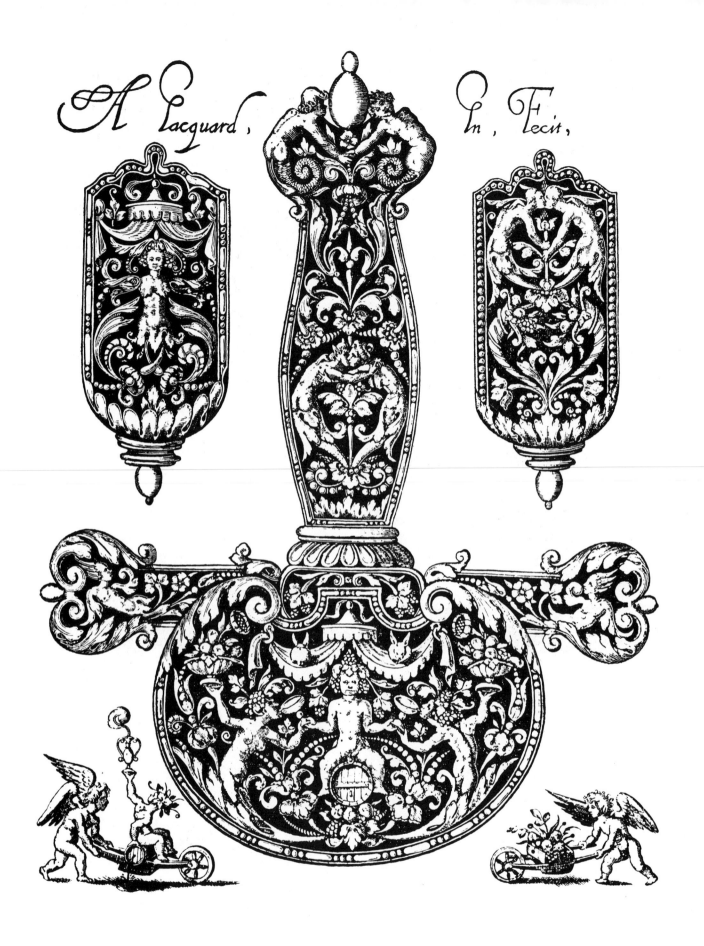

*Hilt and scabbard design by Antoine Jacquard/*POITIERS 17TH CENTURY

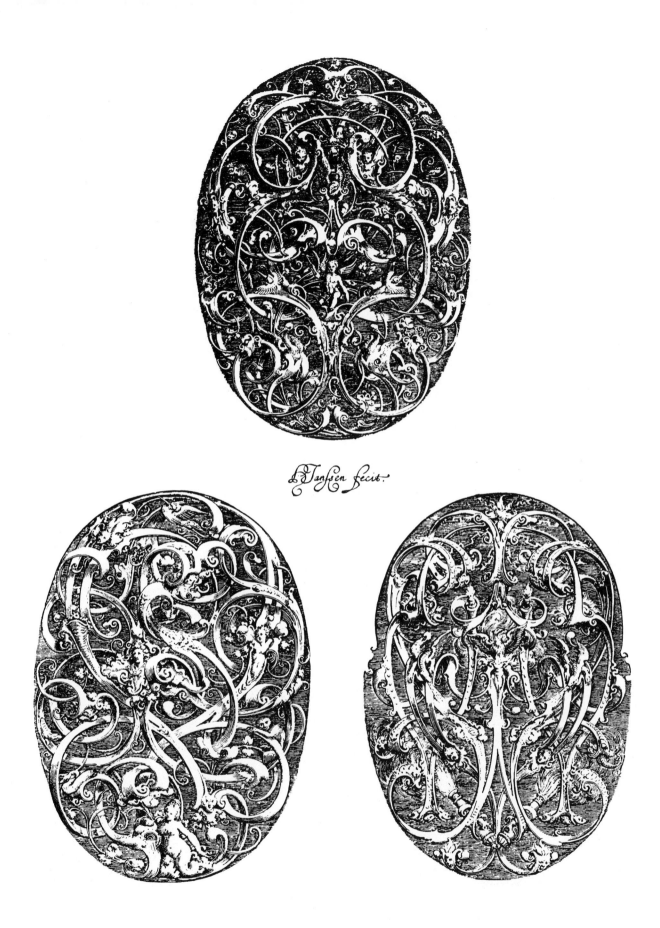

Plaque designs by Henri Janssen/AMSTERDAM 17TH CENTURY

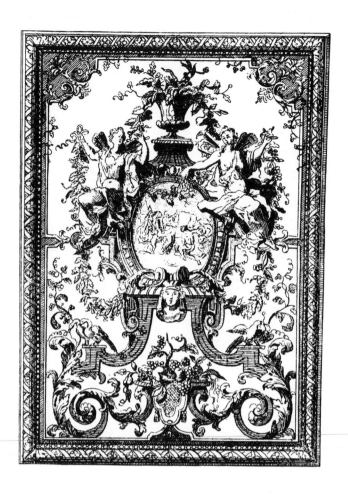

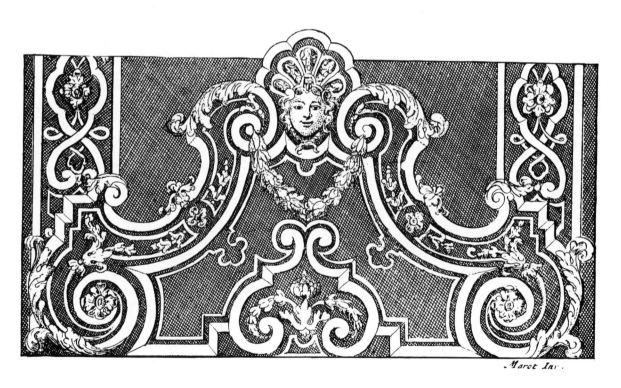

Marot Inv.

Curtain and panel designs by Daniel Marot/THE HAGUE 1712

·178·

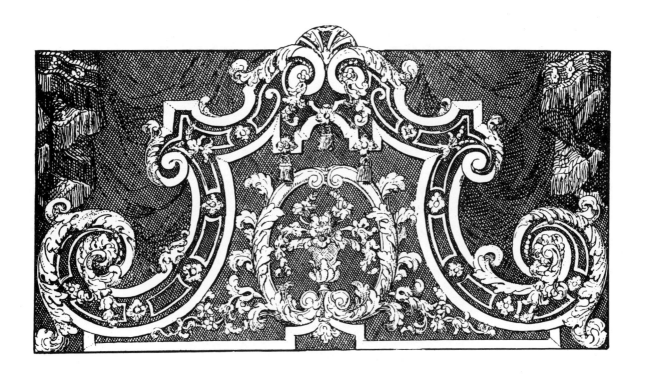

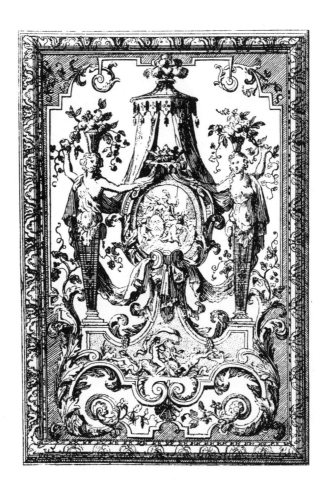

Curtain and panel designs by Daniel Marot/THE HAGUE 1712

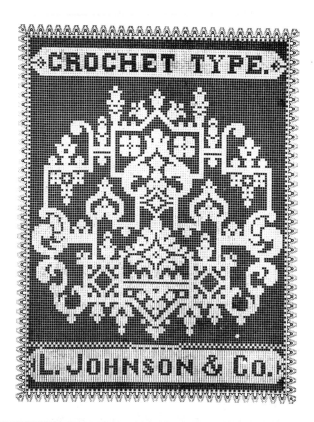

*Crochet type by L. Johnson & Co./*PHILADELPHIA 1873

Script & Scrolls

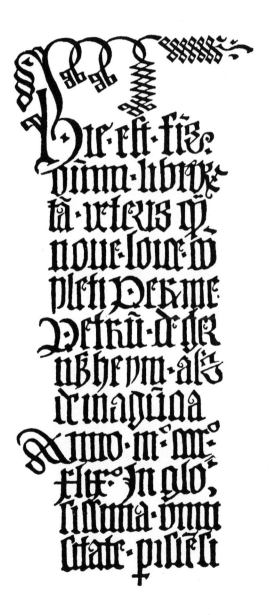

Calligraphic colophon by Peter Schöffer / PARIS 1449

SCRIPT AND SCROLLS

PAGE 181

Calligraphic colophon by Peter Schöffer, writing master at the University of Paris, 1449.

PAGE 184

Calligraphic letter E from a manuscript (Emperor Maximilian I), Germany 15th century.

PAGE 185

Calligraphic book plates by Nicolas Flamel, writing master for Jaques le Grant, for Saint Louis IX and for the Duc de Berry, Paris 14th century.

PAGE 186

Ornamented title from "Missale Ad usum celeberrime ecclesie Eboracensis", printed by M. P. Oliveri (York-Missale), Rouen 1490.

Calligraphic title from Bartholomew de Clanville's "De Proprietate Verum", printed by Wynkyn de Worde, London 1495.

PAGE 187

Ornamented title page from Jean (Dynamantier) Duvet's "Ars Moriendi ou l'Art de bien mourir", Lyons 1496.

PAGE 188

Calligraphic title from Albrecht Dürer's "Apokalypsis", printed by Anton Koberger, Nuremberg 1498.

Calligraphic title from "Dionysii Arlopagitae caelestis hierarchia", printed by Iaccuinus de Tridino, Venice 1502.

PAGE 189

Ornamented title from "Anno Regni Regis Henrici VIII, Statutes", printed by Richard Pynson, London 1515.

Calligraphic title from Bartholomeus Zamberto's "Euclidis Megarensis philosophi platoniy", printed by Johannes Taccuinus, Venice 1517.

PAGE 190

Calligraphic title from Martin Luther's "September Testament", designed by Melchior Lotter, Wittenberg 1522.

Calligraphic page by Nicolaus Werner, Germany 16th century.

PAGE 191

Ornamented pages from Giovanni Antonio Tagliente's "La vera arte dello eccelento scrivere", Venice 1524.

PAGE 192

Title page from Sebastian Francken's "Chronica", printed by Mathias Apiarius, Bern 1539.

PAGE 193

Title page from Johann Stumpffen's "Eydgnoschaft Chronick", printed by Christoph Froschauer, Zurich 1548.

PAGES 194–195

Title page, frontispiece and calligraphic lettering from Caspar Neff's "Thesaurarium", Cologne 1549.

PAGE 196

Calligraphic broadside "Gospel", Nuremberg 1571.

PAGE 197

Title page from Jacob Jacobelln's "Fundament Buch", printed by Bernhard Jobin, Strasbourg 1579.

Ornamented page from a manuscript, Germany 16th century.

PAGE 198

Calligraphic pages from Jan van den Velde's "Spieghel der Schrijfkonste", Rotterdam 1605.

PAGE 199

Calligraphic page from De Beaugrand's "Poecilographie", Paris 1601.

Title page from Maria Strick's "Tooneel der loflijcke Schrijfpen", Delft 1607.

PAGE 200

Ornamental borders and lettering by Salomon Henrix and Petrus Bales from Hondio Judoco's "Theatrum artis scribendi", Amsterdam 1614.

PAGE 201

Calligraphic title page from Richard Gething's "Calligraphotechnia or The Art of faire writing", London 1619.

Calligraphic page from Periccioli's "Il libro della cancellaresche corsive", Siena 1619.

PAGE 202

Calligraphic scrolls from Geobattista Pisani's "Tratteggiato da Penna", Genoa 1640.

PAGE 203

Calligraphic scrolls from Edward Cocker's "The Pen's Transcendencie", London 1657.

PAGE 204

Title page from Edward Cocker's "Penna Volans", London 1661.

Title page from Edward Cocker's "Multum in Parvo", London 1672.

SCRIPT AND SCROLLS

THE ART of occidental and oriental writing has been thoroughly studied and ably presented by past and contemporary experts and scholars in their many excellent books and papers on the development of lettering. In nearly every one of these books and treatises, the composition and assessment of the material presented is based strictly on a calligraphic point of view. The main stress of these searching and scholarly papers is on the derivation and evolution of the letter and the alphabet.

It is unfortunate for the interested artist who is not an inveterate lettering man, that the ornamental expressions of the old writing-masters in title pages, borders and flourishes, found in abundance in their sample books and other works, are passed over or brushed aside as unimportant and unnecessary frills in most of these dissertations. Scrolls and calligraphic figure drawings are condemned altogether as ugly degenerations of the art of writing.

The ornamented compositions of the old writing-masters who were inspired by the art of the oriental miniaturist-calligraphers have a decorative value of their own. They show not only the high skill of these craftsmen, but also their artistic realization of the use of calligraphic expressions in design.

From a decorative point of view these scrolls and flourishes are a treasure chest of ornamental gems and a well of delight for the artist, the craftsman and the amateur.

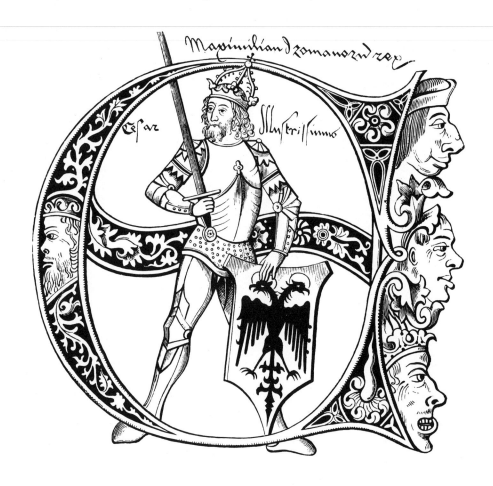

Calligraphic letter E/GERMANY 15TH CENTURY

Calligraphic book plates by Nicolas Flamel/PARIS 14TH CENTURY

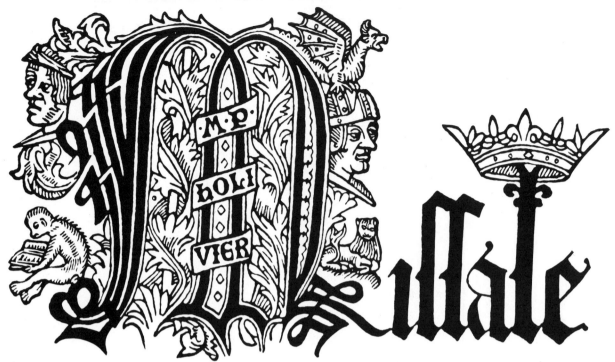

Missale

Ad usum celeberrime ecclesie Eboracensis.

Ornamented title printed by M. P. Oliveri / ROUEN 1490

Bartholomeus de proprietatibus rerum

Calligraphic title printed by Wynkyn de Worde / LONDON 1495

Cum orationibus pulcherrimis dicendis circa agonizantem.

Ornamented title page designed by Jean Duvet/LYONS 1496

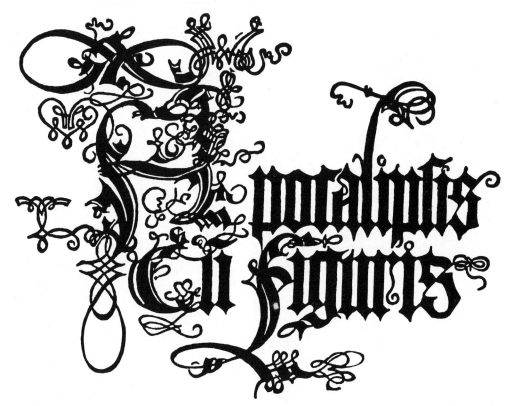

Calligraphic title printed by Anton Koberger/NUREMBERG 1498

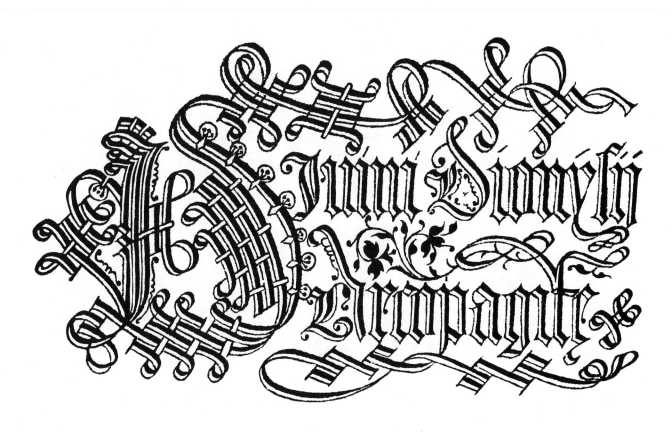

Calligraphic title printed by Iaccuinus de Tridino/VENICE 1502

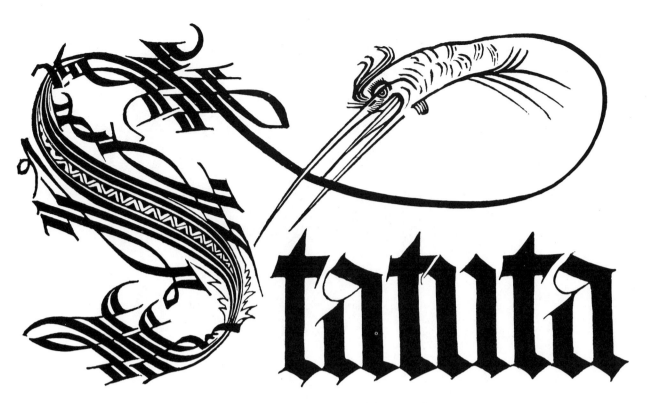

Ornamented title printed by Richard Pynson / LONDON 1515

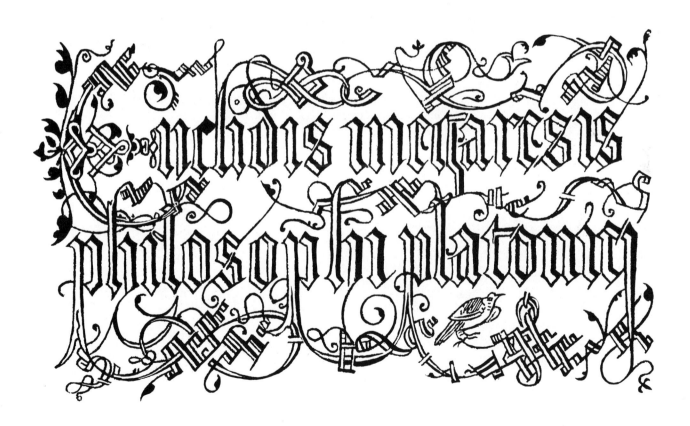

Calligraphic title printed by Johannes Taccuinus / VENICE 1517

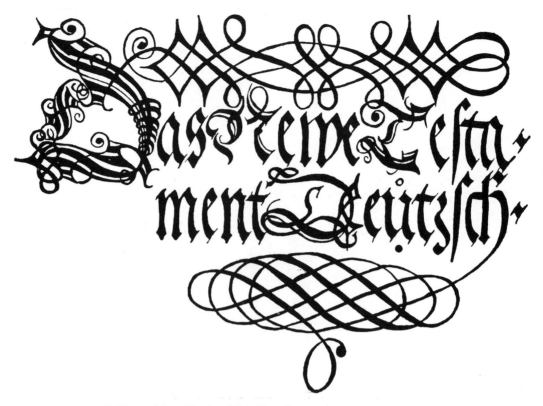

Calligraphic title by Melchior Lotter / WITTENBERG 1522

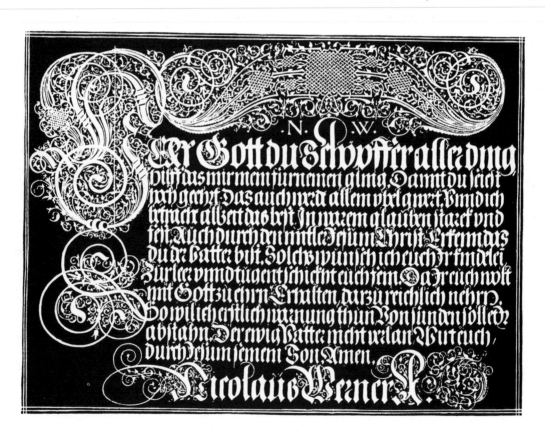

Calligraphic page by Nicolaus Werner / GERMANY 16TH CENTURY

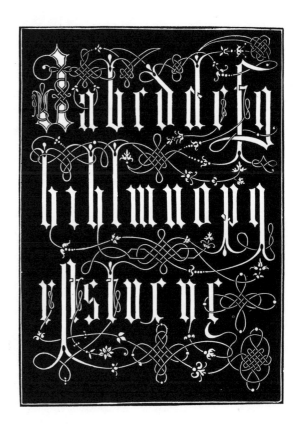

Ornamented pages by Giovanni Antonio Tagliente / VENICE 1524

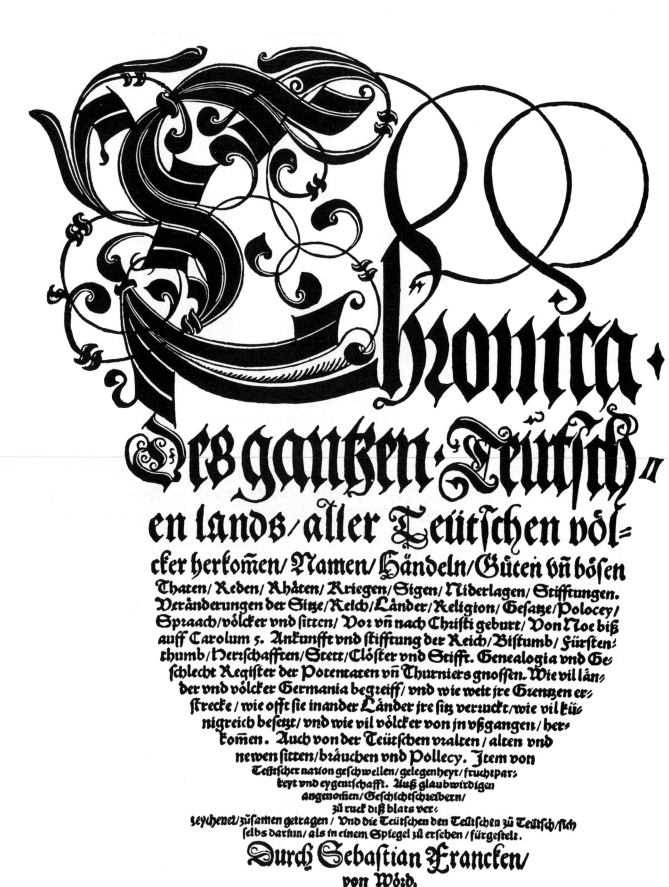

Chronica.

Des ganßen Teütsch=
en lands/ aller Teütschen völ=
cker herkomen/ Namen/ Händeln/ Güten vñ bösen
Thaten/ Reden/ Ahäten/ Kriegen/ Stgen/ Niderlagen/ Stifftungen.
Veränderungen der Sitze/Reich/Länder/Religion/Gesatze/Polocey/
Spraach/völcker vnd sitten/ Vor vñ nach Christi geburt/ Von Noe biß
auff Carolum 5. Ankunfft vnd stifftung der Reich/Bistumb/ Fürsten=
thumb/Herrschafften/Stett/Clóster vnd Stifft. Genealogia vnd Ge=
schlecht Register der Potentaten vñ Thurniers gnossen. Wie vil län=
der vnd völcker Germania begreiff/ vnd wie weit jre Grenzen er=
strecke/ wie offt sie inander Länder jre sitz verruckt/wie vil kü=
nigreich besetzt/ vnd wie vil völcker von jn vßgangen/ her=
komen. Auch von der Teütschen vralten/ alten vnd
newen sitten/bräuchen vnd Pollecy. Item von
Teütscher nation geschwellen/ gelegenheyt/ fruchtpar=
keyt vnd eygentschafft. Auß glaubwirdigen
angenomen/Geschichtschreibern/
zü ruck diß blats ver=
zeychenet/ züsamen getragen/ Vnd die Teütschen den Teütschen zü Teütsch/sich
selbs darinn/ als in einem Spiegel zü ersehen/ fürgestelt.
Durch Sebastian Francken/
von Wörd.

Title page printed by Mathias Apiarius / BERN 1539

Gemeiner lobli-
cher Eydgnoschafft Stetten/
Landen und Völckeren Chronick wir-
diger thaaten beschreybung.

Hierin wirt auch die gelegenheit der gantzen
Europe/ Item ein kurtzuergriffne Chronica Germanie oder Teütsch-
lands/in sonders aber ein fleyssige histori und ordenliche beschreybung Gallie oder Franck-
rychs fürgestellt/darauff deß obgedachte der Eydgnoschafft beschreybung volget. Welchs
alles mit gar schönen Geographischen Landtaflen/ Contrafetischem abmalen der Stetten/
Fläcken und Schlachten/auch mit vilen alten und herrlichen Waapen/künigklicher/
fürstlicher und Edler geschlächten oder Geburtstaflen fürgebildet/darzů mit
fleyssigen Registern auffgescheiden/Durch Johann Stumpffen beschri-
ben/und in XIII. bücher abgeteilt ist. Welcher summen und
innhalt nach 5. nächst umbgewendten blettern
eigentlich verzeichnet findst.

M· D· XLVIII·

Getruckt Zürych in der Eydgnoschafft
bey Christoffel Froschouer.

Title page printed by Christoph Froschauer / ZURICH 1548

THESAVRARIVM
ARTIS SCRIPTORIAE ET

Cancellariæ Scribarumq; Clenodium pretiosum Libellus plane au-
reus varia ex vero deprompta fudamento scripta continens
antea non visa
nuc primum in lucem ædita
CASPARE NEVIO COLONIÆ AGRIP-
pinæ Scriba & Arithmetico authore Anno redeptoris nostri
1 5 4 9.

Scripta hoc in Thesaurario conteca sunt Latina Italica
Gallica Germanica Brabatica & Anglica

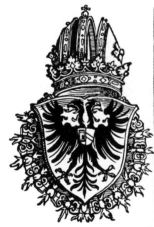 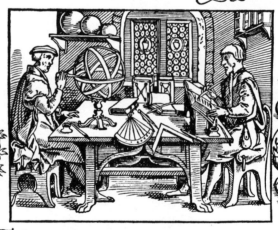 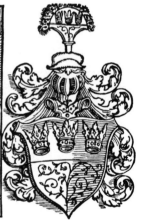

Vbiorum Coloniæ Agrippinæ cælatum & impressum Impensis
Casparis Vopelij Medeb. Mathematum professoris
cum Gratia & priuilegio Cæsariæ Maiestatis ad decennium

Title page and frontispiece by Caspar Neff / COLOGNE 1549

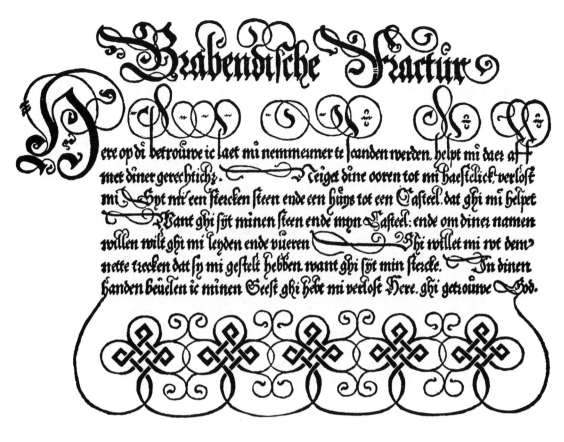

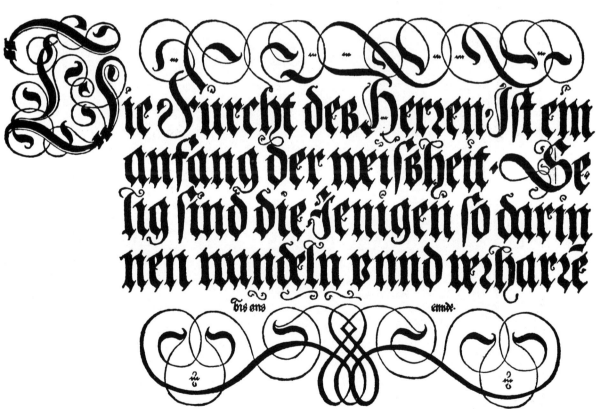

*Calligraphic lettering by Caspar Neff/*COLOGNE 1549

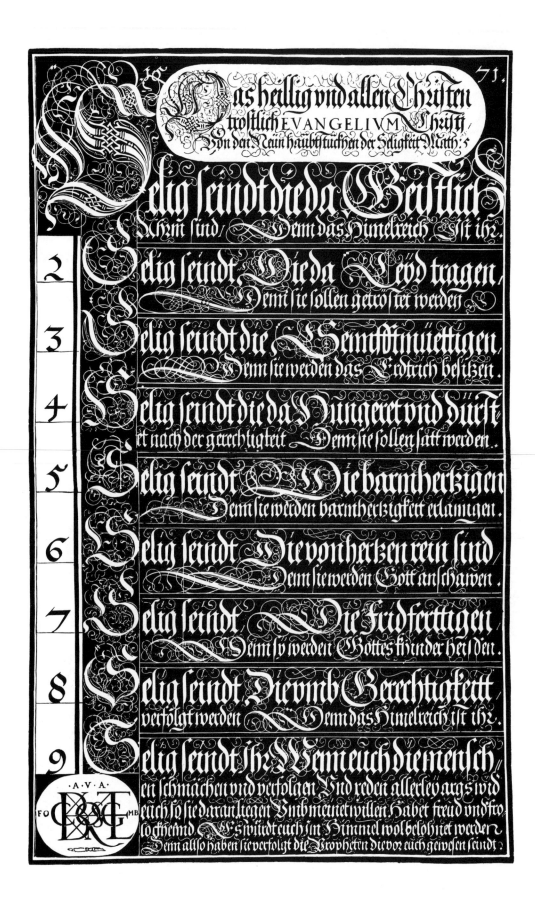

Calligraphic broadside / NUREMBERG 1571

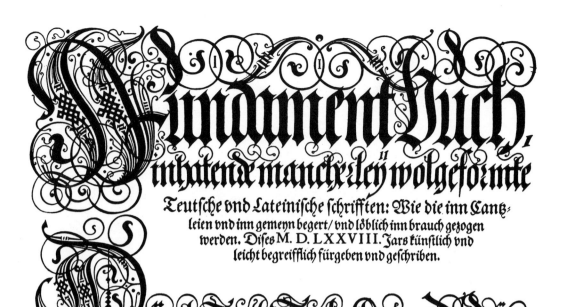

Title page by Jacob Jacobelln / STRASBOURG 1579

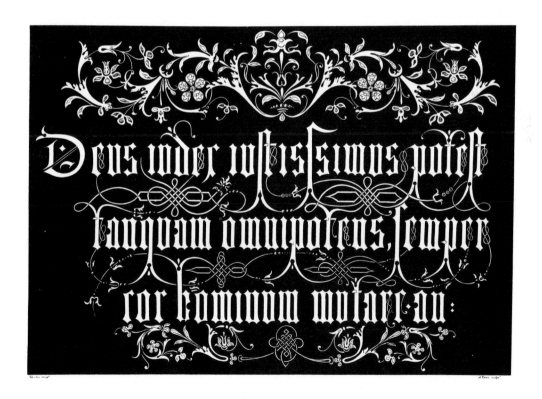

Ornamented page from a manuscript / GERMANY 16TH CENTURY

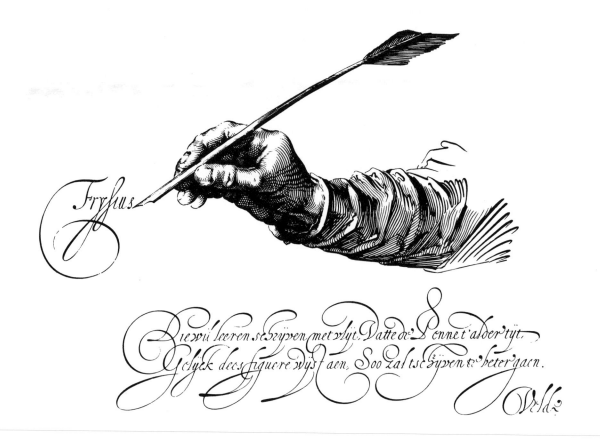

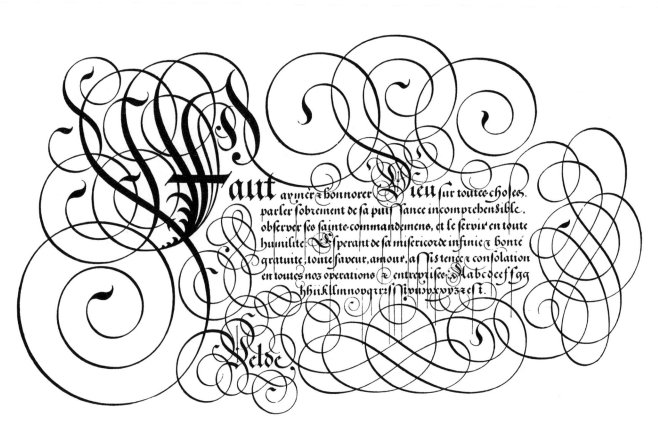

Calligraphic pages by Jan van den Velde/ROTTERDAM 1605

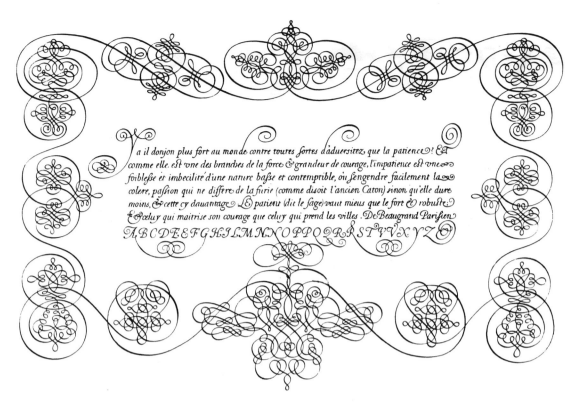

Calligraphic page by De Beaugrand / PARIS 1601

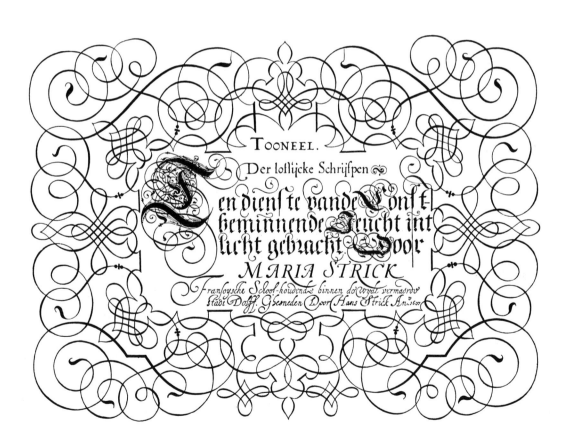

Calligraphic title page by Maria Strick / DELFT 1607

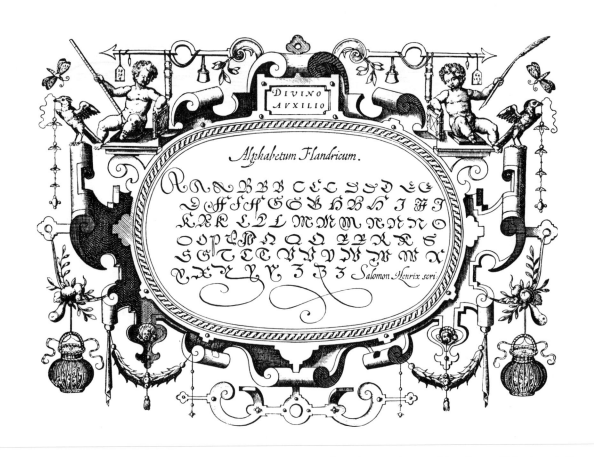

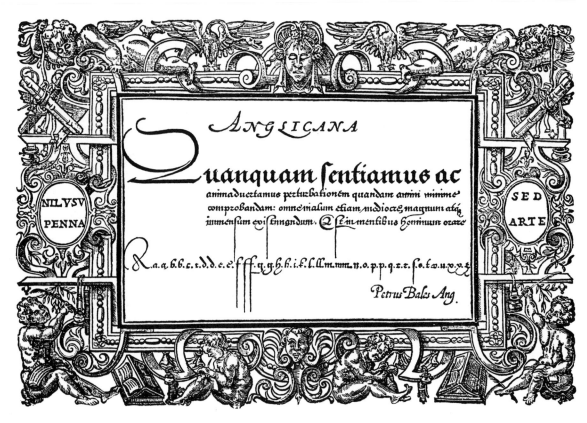

Ornamented pages by Salomon Henrix and Petrus Bales / AMSTERDAM 1614

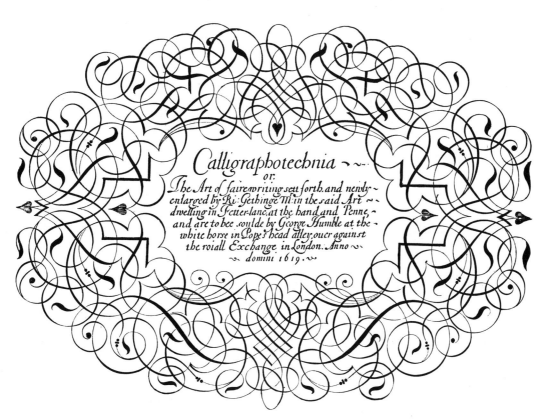

*Calligraphic title page by Richard Gething/*LONDON 1619

*Calligraphic page by Periccioli/*SIENA 1619

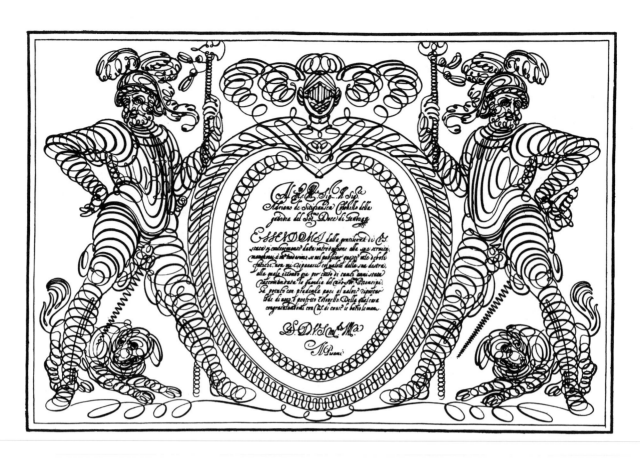

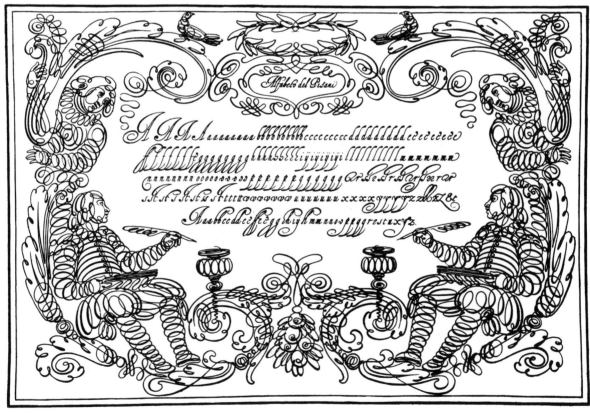

Scrolls by Geobattista Pisani / GENOA 1640

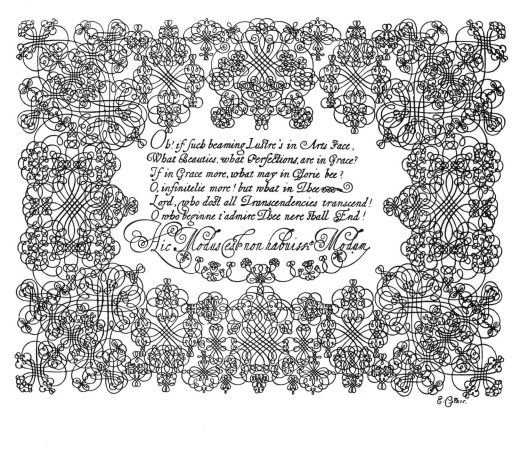

Oh! if such beaming Lustre's in Arts Face,
What Beauties, what Perfections, are in Grace?
If in Grace more, what may in Glorie bee?
O, infinitelie more! but what in Thee
Lord, who dost all Transcendencies transcend!
O who beginne t'admire Thee nere shall End!

Hic Modus est non habuisse Modum

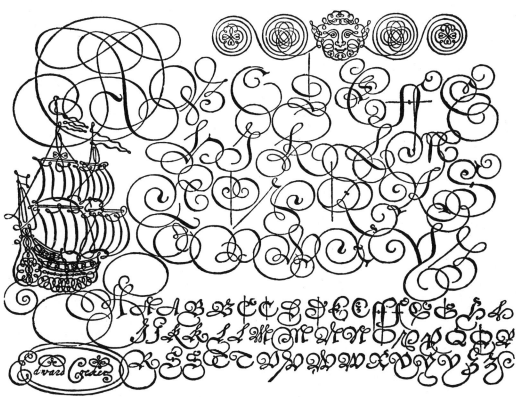

Scrolls by Edward Cocker / LONDON 1657

· 203 ·

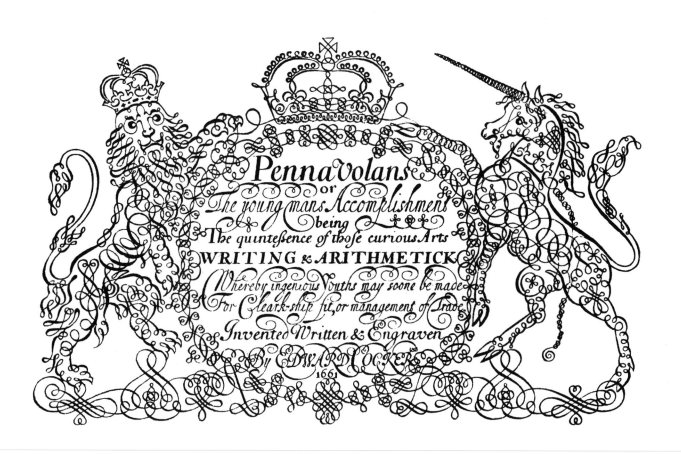

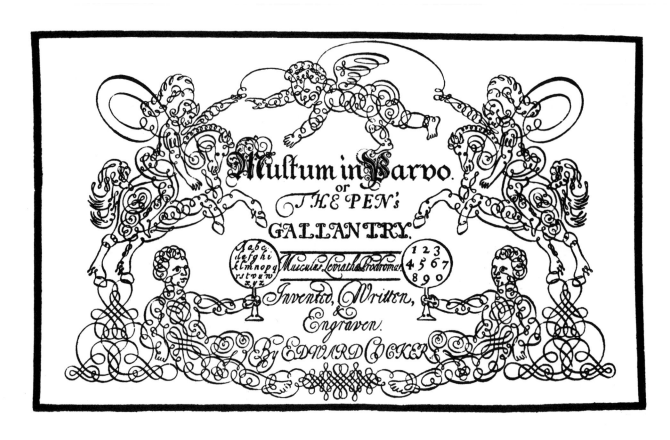

Scrolls by Edward Cocker / LONDON 1661 AND 1672

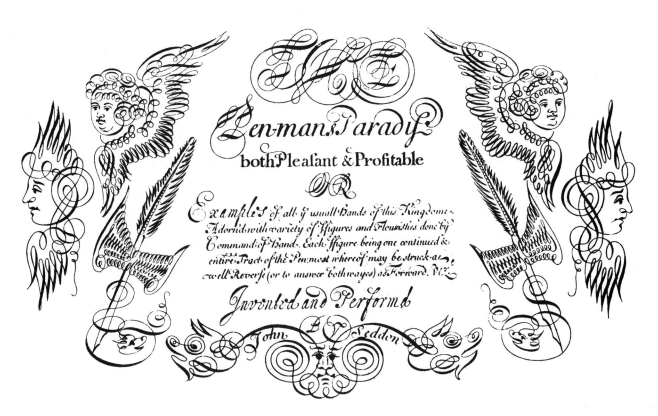

Penman's Paradise
both Pleasant & Profitable
OR

Examples of all y usuall hands of this Kingdome.
Adorn'd with variety of ffigures and Flourishes done by
Command of hand. Each ffigure being one continued &
entire Tract of the Pen most whereof may be struck at
well Reverse (or to answer bothwayes) as Forward. VIZ.

Invented and Perform'd

John Seddon

Sold by W[m] Court at y Mariner & Anchor on little Tower hill London

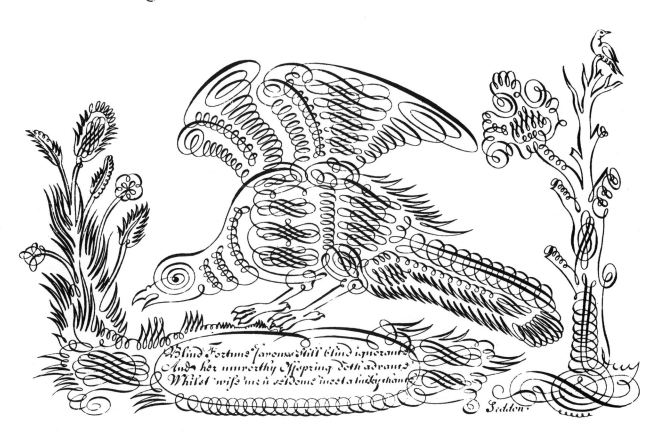

Blind Fortune favours still blind ignorants
And her unworthy Offspring doth advance
Whilst wise men seldome meet a lucky chance

Seddon

Scrolls by John Seddon / LONDON 1695

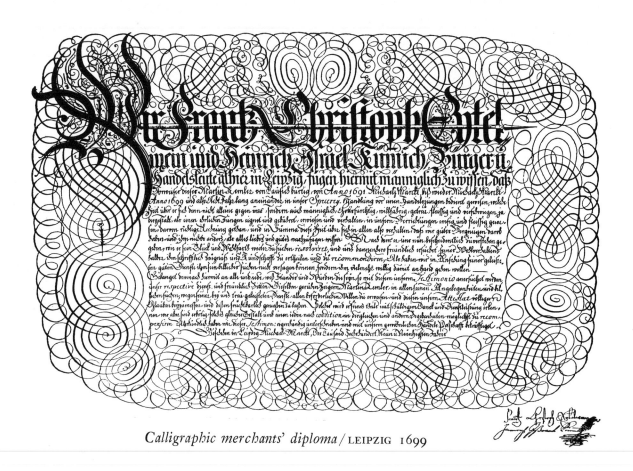

Calligraphic merchants' diploma / LEIPZIG 1699

Calligraphic page by John Clark / LONDON 1714

Ornamented pages by Michael Baurenfeind / NUREMBERG 1716

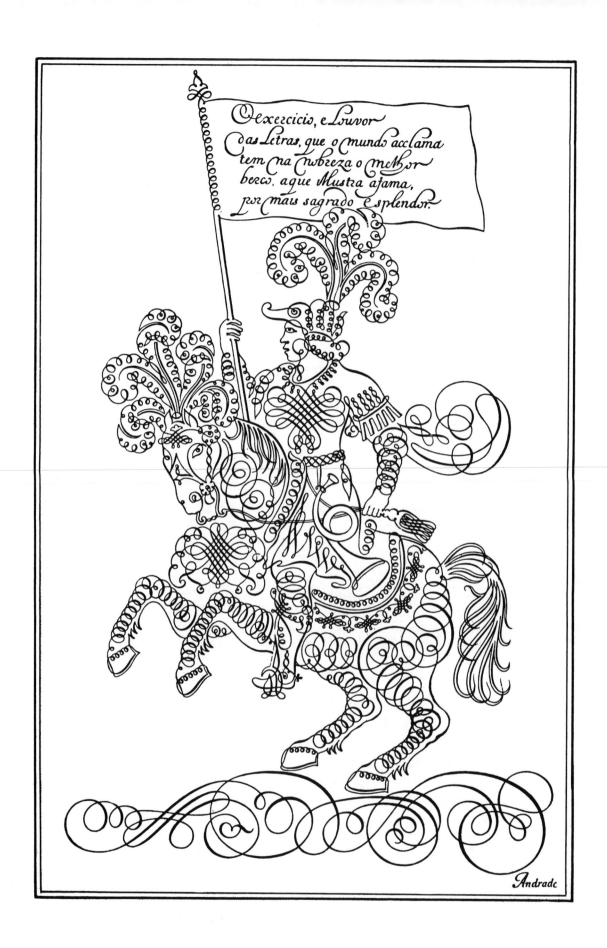

O exercicio, e Louvor
das Letras, que o mundo acclama
tem na nobreza o melhor
berco, aque Mustra ajama,
por mais sagrado esplendor.

Andrade

Scroll by Mánoel Andrade de Figueiredo / LISBON 1722

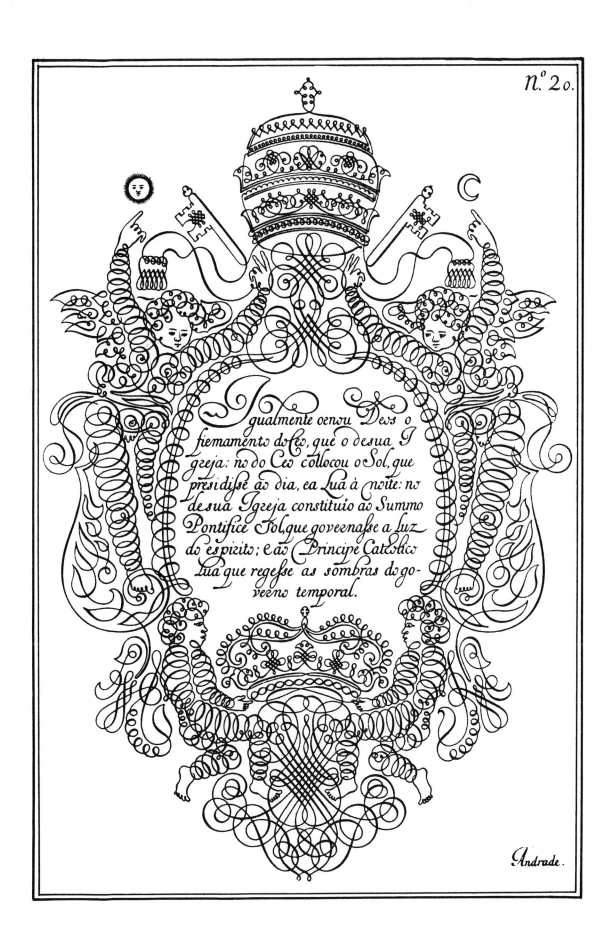

Igualmente oenou Deus o
fiemamento do Ceo, que o desua I
greja: no do Ceo collocou o Sol, que
presidisse ao dia, ea Lua à noite: no
desua Igreja constituio ao Summo
Pontifice Sol, que governasse a Luz
do espirito; e ao Principe Catolico
Lua que regesse as sombras do go-
verno temporal.

Scroll by Mánoel Andrade de Figueiredo/LISBON 1722

Ornamented page by Johann Georg Schwandner / VIENNA 1756

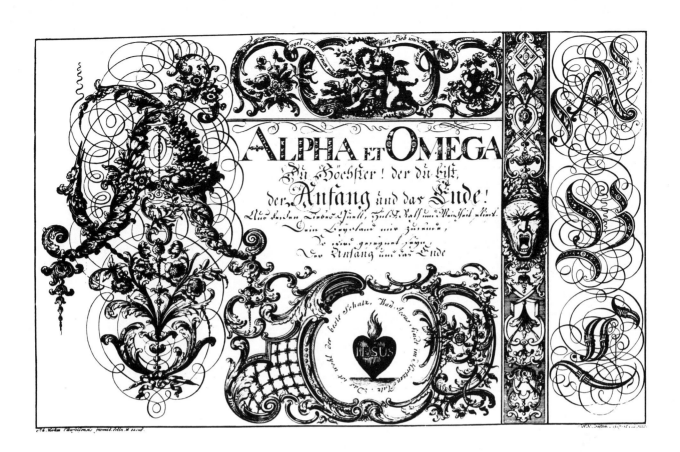

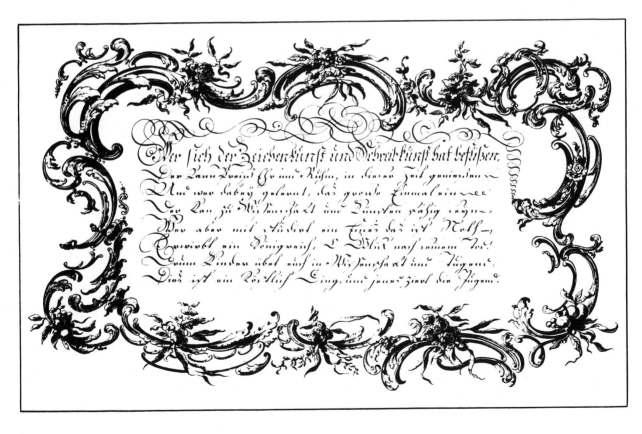

Ornamented pages by Johann Merken/ MÜHLHEIM 1782

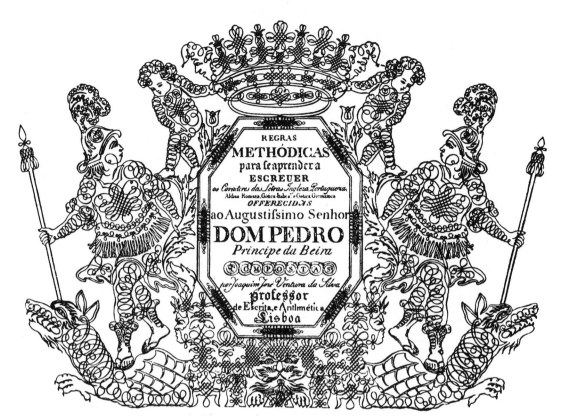

Scroll by Joaquin José Ventura da Silva / LISBON 1803

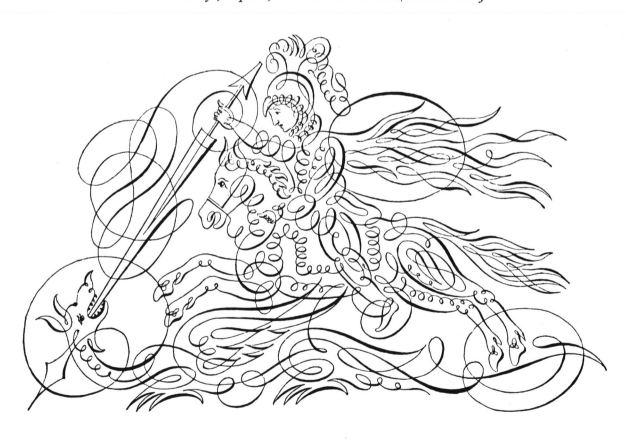

Scroll by Johann Evangelist Mettenleiter / MUNICH 1850

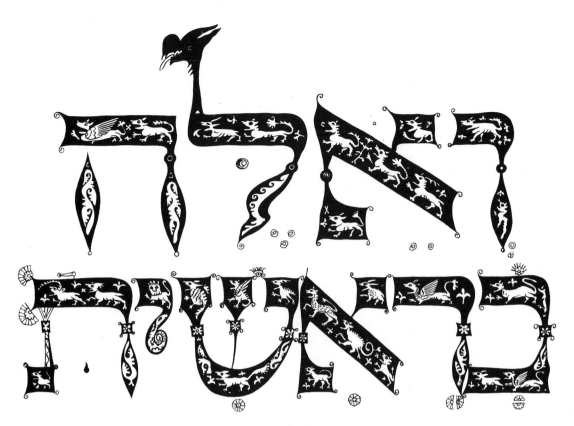

Hebrew title from a manuscript/GERMANY 10TH CENTURY

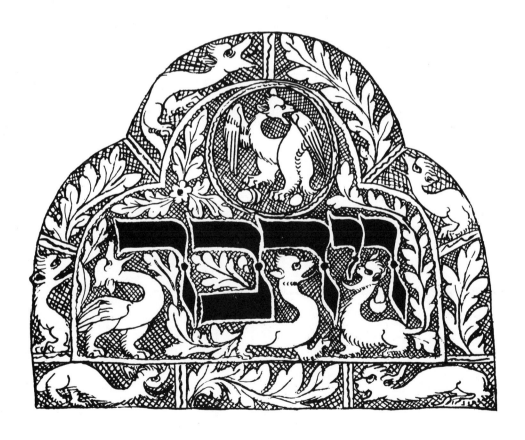

Hebrew title from a manuscript/COLOGNE 1571

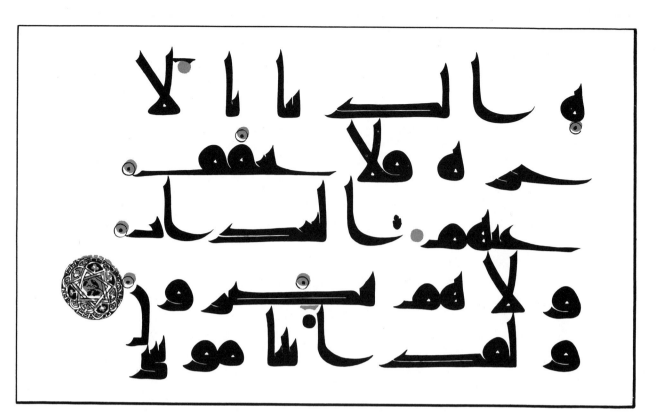

Kufic-Arabic leaf from the Koran / MESOPOTAMIA 7TH CENTURY

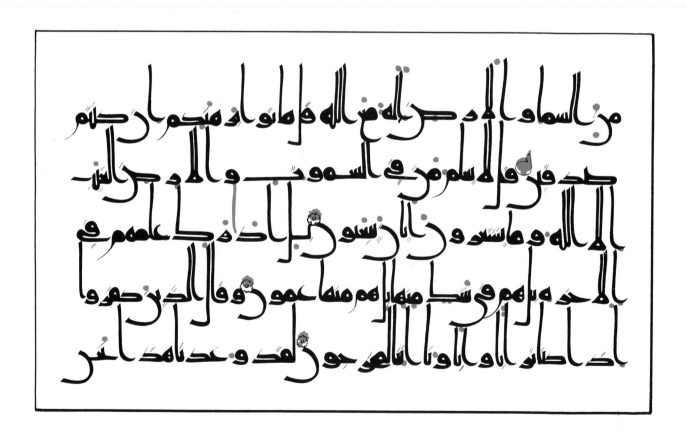

Kufic-Arabic leaf from the Koran / MESOPOTAMIA 9TH CENTURY

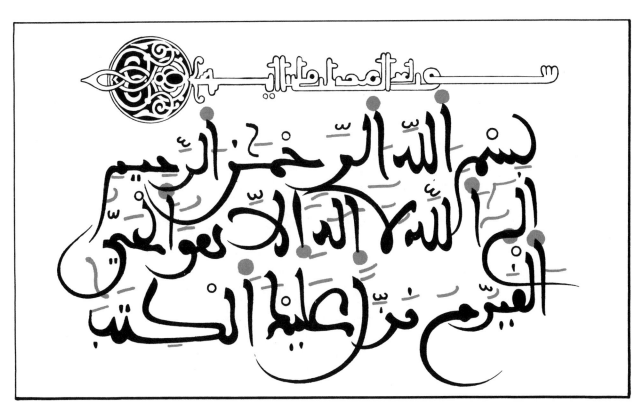

Arabic leaf from the Koran/NORTH AFRICA 15TH CENTURY

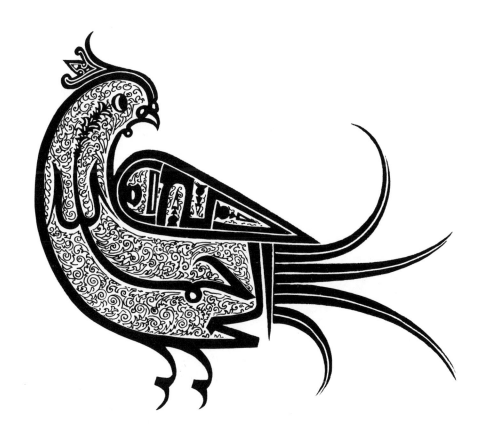

Calligraphic proverb (Bismillah)/PERSIA 17TH CENTURY

·215·

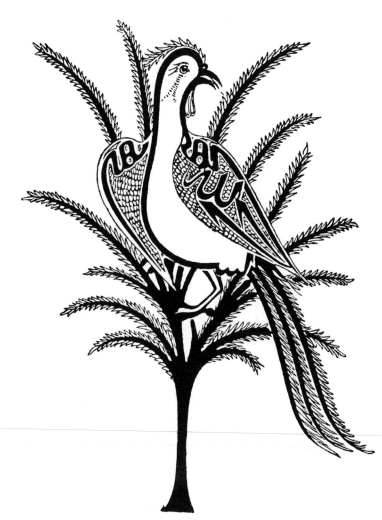

Calligraphic signature (Bismillah) of Emir Beha Ullah / PERSIA

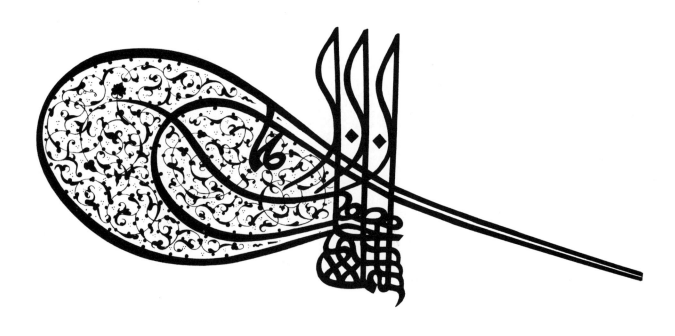

Signature (Thugra) of Sulaiman I the Magnificent / TURKEY 1520–1566

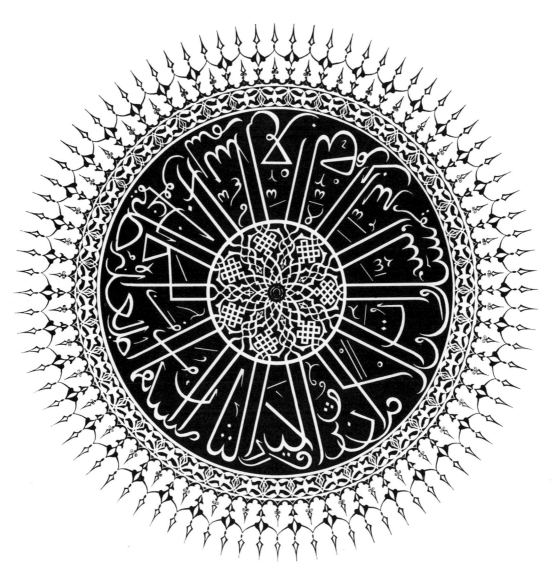

Rosace from the mosque of Sulaiman I/CONSTANTINOPLE 16TH CENTURY

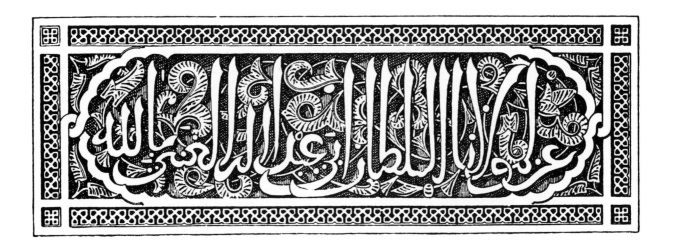

Arabic inscription from the Alhambra/GRANADA 13TH CENTURY

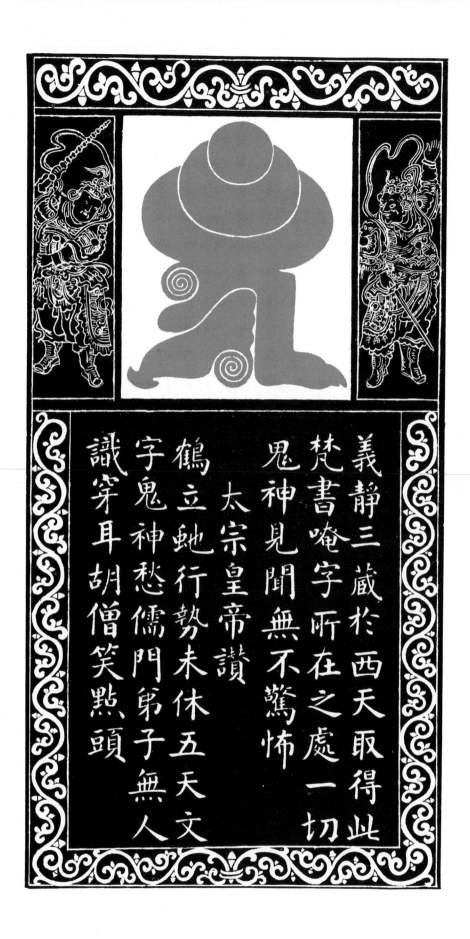

義靜三藏於西天取得此
梵書唵字所在之處一切
鬼神見聞無不驚怖

太宗皇帝讚

鶴立虵行勢未休五天文
字鬼神愁儒門弟子無人
識穿耳胡僧笑點頭

Calligraphic inscription by Emperor T'ai-Tsung / CHINA 970–998

· 2 1 8 ·

HERALDIC ORNAMENTS &
ALLEGORIC CARTOUCHES

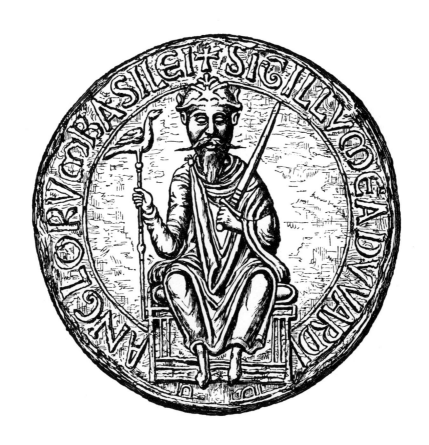

Seal of Edward the Confessor / ENGLAND 1043–1066

HERALDIC ORNAMENTS AND ALLEGORIC CARTOUCHES

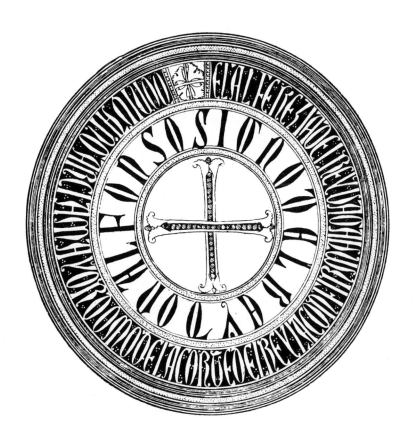

Calligraphic sigil of Alfonso the Wise/SPAIN 1226–1284

HERALDIC ORNAMENTS AND ALLEGORIC CARTOUCHES

HERALDIC ORNAMENTS and allegoric decorations are the most extensive and elaborate single groups in applied art. The use of seals and cartouches is as old as Egypt, Babylonia and Assyria. Allegoric designs were already employed in early Greek, Etruscan and Roman mythologic art. You could fill to overflowing voluminous libraries and collections with the uncountable legions of medieval seals, stamps, family trees, pedigrees, religious diagrams, worldly and ecclesiastical adornments, title pages of anniversary and festival pamphlets, genealogic and heraldic manuals, cartographic decorations in books on voyages and discoveries, ornaments and cartouches for maps and atlases.

Their inestimable number, their unrestrained galaxy in forms and shapes, their overwhelming abundance in simple and elaborate decorative elements are an inexhaustible mine of inspiration for every designer and craftsman.

Seals and stamps in their old heraldic forms and applications are still part of our everyday life. They are used to establish the right of private ownership, to confirm the authenticity of documents and signatures, and to underline the position of certain office holders.

Pedigrees and trees are finding an extensive variety of uses in the more commercialized form of graphs and diagrams in today's science, technique, economy, commerce, administration and communication.

Figurative and embellished charts and maps are designed in abundance today by leading contemporary artists for wall decorations and illustrations. Cartouches are also widely used for trade marks, labels and advertisements.

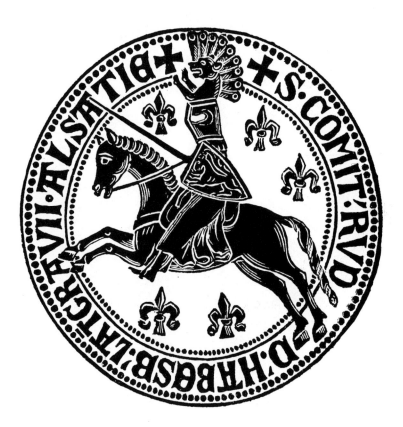

Seal of Rudolf I of Hapsburg, Holy Roman Emperor / 1273–1291

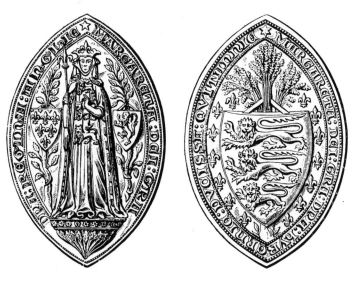

Seal of Margaret of France / 1299

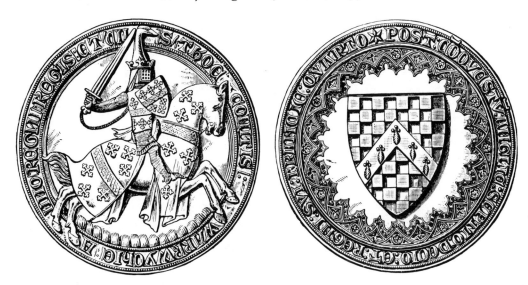

Seal of Thomas De Beauchamp / 1369

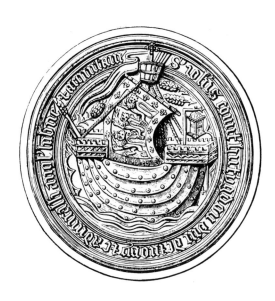

Seal of John Holland / 1436

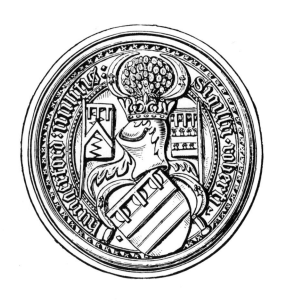

Seal of Robert De Hungerford / 1449

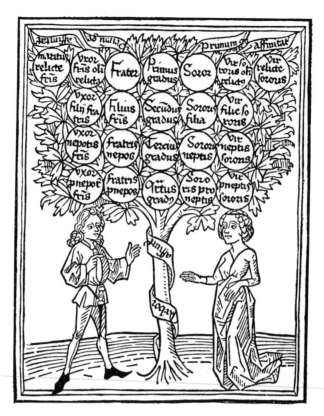

Tree of affinity printed by Ludwig Hohenwang / AUGSBURG 1477

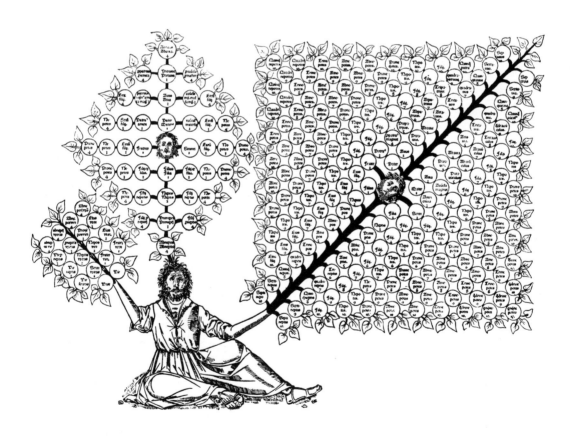

Tree of affinity printed by Joannes Hamman de Landoia / VENICE 1490

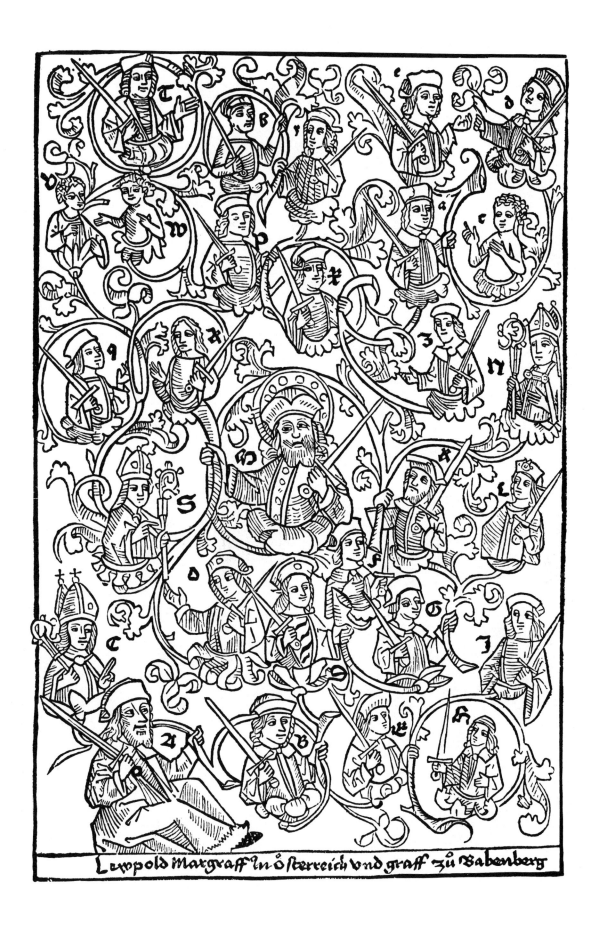

Pedigree of Leopold zu Babenberg/BASEL 1491

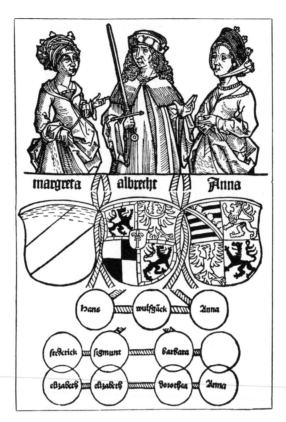

*Family diagram of Albrecht von Sachsen/*MAINZ 1492

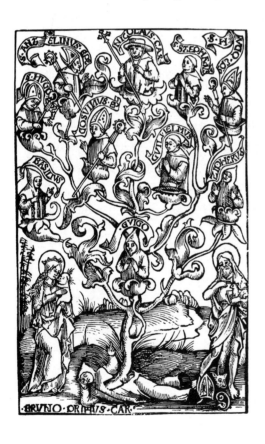

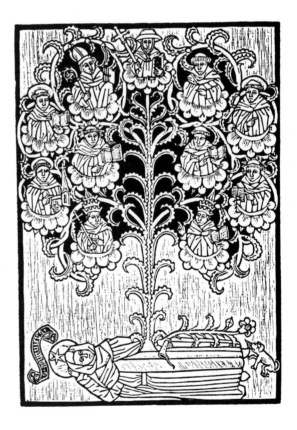

*Tree of succession/*BASEL 1499 *Tree of succession/*FRANCE 15TH CENTURY

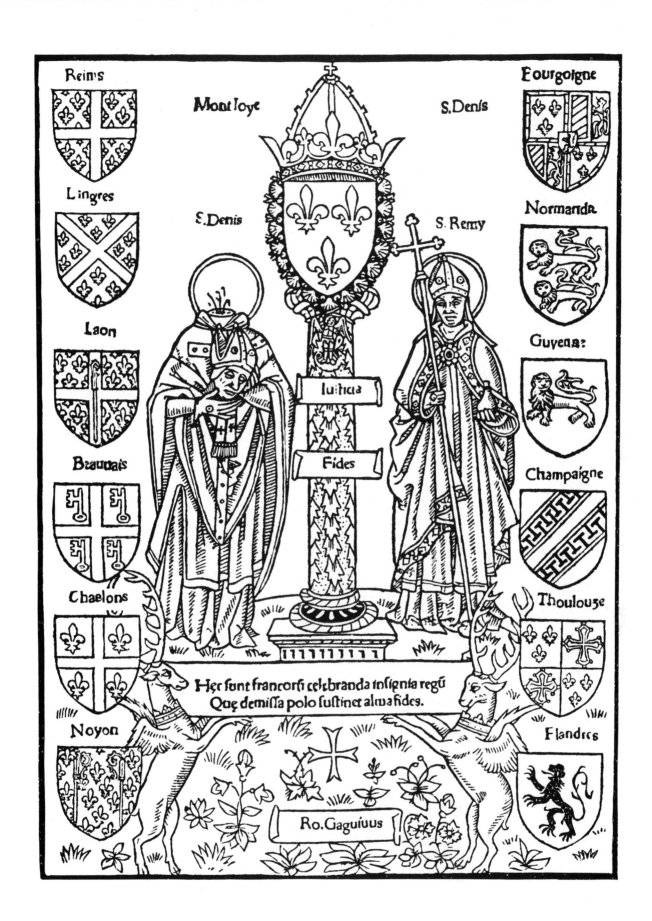

Reins

Lingres

Laon

Beaunais

Chaelons

Noyon

Mont Ioye

S. Denis

Iuſticia

Fides

Hęc ſunt francorũ celebranda inſignia regũ
Quę demiſſa polo ſuſtinet alma fides.

Ro. Gaguinus

S. Denis

S. Remy

Eourgoigne

Normandie

Guyeñe

Champaigne

Thoulouze

Flandres

Heraldic title page printed by Thielmann Kerver/PARIS 1500

· 227 ·

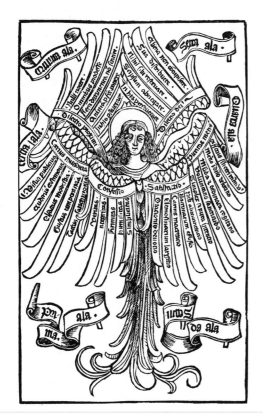

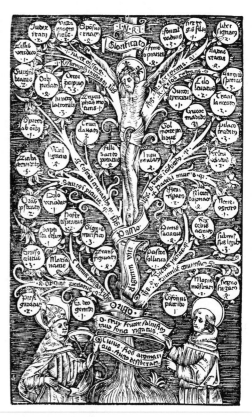

Religious diagrams by Jacob de Leucho / VENICE 1504

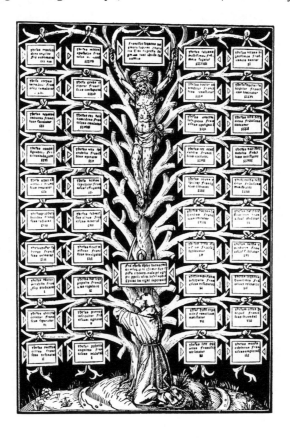

Religious diagram by Gotardo da Ponte / VENICE 1510

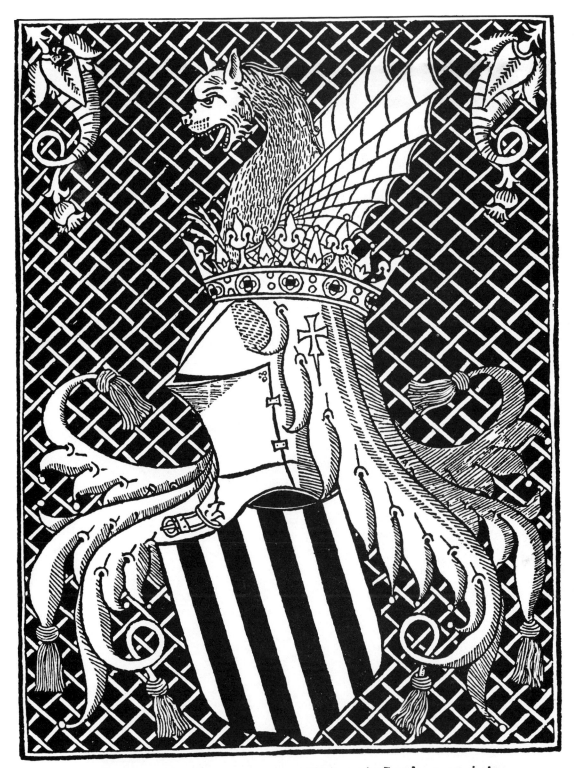

 Ureum opus regalium priuilegiorum ciuita tis et regni Ualentie cum historia cristianissi mi Regis Jacobi ipsius primi aquistatoris

*Heraldic title page printed by Diego de Gumiel/*VALENCIA 1515

Reformacion der bayrischn Lanndrecht nach Cristj vnsers Hailmachers geburde Im fünfftzehenhundert vnnd Achtzehendm Jar aufgericht·

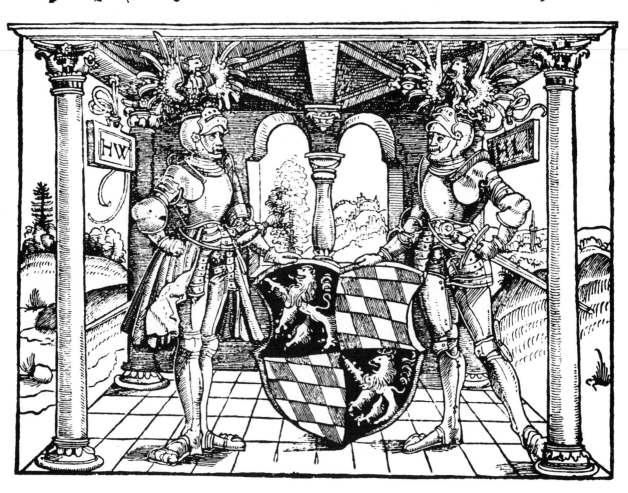

*Heraldic title page by Casper Clofigl/*MUNICH 1518

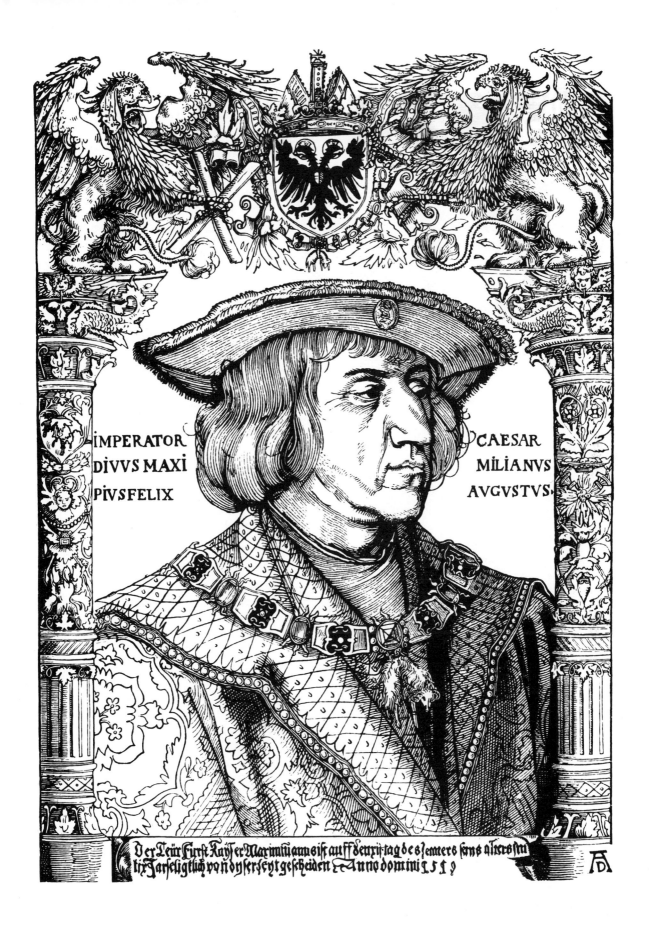

IMPERATOR
DIVVS MAXI
PIVSFELIX

CAESAR
MILIANVS
AVGVSTVS.

Emperor Maximilian I by Albrecht Dürer / NUREMBERG 1519

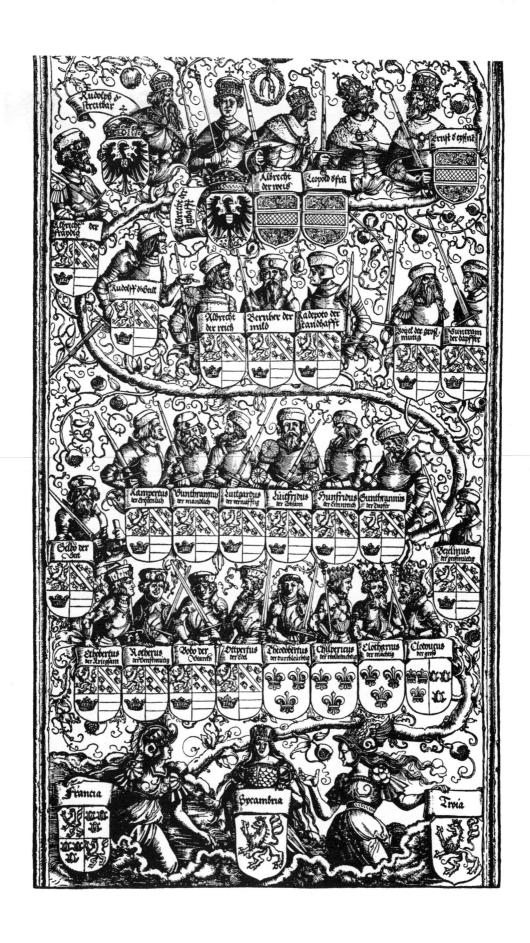

Pedigree of Maximilian I by Albrecht Dürer / NUREMBERG 1515–1519

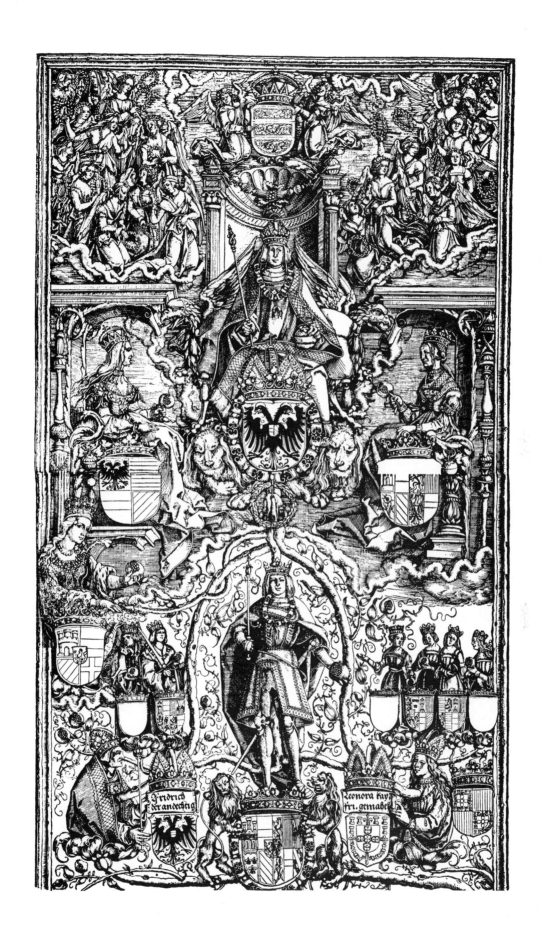

Pedigree of Maximilian I by Albrecht Dürer / NUREMBERG 1515–1519

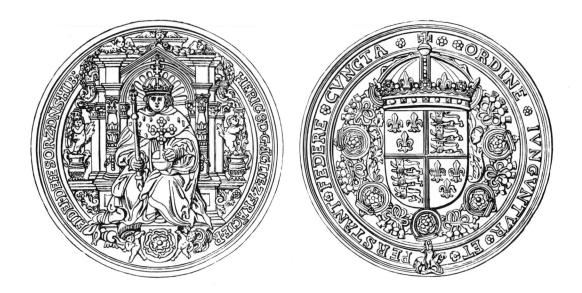

The great seal and counter seal / ENGLAND 1527

Cartouches by Donato Aelio / VENICE 1532

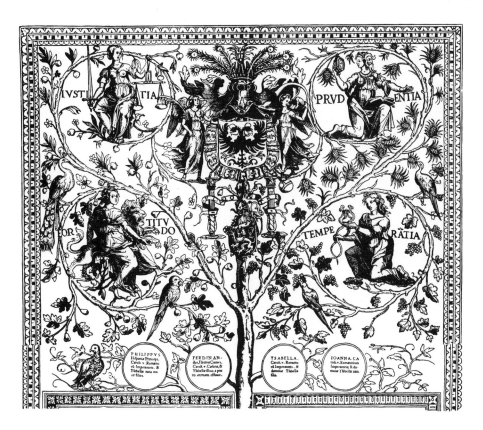

Family tree of Ferdinand of Austria by Robert Peril / AMSTERDAM 1540

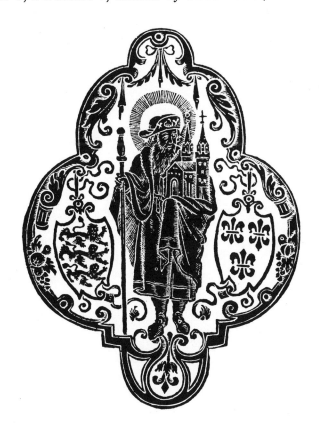

Cartouche "Saint Sebaldus" / NUREMBERG 1540

· 235 ·

Map cartouche by Lafreri/ROME 1546

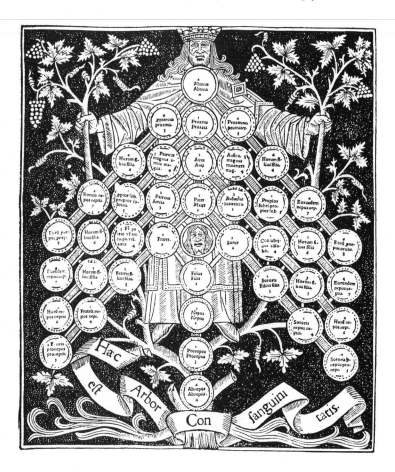

Religious diagram by Hugo à Porta/LYONS 1559

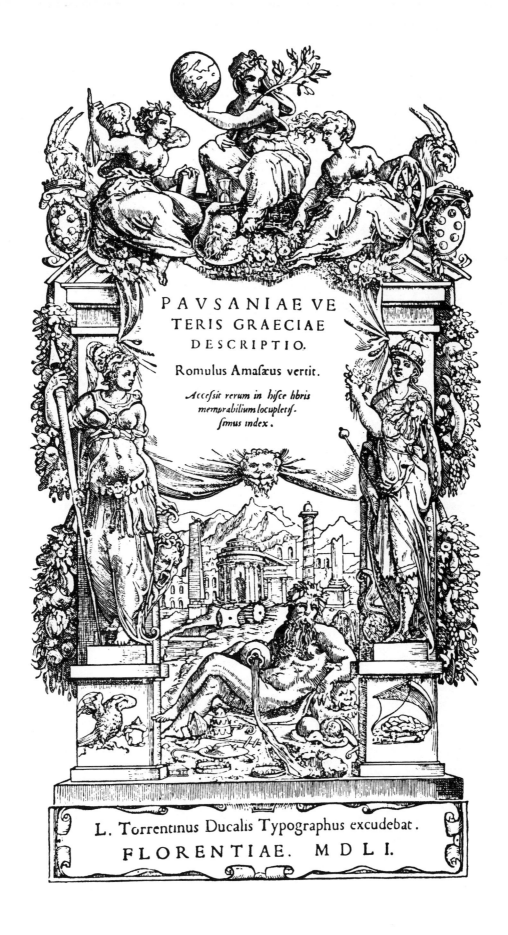

PAVSANIAE VE
TERIS GRAECIAE
DESCRIPTIO.

Romulus Amaſæus vertit.

Accefsit rerum in hifce libris
memprabilium locupletiſ-
ſimus index.

L. Torrentinus Ducalis Typographus excudebat.
FLORENTIAE. MDLI.

Allegoric title page printed by Lorenzo Torrentino / FLORENCE 1551

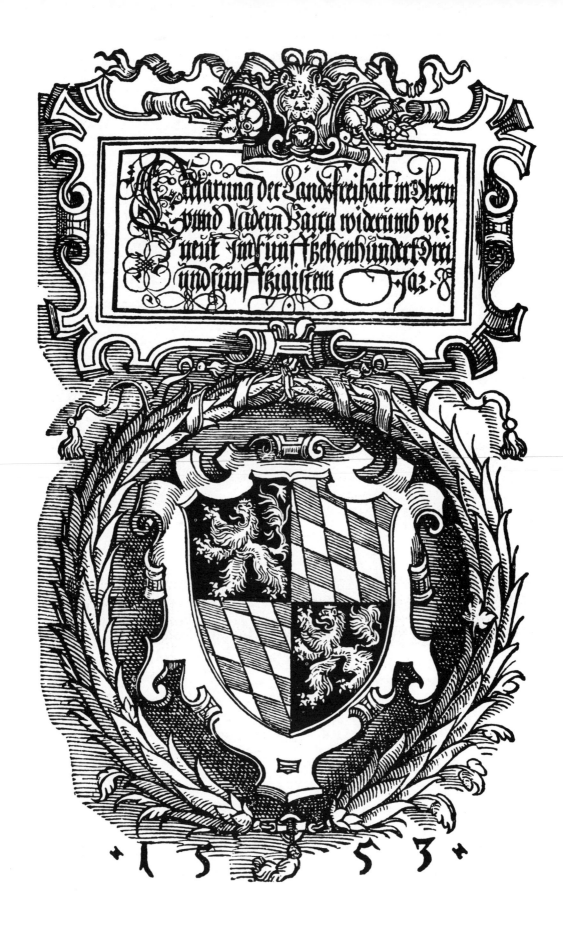

Heraldic title page/INGOLSTADT 1553

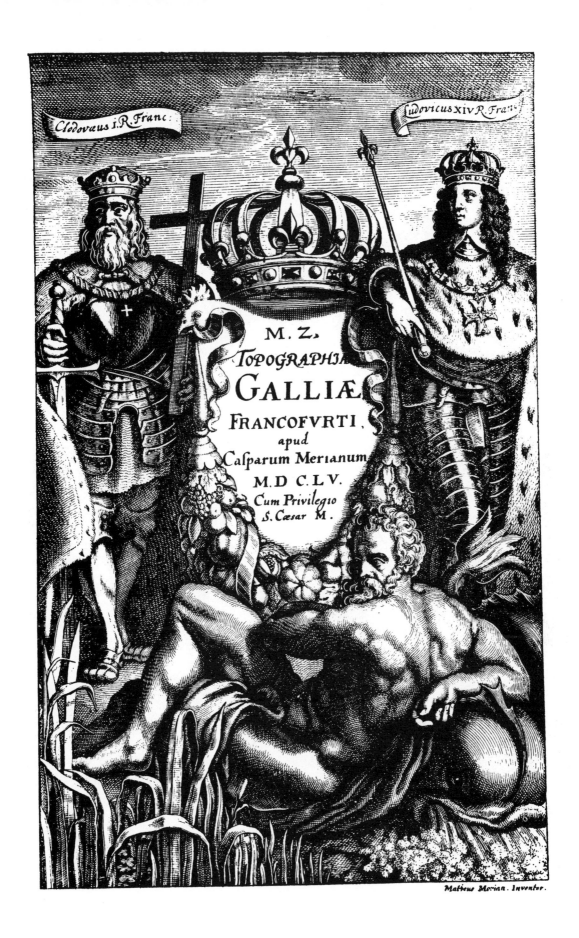

Allegoric title page by Matheus Merian/BASEL 1555

TAR'
TARIAE
SIVE MAG
NI CHAMI
REGNI
tÿpus

BVRGVN
DIAE IN
FERIORIS,
QVÆ DVCA
TVS NOMI
NE CENSE
TVR, DES.
1584.

CVM PRIVILEGIO IM'
PERIALI ET BELGICO
AD DECENNIVM

BAVARIAE,
OLIM VIN'
DELICIAE,
DELINEATI
ONIS COM
PENDIVM
EX tabula Philippi
Apiani Math

Map cartouches by Abraham Ortelius / ANTWERP 1570–1584

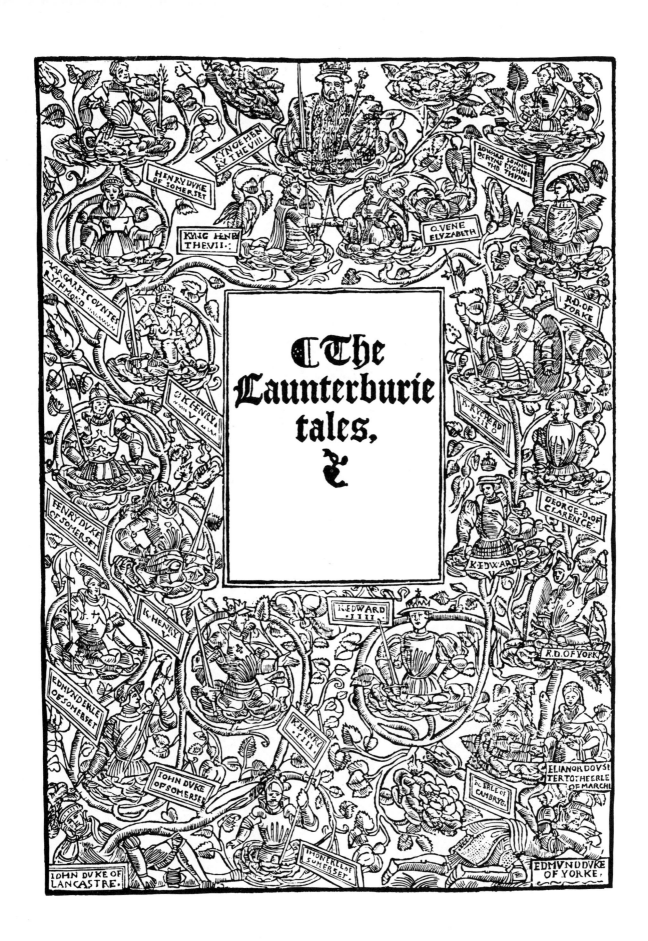

The Caunterburie tales,

Pedigree of King Henry VIII / LONDON 1561

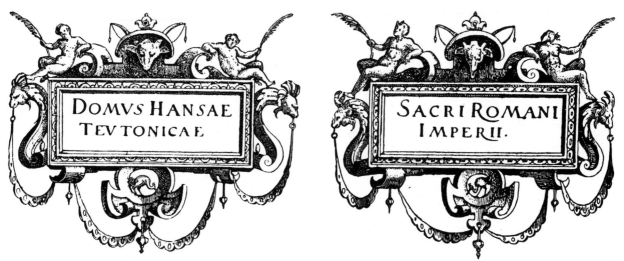

Cartouches by F. de Wit / ANTWERP 1568

Sigil of the University of Oxford / 16TH CENTURY

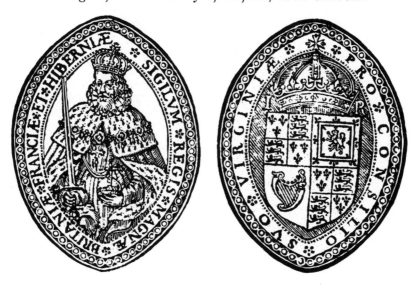

Seal and counter seal of the Kings Council / COLONY OF VIRGINIA 1606

Book stamp of Jacopo Bocampagni,
Duke of Sora / 1612

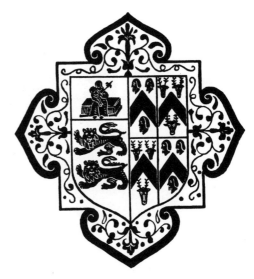

Book stamp of John Williams,
Bishop of Lincoln / 1642–1650

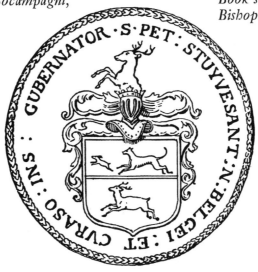

Sigil of Governor Peter Stuyvesant / NEW NETHERLAND 1647–1664

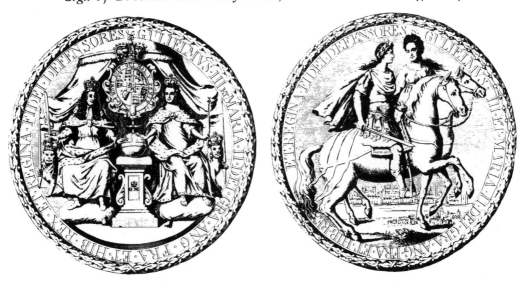

The great seal of King William III and Queen Mary / ENGLAND 1689–1695

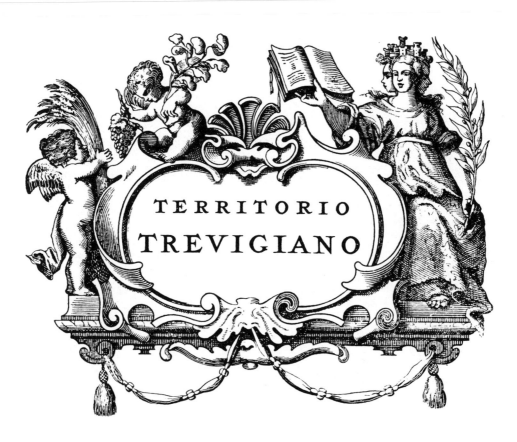

Map cartouches/ITALY 17TH CENTURY

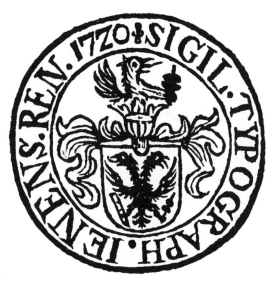

Sigil of the Printers Guild / JENA 1720

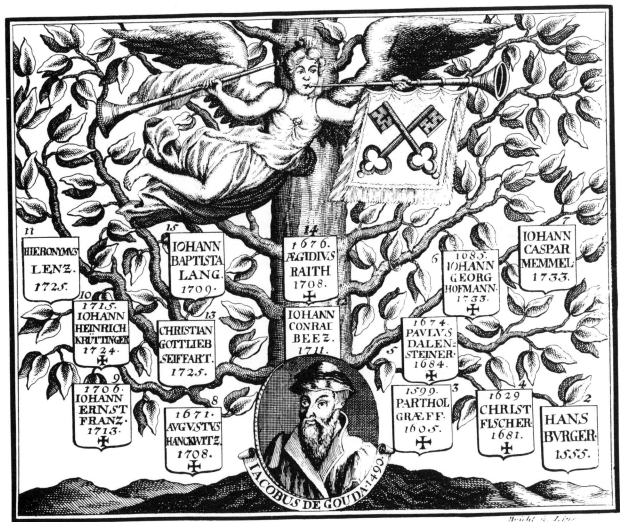

Diagram of the Printers Guild / REGENSBURG 1740

Book stamp of Baptist Noel,
Earl of Gainsborough / 1714

Book stamp of Hugh Boscawen,
Viscount Falmouth / 1715

Book stamp of Pope Pius VI / ROME 1775–1799

BIBLIOGRAPHY

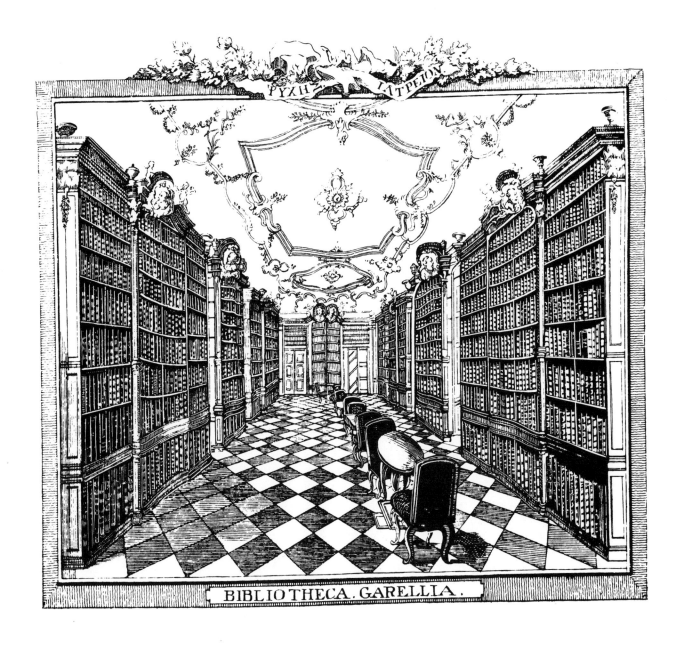

BIBLIOTHECA. GARELLIA.

The K. K. Garellian Public Library at the Theresiano in Vienna / 1780

BIBLIOGRAPHY

[The works indicated by an asterisk have been reprinted by Dover Publications.]

PRINTING AND TYPOGRAPHY

ALVIN, M. *Les Commencements de la gravure aux Pays-Bas.* Bruxelles, 1857.

AMES, JOSEPH. *Typographical antiquities or the history of printing in England, Scotland and Ireland.* London, 1810–1819, W. Miller.

ANDREÄISCHE BUCHHANDLUNG. *Probeblätter.* Frankfurt a.M., 1838.

AUDIN, MARIUS. *Histoire de l'Imprimerie.* Paris, 1929, Henri Jonquières.

———. *Le livre, son illustration, sa décoration.* Paris, 1926, C. Crès & Cie.

———. *Les livrets typographiques des fonderies françaises créées avant 1800.* Paris, 1933, Pégasus.

AUER, ALOIS. *Typenschau des gesammten Erdkreises.* Wien, 1844, Hof- & Staatsdruckerei.

BAUER, KONRAD F. *Aventur und Kunst.* Frankfurt a.M., 1940, Bauersche Giesserei.

*BEARDSLEY, AUBREY VINCENT. *The early and the later work of . . .* London, 1899–1912, John Lane.

BEYERHAUS, A. *Schriftproben.* Berlin, 1840.

BLADES, WILLIAM. *The Pentateuch of Printing.* Chicago, 1891, McClurg & Co.

BLISS, DOUGLAS PERCY. *A History of Wood Engraving.* London, 1928, Dent & Sons.

BODONI, GIAMBATTISTA. *Manuale Tipografico.* Parma, 1818.

BROWN, HORATIO (ROBERT FORBES). *The Venetian Printing Press.* New York, 1891, G. P. Putnam's Sons.

BRUN, (HENRI) MARCELIN AIMÉ. *Manuel pratique de la Typographie Française.* Paris, 1825, Firmin Didot.

BÜCHLER, EDWARD. *Die Anfänge des Buchdruckes in der Schweiz.* Bern, 1930, Schweizerisches Gutenbergmuseum Bibl. No. 2.

CHATTO, WILLIAM ANDREW. *A Treatise of Wood-Engraving.* London, 1839, Knight & Co.

CLAUDIN, ANATOLE. *Histoire de l'Imprimerie en France au XVe et XVIe Siècle.* Paris, 1900–1914, Imprimerie Nationale.

CONWAY, W. C. *The woodcutters of the Netherlands in the 15th century.* Cambridge, 1884.

CRANE, WALTER. *The decorative illustration of books.* London, 1896, G. Bell & Sons.

DENIS, MICHAEL. *Die Merkwürdigkeiten der k.k.garellischen öffentlichen Bibliothek am Thersiano.* Wien, 1780, Augustin Bernardi.

DE VINNE, THEODORE LOW. *The Invention of Printing.* New York, 1876, Francis Hart & Co.

———. *Titlepages as seen by a printer.* New York, 1901, Grolier Club.

DIDOT, AMBROISE FIRMIN. *Catalogue illustré des dessins et estampes.* Paris, 1877.

———. *Essai typographique et bibliographique de l'histoire de la gravure sur bois.* Paris, 1863.

DODGSON, CAMPBELL. *Catalogue of Early German and Flemish Woodcuts in the British Museum.* London, 1903–1911, Longmans & Co.

DUFF, EDWARD GORDON. *Early English Printing.* London, 1896, Kegan Paul, Trench, Trübner & Co.

DUPORTAL, JEANNE. *Études sur les livres a figures édités en France de 1601–1660.* Paris, 1914, Honoré Champion.

ENGEL, JOHANN JOSEPH. *Specimen Characterum Latinorum, Hungaricorum et Bosniaco-Croaticorum.* Pecs-Fünfkirchen, 1773.

ENSCHEDÉ, ADRIAN JUSTUS. *Spécimen de caractères typographiques anciens.* Haarlem, 1867, J. Enschedé en Zonen.

ENSCHEDÉ, CHARLES. *Fonderies de caractères et leur matériel dans les Pays-Bas du XVe au XIXe siècle.* Haarlem, 1908, De Erven F. Bohn.

ENSCHEDÉ, J. *Proof van Letteren.* Haarlem, 1768.

ERNESTI, JOHANN HEINRICH GOTTFRIED. *Die Wol-eingerichtete Buchdruckerey.* Nürnberg, 1721, Johann Andrea Endters Erben.

ESTEVES DOS SANTOS, RAUL. *A arte negra.* Lisboa, 1941, Editorial Império.

FAGAN, LOUIS. *History of engraving in England.* London, 1893.

FALKENSTEIN, KARL CONSTANTIN. *Geschichte der Buchdruckerkunst in ihrer Entstehung und Ausbildung.* Leipzig, 1840, B. G. Teubner.

FARMER, LITTLE & Co. *Specimen book of printing Types.* New York, 1862.

————. *Specimens of printing Types, Ornaments and Borders.* New York, 1873.

FAULMANN, KARL. *Illustrierte Geschichte der Buchdruckerkunst.* Wien, 1882, A. Hartleben.

FOURNIER, JR., PIERRE-SIMON. *Manuel Typographique.* Paris, 1764–1766, J. Barbou.

————. *Modéles des Caractères de l'Imprimerie.* Paris, 1742.

FRÄNGLER, WILHELM. *Altdeutsches Bilderbuch.* Leipzig, 1930, H. Stubenrauch.

FRIEDLÄNDER, MAX J. *Holzschnitte von Hans Weiditz.* Berlin, 1922, Verein f. Kunstwissenschaften.

GERLACH, MARTIN. *Das alte Buch und seine Ausstattung.* Wien-Leipzig, 1915, Die Quelle No. 13.

GILLÉ, JOSEPH. *Épreuves des Caractères.* Paris, 1773.

GOETZE, ALFRED AUGUST WOLDEMAR. *Die hochdeutschen Drucker der Reformationszeit.* Strassburg, 1905, Karl J. Trübner.

GOLLOB, HEDWIG. *Der Wiener Holzschnitt von 1490–1550.* Wien, 1926, Krystal Verlag.

GRAUTOFF, OTTO. *Moderne Buchkunst in Deutschland.* Leipzig, 1901, Hermann Seemann Nachf.

GRESS, EDMUND GEIGER. *The Art and Practise of Typography.* New York, 1910, Oswald Publishing Co.

GRÜNBERG, JEANNOT. *Iwan Fedorow.* Leipzig, 1911, Archiv für Buchgewerbe.

GUTENBERG FESTSCHRIFT. Mainz, 1925, Gutenberg Gesellschaft.

HAEBLER, KONRAD. *Der Deutsche Drucker des XV. Jahrhunderts im Auslande.* München, 1924, Jacques Rosenthal.

————. *Geschichte der spanischen Frühdrucke in Stammbäumen.* Leipzig, 1923, K. W. Hiersemann.

————. *Der italienische Wiegendruck in Original-Typenbeispielen.* München, 1927, Weiss & Co.

HAUSENSTEIN, WILHELM. *Rokoko.* München, 1924, R. Piper & Co.

HECKETHORN, CHARLES WILLIAM. *The Printers of Basle in the XV and XVI Centuries.* London, 1897, Unwin Bros.

HEITZ, PAUL. *Originalabdrücke von Formschneiderarbeiten des XVI., XVII. und XVIII. Jahrhunderts.* Strassburg, 1892–1899, Heitz & Mündel.

HELLER, JOSEPH. *Geschichte der Holzschneidekunst.* Bamberg, 1823, C. F. Kunz.

*HIND, ARTHUR MAYGER. *A history of engraving and etching.* London, 1908, Constable & Co.

*————. *A history of woodcut.* London, 1935, Constable & Co.

HIRTH, GEORGE and MUTHER, RICHARD. *Meisterholzschnitte aus vier Jahrhunderten.* München, 1893.

HOLTROP, JAN WILLEM. *Monuments typographiques des Pays-Bas.* La Haye, 1868, M. Nijhoff.

HUMPHREYS, HENRY NOEL. *A History of the Art of Printing.* London, 1867, Bernard Quaritch.

IMPRIMERIE NATIONALE. *Specimen des caractères, vignettes, armes, trophées et fleurons de l'Imprimerie Royale.* Paris, 1819.

JANSEN, HENRIK. *Essai sur l'Origine de la Gravure en Bois et en Taille-douce.* Paris, 1808, F. Schoell.

JOHNSON, ALFRED FORBES. *One hundred Title-pages 1500–1800.* London, 1928, John Lane.

KAPPENS, JOHANN ERHARD. *Die so nöthige und nützliche Buchdruckerkunst und Schriftgiesserey.* Leipzig, 1740–1745, Christian Friedrich Gessner.

KEHRLI, J. OTTO. *Typographie und Kunst.* Bern, 1945, Schweizerisches Gutenbergmuseum.

KRISTELLER, PAUL. *Early Florentine Woodcuts.* London, 1897, Kegan Paul, Trench, Trübner & Co.

————. *Kupferstich und Holzschnitt in vier Jahrhunderten.* Berlin, 1922, Bruno Cassierer.

————. *Die Lombardische Graphik der Renaissance.* Berlin, 1913, Bruno Cassierer.

*KURTH, WILLI. *Albrecht Dürers sämtliche Holzschnitte.* München, 1927, Holbein Verlag.

KUTSCHMANN, TH. *Geschichte der deutschen Illustration.* Goslar, 1899, F. Jäger.

LABITTE, ADOLPHE. *Gravure sur bois tirées des livres français du XVe siècle.* Paris, 1868.

LACROIX, PAUL and FOURNIER, EDUARD. *Histoire de l'imprimerie et des arts et professions.* Paris, 1852, Ferdinand Seré.

LEJARD, ANDRÉ. *The art of the French Book.* Paris, 1947, Du Chêne.

LIPPMANN, FRIEDRICH. *Italian Wood engravings in the Fifteenth Century.* London, 1888, Bernard Quaritch.

———— and DOHME, R. *Druckschriften des XV. bis XVIII. Jahrhunderts in getreuen Nachbildungen.* Berlin, 1884–1887, Reichsdruckerei.

LOUISY, M. P. *Le Livre et les Arts qui s'y rattachent.* Paris, 1887, Firmin Didot.

LOYSON & BRIQUET. *Épreuve des Caractères.* Paris, 1751.

LUCE, LOUIS RENÉ. *Épreuve du premier alphabet droit et penché, ornée de quadres et de cartouches.* Paris, 1740, Imprimerie Royale.

———. *Essai d'une Nouvelle Typographie.* Paris, 1771, J. Barbou.

LUCKOMBE, PHILIP. *The History and Art of Printing.* London, 1771, J. Johnson.

LÜTZOW, C. VON. *Geschichte des deutschen Kupferstichs und Holzschnitts.* Berlin, 1891.

MacKELLAR, SMITH & JORDAN. *Specimens of Printing Types.* Philadelphia, 1873.

McMURTRIE, DOUGLAS CRAWFORD. *The golden book.* Chicago, 1927, Pascal Covici.

MANTEUFFEL, K. ZOEGE VON. *Der deutsche Kupferstich.* München, 1922, Hugo Schmidt.

MARTIN, HENRY MARIE RADEGONDE. *Le Livre Français des Origines à la fin du Second Empire.* Paris-Bruxelles, 1924, G. van Oest.

MASSÉNA, VICTOR (PRINCE DE ESSLING). *Les livres à figures vénetiens de la fin du XVe siècle et du commençement du XVIe.* Paris, 1889–1890, Henri Leclerc.

MAYER, ANTON. *Wiens Buchdruckergeschichte.* Wien, 1883–1887, W. Frick.

MEYNELL, SIR FRANCIS. *English printed books.* London, 1946, Collins.

——— and MORISON, STANLEY. *Causerie numero neuf où l'on parle du fleuron en typographie.* London, 192?.

MORISON, STANLEY. *The Art of the Printer.* London, 1925, Ernest Benn.

———. *Four centuries of fine printing.* New York, 1949, Farrar & Straus.

——— and JACKSON, HOLBROOK. *A brief survey of printing history and practice.* London, 1923, The Fleuron.

MUTHER, RICHARD. *Die deutsche Buchillustration der Gothik und Frührenaissance.* München, 1884, George Hirth.

NIJHOFF, WOUTER. *L'art typographique dans les Pays-Bas.* La Haye, 1926.

ONGANIA, FERDINANDO. *L'arte della stampa nel rinascimento italiano.* Venezia, 1894.

———. *Early Venetian Printing.* Venezia, 1895.

PAPILLON, JEAN BAPTISTE MICHEL. *Traité historique et pratique de la gravure de bois.* Paris, 1766, P. G. Simon.

PFLUGK-HARTUNG, JULIUS ALBERT GEORG VON. *Rahmen deutscher Buchtitel im XVI. Jahrhundert.* Stuttgart, 1909, Fritz Lehmann.

PHILIPPE, JULES PIERRE JOSEPH. *Origine de l'Imprimerie à Paris.* Paris, 1885, Charavay Frères.

POLLARD, ALFRED WILLIAM. *Early illustrated books.* London, 1893, Kegan Paul, Trench, Trübner & Co.

———. *Fine Books.* London, 1912, The Connoisseur.

REDGRAVE, GILBERT RICHARD. *Erhard Ratdolt and his work at Venice.* London, 1894, Bibliographical Society Monograph No. 1.

REED, TALBOT BAINES. *A History of the Old English Letter Foundries.* London, 1887, Elliot Stock.

REICHSDRUCKEREI. *Alphabete und Schriftzeichen des Morgen- und Abendlandes.* Berlin, 1924.

———. *Druckschriften des 15. bis 18. Jahrhunderts.* Berlin, 1884–1887.

———. *Randeinfassungen, Initialen und Zierleisten für den Buchdruck.* Berlin, 1884–1888.

REINER, IMRE. *Modern and Historical Typography.* St. Gallen, 1944–1950, Zollikofer & Co.

REMIZOV, ALEKSEI MICHAILOVICH. *Ivan Fedorov.* Paris, 1935, Papyrus.

RENOUVIER, JULES. *Histoire de la gravure dans les Pays-Bas.* Bruxelles, 1860.

RINGWALT, J. LUTHER. *American Encyclopaedia of Printing.* Philadelphia, 1871, J. B. Lippincott & Co.

RITCHEL VON HARTENBACH, JR., J. *Proben der Polytypen.* Erfurt, 1836.

SCHMIDT, R. W. *Die Technik in der Kunst.* Stuttgart, 1922, Dieck & Co.

SCHOEPFLIN, JOHANN DANIEL. *Vindiciae Typographicae.* Strassburg, 1760, Johann Gottfried Bauer.

SCHOTTENLOHER, KARL. *Das alte Buch.* Berlin, 1919, Schmidt & Co.

SCHRAMM, A. *Der Bilderschmuck der Frühdrucke.* Leipzig, 1920–1923, Deutsches Museum für Buch und Schrift.

SIMON, HOWARD. *500 Years of Art in Illustration.* Cleveland-New York, 1942, World Publishing.

STEINHAUSEN, GEORG. *Der Kaufmann in der deutschen Vergangenheit.* Leipzig, 1899, Eugen Diederichs.

STUDIO, THE. *The Art of the Book.* London, 1914.

THIBAUDEAU, F. *La Lettre d'Imprimerie.* Paris, 1921, Bureau de l'Édition.

THIBOUST, CLAUDE LOUIS. *Typographiae Excellentia.* Paris, 1754.

THOMAS, ISAIAH. *The History of Printing in America.* Boston-Worcester, 1810, Isaac Sturtevant.

———. *A Specimen of Printing Types.* Boston-Worcester, 1785.

*TORY, GEOFROY. *Champ Fleury.* Paris, 1529.

TRATTNER, JOHANN THOMAS. *Abdruck von denjenigen Röslein und Zierrathen welche sich in der K. K. Hofschriftgiesserey dermalen befinden.* Wien, 1760.

UPDIKE, DANIEL BERKELEY. *Printing Types, their history, forms and use.* Cambridge, Mass., 1922, Harvard University Press.

VALLANCE, AYMER. *The art of William Morris.* London, 1897, G. Bell & Sons.

VOULLIÉME, ERNST HERMANN. *Die deutschen Drucker des 15. Jahrhunderts.* Berlin, 1922, Reichsdruckerei.

WATSON, JAMES. *The History of the Art of Printing.* Edinburgh, 1713.

WEIGEL, THEODOR O. and ZESTERMANN, AUGUST CH. *Die Anfänge der Druckerkunst in Bild und Schrift.* Leipzig, 1866.

WEIGL, RUDOLPH. *Jost Amman.* Leipzig, 1854.

WHITE, JOHN T. *Type, Flowers and Ornaments.* New York, 1843.

WINKLE, CORNELIUS VAN. *The printer's guide.* New York, 1818.

WOLFFGER, GEORG. *New-Auffgesetztes Format-Büchlein.* Graz, 1670.

WORRINGER, WILHELM. *Die Altdeutsche Buchillustration.* München, 1921, R. Piper & Co.

WUTTKE, HEINRICH. *Geschichte der Schrift und des Schrifttums.* Leipzig, 1872, Ernst Fleischer.

CALLIGRAPHY AND LETTERS

ANDRADE DE FIGUEIREDO, MÁNOEL. *Nova escola para eprender a ler, escrever e contar.* Lisboa, 1722.

ASTLE, THOMAS. *The Origin and Progress of Writing.* London, 1803.

BAURENFEIND, MICHAEL. *Vollkommene Wieder-Herstellung der Schreib-Künst.* Nürnberg, 1716, Christoph Weigel.

BEAUGRAND, DE. *Poecilographie.* Paris, 1601.

BERGER, PHILIPPE. *Histoire de l'écriture dans l'antiquité.* Paris, 1891, Imprimerie Nationale.

BROWN, FRAN CHOUTEAU. *Letters and Lettering.* Boston, 1902, Bates & Guild.

BRY, JOHANN THEODOR and JOHANN ISRAEL DE. *Alphabeta et Characteres.* Frankfurt a.M. 1596.

BULLINGER, EDWIN WILSON. Alphabets, Monograms, Initials, Crests. New York, 1887.

CAMPOS FERREIRA LIMA, HENRIQUE DE. *Subsidio para um dicionário bio-bibliográfico dos caligrafos portugueses.* Lisboa, 1923, Biblioteca National.

CLARK, JOHN. *Writing improv'd.* London, 1714.

CLODD, EDWARD. *The Story of the Alphabet.* New York, 1900, D. Appleton & Co.

COCKER, EDWARD. *Multum in Parvo, or The Pen's Gallantry.* London, 1672.

———. *Penna Volans, or The young mans Accomplishment.* London, 1661.

———. *The Pen's Transcendencie, or fair Writing's Labyrinth.* London, 1657.

COTARELO Y MORI, EMILIO. *Diccionario biográfico y bibliográfico de caligrafos españoles.* Madrid, 1914–1916.

CRESCI, GIOVANNI FRANCESCO. *Il perfetto Scrittore.* Roma, 1569.

D'AVENNES, PRISSE. *L'Art arabe d'après les monuments du Kaire.* Paris, 1877.

DAY, LEWIS FORMAN. *Alphabets Old and New.* London, 1898, B. T. Batsford.

———. *Lettering in Ornament.* London, 1902, B. T. Batsford.

———. *Penmanship of the 16, 17 and 18 Centuries.* London, 1911, B. T. Batsford.

DEAN, HENRY. *Analytical guide to the art of penmanship.* New York, 1808, Hopkins & Bayard.

DEGERING, HERMANN. *Die Schrift.* Berlin, 1929, Ernst Wasmuth.

DELAMOTTE, FREEMAN GAGE. *The book of ornamental alphabets, ancient and medieval.* London, 1860.

DEMENGEOT, CHARLES. *Recueil complet de chiffres modernes à deux lettres.* Paris, 1864, A. Calavas.

DENIS, FERDINAND. *Histoire de l'Ornementation des Manuscrits.* Paris, 1880. E. Rouveyre.

DIRINGER, DAVID. *The Alphabet.* New York, 1948, Philosophical Library.

DRISCOLL, LUCY CATHERINE and TODA, KENJI. *Chinese Calligraphy.* Chicago, 1935, University of Chicago.

FAIRBANK, ALFRED. *A Book of Script.* Harmondsworth, 1949, Penguin No. 48.

———. *A Handwriting Manual.* Leicester, 1932, Dryad Press.

FAULMANN, KARL. *Das Buch der Schrift.* Wien, 1878, K.&K. Hof- & Staatsdruckerei.

———. *Illustrierte Geschichte der Schrift.* Wien, 1880, A. Hartleben.

FRAUBERGER, H. *Verzierte hebräische Schrift und jüdischer Buchschmuck.* Frankfurt a.M., 1909, Ges. zur Erforschung jüdischer Kunstdenkmäler.

FREIMANN, ARON. *Die hebräischen Incunabeln der Druckereien in Spanien und Portugal.* Mainz, 1925, Gutenberggesellschaft Festschrift.

———. *Thesaurus typographiae Hebraicae saeculi XV.* Berlin, 1924, Marx & Co.

GARDTHAUSEN, VIKTOR EMIL. *Das alte Monogramm.* Leipzig, 1924, K. W. Hiersemann.

GETHING, RICHARD. *Calligraphotechnia or The Art of faire writing.* London, 1619.

GRAY, NICOLETTE. *Nineteenth Century ornamented Letters and Title Pages.* London, 1938, Faber & Faber.

HEAL, SIR AMBROSE. *The English Writing Masters and their Copy Books.* London, 1931, Cambridge University Press.

HEITZ, PAUL. *Der Initialenschmuck in den elsässischen Drucken des XV. und XVI. Jahrhunderts.* Strassburg, 1894, Heitz & Mündel.

HONDIO, JUDOCO. *Theatrum artis scribendi.* Amsterdam, 1614.

HRACHOWINA, CARL. *Initialen, Alphabete und Randleisten verschiedener Kunstepochen.* Wien, 1883, Carl Graeser.

HUART, CLÉMENT. *Les Calligraphes et les Miniaturists de l'Orient Musulman.* Paris, 1908, Ernest Leroux.

HUMPHREYS, HENRY NOEL. *The origin and progress of the Art of Writing.* London, 1853.

JACOBELLN VOM NEWMARCK, JACOB. *Fundament Buch.* Strassburg, 1579, Bernhard Jobin.

JESSEN, PETER. *Meister der Schreibkunst aus drei Jahrhunderten.* Stuttgart, 1923, Julius Hoffmann.

JOHNSON, ALFRED FORBES. *Decorative initial letters.* London, 1931, Cresset Press.

JOHNSTON, EDWARD. *Writing, Illuminating and Lettering.* New York, 1906, MacMillan.

JÜDISCHE VOLKSKUNDE, JAHRBUCH FUR. Berlin, 1898–1929, Benjamin Harz.

KHEIRI, SATTAR. *Indische Miniaturen der Islamitischen Zeit.* Berlin, 1921, Orbis Pictus No. 6.

KILIAN, LUCAS. *Newes A B C Büchlein.* Augsburg, 1627.

KOCH, RUDOLF. *Klassische Schriften nach Zeichnungen von Gutenberg, Dürer, Morris, König, Hupp, Eckmann, Behrens u.a.* Dresden, 1908, Kühtmann.

KRUITWAGEN, BONAVENTURA. *Laat - Middeleeuwsche paleografica, paleotypica, liturgica, kalendalia, grammaticalia.* s'Gravenhage, 1942, M. Nijhoff.

KÜHNEL, ERNST. *Islamitische Kleinkunst.* Berlin, 1925, Schmidt & Co.

LAMPRECHT, KARL GOTTHARD. *Initialornamentik des 8. bis 13. Jahrhunderts.* Leipzig, 1882, Alphons Dürr.

LARISCH, RUDOLF VON. *Beispiele künstlerischer Schrift aus vergangenen Jahrhunderten.* Wien, 1910, Staatsdruckerei.

LEAF, REUBEN. *Hebrew Alphabets.* New York, 1950.

LEHMANN-HAUPT, HELLMUT. *Calligrapher's paradise.* New York, 1942, A.D. Feb.-Mar.
———. *Initials from French Incunabula.* New York, 1948, Aldus.

LÖFFLER, KARL. *Romantische Zierbuchstaben und ihre Vorläufer.* Stuttgart, 1927, Hugo Matthaes.

MASON, WILLIAM ALBERT. *A history of the art of writing.* New York, 1920, MacMillan Co.

MASSEY, W. *The Origin and Progress of Letters.* London, 1763, J. Johnson.

MERKEN, JOHANN. *Liber artificiosus alphabeti majoris.* Mühlheim 1782–1785, J. C. Eyrich.

MOÉ, ÉMILE-A. VAN. *The decorated Letter.* Paris, 1950, Édition du Chêne.

MONUMENTA PALAEGRAPHICA. *Denkmäler der Schreibkunst des Mittelalters.* München, 1902–1917, F. Bruckmann.

MOORHOUSE, A. C. *Writing and the Alphabet.* London, 1946, Cobbett Press.

MÜLLER, DAVID HEINRICH and SCHLOSSER, JULIUS VON. *Die Haggadah von Sarajevo.* Wien, 1898, A. Hölder.

MUNCH, GOTTLIEB S. *Ordnung der Schrift.* Dresden, 1744.

MUNSCH, RENÉ H. *L'écriture et son dessin.* Paris, 1948, Eyrolles.

NEFF, CASPAR. *Thesaurarium artis scriptoriae.* Köln, 1549, Kaspar Vopelius.

*NESBITT, ALEXANDER. *Lettering, the History and Technique of Lettering as Design.* New York, 1950, Prentice-Hall.

NIEDLING, A. *Bücher-Ornamentik in Miniaturen, Initialen und Alphabeten im IX. bis XVIII. Jahrhundert.* Weimar, 1895, B. F. Voigt.

OGG, OSCAR. *The 26 Letters.* New York, 1948, Crowell.

PASERO, CARLO. *Libri di calligrafia.* Firenze, 1933, Bibliofilia.

PERICCIOLI. *Il terzo libro della cancellaresche corsive.* Siena, 1619.

PETZENDORFER, L. *Schriften Atlas.* Stuttgart, 1889, J. Hoffmann.

PISANI, GIOBATTISTA. *Tratteggiato da Penna.* Genova, 1640.

POLLARD, ALFRED W. *Some pictorial and heraldic initials.* London, 1897, Bibliographica.

POLYGRAPHIA CURIOSA. *The Book of Initial Letters and Ancient Alphabets for ornamental purposes.* London, 1844.

PREISLER, JOHANN DANIEL. *Orthographia.* Nürenberg, 1700, Johann Christoph Weigl.

SCHULZ, PHILIPP WALTER. *Die persisch-islamitische Miniaturmalerei.* Leipzig, 1914, K. W. Hiersemann.

*SCHWANDNER, JOHANN GEORG. *Dissertatio de Calligraphiae Nomenclatione Cultu, Praestantia, Utilitate.* Wien, 1756, Johann Leopold Kaliwoda.

SEDDON, JOHN. *The Pen-mans Paradis both Pleasant and Profitable.* London, 1695, Wm. Court.

SHAW, HENRY. *Alphabets, Numerals and Devices of the Middle Ages.* London, 1845.

———. *Hand Book of Mediaeval Alphabets and Devices.* London, 1856, Henry George Bohn.

SILVESTRE, JOSEPH BALTHAZAR. *Alphabet Album.* Paris, 1843–1844.

———. *Paléographie Universelle.* Paris, 1839–1841, Firmin Didot Fréres.

SMITH, WILLIAM ANDERSON. *According to Cocker.* London, 1887, A. Gardner.

STANDARD, PAUL. *Calligraphy's Flowering, Decay and Restauration.* Chicago, 1947, Soc. of Typographic Arts.

STRANGE, EDWARD FAIRBROTHER. *Alphabets.* London, 1895, G. Bell & Sons.

———. *The early English Writing Masters.* London, 1897, Bibliographica.

———. *The writing books of the 16th century.* London, 1896, Bibliographical Soc. Trans.

STRICK, MARIA. *Tooneel der loflijcke Schrijfpen.* Delft, 1607.

TAGLIENTE, GIOVANNI ANTONIO. *La vera arte dello eccellento scrivere.* Venezia, 1524, Stephano da Sabio.

THOMPSON, SIR EDWARD MAUNDE. *Calligraphy in the Middle Ages.* London, 1897, Bibliographica.

TSCHICHOLD, JAN. *Geschichte der Schrift in Bildern.* Basel, 1941, Holbein Verlag.

———. *Schatzkammer der Schreibkunst.* Basel, 1945, Birkhäuser.

VELDE, JAN VAN DEN. *Spieghel der Schrijfkonste.* Rotterdam, 1605.

VENTURA DA SILVA, JOAQUIM JOSÉ. *Regas Methodicas para se aprendera escrever.* Lisboa, 1803.

VESPASIANO DE FERRARE, AMPHIAREO. *Opera nellaquale si insegna a scrivere.* Venezia, 1554.

VICENTINO, LUDOVICO. *Regolo da imparare scrivere.* Venezia, 1533, Nicolo Zoppino.

WEALE, JOHN. *Monograms, old architectural ornaments, sacred illustrations, borders and alphabets.* London, 1852, Standidge & Co.

WEISE, OSKAR. *Schrift und Buchwesen in alter und neuer Zeit.* Leipzig, 1903, B. G. Teubner.

WILLIAMS, HENRY SMITH. *Manuscripts, inscriptions and muniments Oriental, comprehending the History of the Art of writing.* London, 1902, Merrill & Baker.

YANG YU-HSUN. *La Calligraphie Chinoise depuis les Han.* Paris, 1935, Paul Geuther.

YCIAR, JUAN DE. *Arte subtilissima por la qual se esseña a escrivir perfectamente.* Zaragoza, 1550.

ORNAMENTS AND PATTERN BOOKS

BANGE, ERNST FRIEDRICH. *Peter Flötner.* Leipzig, 1926, Meister der Graphik No. 14.

BAUD-BOVY, DANIEL. *Schweizer Bauerkunst.* Zürich, 1926, Orell Füssli.

BERLINER, RUDOLF. *Ornamentale Vorlageblätter des 15. bis 18. Jahrhunderts.* Leipzig, 1925, Klinkhardt & Biermann.

BOSSERT, HELMUTH THEODOR. *Ornament in applied art.* New York, 1924, E. Weyhe.

BRISVILLE, HUGUES. *Diverses pieces de Serruriers, engraved by Jean Berain.* Paris, 1663, N. Longlois.

COLUMNA, FRANCISCO. *Hypnerotomachia Poliphili.* Venezia, 1499, Aldus Manutius.

CRANACH THE ELDER, LUCAS. *Dye zaigung des hochlobwirdigen hailigthums der Stifft kirchen aller hailigen.* Wittenburg, 1509.

CUNDALL, JOSEPH. *On ornamented art, applied to ancient and modern bookbinding.* London, 1848, Society of Arts.

DOLMETSCH, HEINRICH. *Ornamental Treasures.* Stuttgart, 1912, J. Hoffmann.

———. *Der Ornamentenschatz.* Stuttgart, 1887, J. Hoffmann.

FLÖTNER, PETER. *Maureskenbuch.* Zürich, 1546, Rudolph Wyssenbach.

FOILLET, IAQUES. *Nouveaux pourtraicts de Point coupé.* Montbeliard, 1598.

FRANCO, GIACOMO. *Nuova inventione de diverse mostre.* Venezia, 1596.

GLAZIER, RICHARD. *The Manual of historic Ornament.* London, 1899, B. T. Batsford.

GRANLUND, STEN and JESSEN, JARNO. *Peasant art in Sweden, Lapland and Iceland.* London, 1910, The Studio.

GRUNER, LUDWIG (LEWIS). *Die Dekorative Kunst.* Dresden, 1881, Bleyl & Kaemmerer.

———. *Specimens of Ornamental Art.* London, 1850, T. M'Lean.

HABERLAND, M. *Peasant Art in Austria and Hungary.* London, 1911, The Studio.

HAMLIN, ALFRED DWIGHT FOSTER. *History of Ornament.* New York, 1916, Century.

HIRTH, GEORG. *Formenschatz.* München-Leipzig.

————. *Kulturgeschichtliches Bilderbuch.* München-Leipzig.

JESSEN, PETER. *Meister des Ornamentstiches.* Berlin, 1923, Verlag für Kunstwissenschaften.

————. *Der Ornamentstich.* Berlin, 1920, Verlag für Kunstwissenschaften.

JONES, OWEN. *Grammar of Ornaments.* London, 1856, Day & Son.

LICHTWARCK, ALFRED. *Der Ornamentstich der Deutschen Frührenaissance.* Berlin, 1888, Weidemannsche Buchhandlung.

LOTZ, ARTHUR. *Bibliographie der Modelbücher.* Leipzig, 1933, K. W. Hiersemann.

MAROT, DANIEL. *Das Ornamentwerk des. . . .* Berlin, 1892, Ernst Wasmuth.

*MEYER, FRANZ SALES. *Handbuch der Ornamentik.* Leipzig, 1890, E. A. Seemann.

OPRESCU, G. *Peasant Art in Rumania.* London, 1929, The Studio.

OSTAVS, GIOVANNI. *La vera perfettione del disegno di varie sorti per punti i Ricami.* Venezia, 1567.

PAGAN, MATTHEO. *Giardinetto novo di punti tagliati.* Venezia, 1543.

PAGANINO, ALESSANDRO P. *Il burato libro de recami.* Venezia, 1518.

PELLEGRIN, FRANCESQUE. *Lafleur de la science de Pourtraicture.* Paris, 1530.

PUGIN, AUGUSTUS WELBY NORTHMORE. *A Glossary of Ecclesiastical Ornament.* London, 1844, Bernard Quaritch.

QUENTEL, PETER. *Eyn newe kunstlich moetdelboeck.* Cöllen, 1532.

RACINET, ALBERT CHARLES AUGUSTE. *L'Ornement polychrome.* Paris, 1885, Firmin Didot & Cie.

REYNARD, OVIDE. *Ornaments des Anciens Maîtres des XVe, XVIe, XVIIe et XVIII Siècles.* Paris. 1844, A. Lèvy.

RICCI, ELISA. *Antiche trine Italiane raccolte e ordinate.* Bergamo, 1908, Instituto Italiano d'Arti Grafiche.

ROETTINGER, HEINRICH. *Peter Flötners Holzschnitte.* Strassburg, 1916, J. H. E. Heitz.

SHAW, HENRY. *The Decorative Arts, Ecclesiastical and Civil, of the Middle Ages.* London, 1851, William Pickering.

————. *The Encyclopedia of Ornament.* London, 1842, William Pickering.

SIBMACHER, HANS. *Schön Neues Modelbuch von allerley lustigen Mödeln.* Nürnberg, 1597, Balthaser Xaimoyen.

*SPELTZ, ALEXANDER. *Styles of Ornament.* New York, 1908.

STAUD, JOHN JOSEPH. *Pennsylvania Folk-Art.* Allentown, Pa., 1948, Schlechter's.

STRANGE, EDWARD FAIRBROTHER. *Early pattern-books of lace, embroidery and needlework.* London, 1902, Bibliographical Society Trans. No. 7.

STUDIO, THE. *Peasant Art in Italy.* London, 1913.

————. *Peasant Art in Russia.* London.

TERRY, GARNET. *Commeditor, A Book of New and Allegorical Devices.* London, 1795, Bowles & Carner.

UBISCH, E. *Über Spitzenbücher und Spitzen.* Berlin, 1893, Repertorium für Kunstwissenschaften.

VAVASORE, GIOVANNI ANDREA. *Essemplario di lavori.* Venezia, 1532.

VINCIOLO, FEDERIC DE. *Les singuliers et nouveaux pourtraicts, pour toutes sortes d'ouvrages de Lingeries.* Paris, 1606, Jean le Clerc.

WARD, JAMES. *Historic Ornament.* London, 1897, Chapman & Hall.

ZAHN, W. *Ornamente aller Klassischen Kunst-Epochen.* Berlin, 1849.

ZOPPINO, NICOLO. *Essemplario di lavori.* Venezia, 1529.

SILHOUETTES AND SHADOW PUPPETS

BEUNINGEN VAN HELSDINGEN, R. VAN. *The Javanese Theatre.* Singapore, 1913, Royal Asiatic Society Straits Branch Journal No. 65.

BOEHN, MAX VON. *Miniaturen und Silhouetten.* München, 1919, F. Bruckmann.

BUSS, GEORG. *Aus der Blütezeit der Silhouette.* Leipzig, 1913, Xenien.

COKE, DESMOND. *The art of silhouette.* London, 1913, Martin Secker.

DELACHAUX, THEODCR. *Un artiste paysan du Pays d'Enhaut, Jean Jacob Hauswirth.* Basel, 1916, Schweizer Archiv für Volkskunde.

GRIAULE, MARCEL. *Silhouettes et graffiti abyssins.* Paris, 1933, Larose.

GUDENRATH, EDUARD. *Exotische Schattenspiele und die Belebungsversuche im Abendland.* 1927, Das Theater, Oktober.

HAWLEY, W. N. *Chinese Folk Design.* Hollywood, 1949.

HEGE, WALTER. *Griechische Schattenspiele.* Berlin, 1930, Atlantis, September.

HOEVER, OTTO. *Javanische Schattenspiele.* Leipzig, 1923, Wilhelm Goldmann.

JACKSON-NEVILLE, EMILY. *History of Silhouettes.* London, 1911, The Connoisseur.

JACOB, GEORG. *Einführung in die altchinesischen Schattenspiele.* Stuttgart, 1935, W. Kohlhammer.

———. *Geschichte des Schattentheaters im Morgen- und Abendland.* Hannover, 1935, Heinz Lafaire.

———. *Die Herkunft der Silhouetten-Kunst aus Persien.* Berlin, 1917, Mayer & Müller.

———. *Schattenschnitte aus Nordchina.* Hannover, 1923, Heinz Lafaire.

——— and JENSEN, HANS. *Das Chinesische Schattentheater.* Stuttgart, 1933, W. Kohlhammer.

———. *Das Indische Schattentheater.* Stuttgart, 1931, W. Kohlhammer.

KAHLE, PAUL. *Islamitische Schattenspielfiguren aus Egypten.* Strassburg, 1910–11, Der Islam.

———. *Der Leuchtturm von Alexandria.* Stuttgart, 1930, W. Kohlhammer.

KNAPP, MARTIN. *Deutsche Schatten- und Scherenbilder aus drei Jahrhunderten.* Dachau, Der Gelbe Verlag.

KUNST, J. *Een en ander over de Javaansche Wajang.* Amsterdam, 1940, Koloniaal Instituut Mededeeling No. 53.

MÄRTEN, LU. *Schattenrisse von einem anonymen Wiener Meister des 18. Jahrhunderts.* Wien, 1913, E. Beyerl's Nachflg.

MÉGROZ, RODOLPHE LOUIS. *Profile art through the ages.* London, 1948, The Art Trade Press.

MELCHERS, BERND. *Chinesische Scherenschnitte.* München, 1921, H. Bruckmann.

MUELLER, F. W. K. *Nang, Siamesische Schattenspiele.* Leiden, 1894, Internationales Archiv für Ethnographie.

NANYO KYOKAI. *Wajang, Javanese puppet shadow picture shows.* Tokyo, 1941, South Sea Association Bulletin, February.

PAZAUREK, GUSTAV E. *Schwarzkunst in Schwaben.* 1909, Westermanns Monatshefte, Januar.

PHILLIPS, HENRY A. *China's vanishing shadow shows.* New York, 1934, Asia, July.

SCHÜLLER, SEPP. *Das javanische Wajang-Schattenspiel.* Zürich, 1935, Atlantis, Februar.

SEEMANN, ARTHUR. *Japanische Färbeschablonen.* Leipzig, 1899.

SERRURIER, LINDOR. *De Wajang poerwa, eene ethnologische Studie.* Leiden, 1896, E. J. Brill.

SPAMER, ADOLF. *Das kleine Andachtsbild vom 14 bis zum 20. Jahrhundert.* München, 1930, F. Bruckmann.

STERLING, ADELINE. *The shadowplay in Siam.* Weltevreden, 1932, Inter Ocean.

WAJANG PURWA. *Das Javanische Schattenspiel.* Braunschweig, 1898, Globus.

WIMSATT, GENEVIEVE. *Chinese shadow shows.* Cambridge, Mass., 1936, Harvard University Press.

YUYNBOLL, H. H. *Javanische Schattenspiele.* Leiden, 1900, Internationales Archiv für Ethnographie.

HERALDIC ORNAMENTS AND MAP CARTOUCHES

ALMAGIA, R. *Monumenta Italiae Cartographica.* Firenze, 1929, Instituto Geografico Militare.

AMMAN, JOST. *Wapen und Stambuch.* Frankfurt a.M., 1579–1589, Sigmund Feyerabend.

BAUER, KONRAD F. *Das Bürgerwappen.* Frankfurt a.M., 1935, Hauserpresse.

———. *Der Greif.* Frankfurt a.M., 1939, Bauersche Giesserei.

BERCHEM, EGON VON. *Die Wappenbücher des Deutschen Mittelalters.* Basel, 1928, Emil Birkhäuser.

BOUTELL, CHARLES. *English Heraldry.* London, 1867, Reeves & Turner.

BROWN, LLOYD A. *The Story of Maps.* Boston, 1950, Little, Brown & Co.

CHUBB, T. *The Printed Maps in the Atlases of Great Britain and Ireland.* London, 1927, Homeland Association.

COLE, HERBERT. *Heraldry and Floral Forms as used in Decoration.* London, 1922, J. M. Dent & Sons.

COPINGER, WALTER ARTHUR. *Heraldry simplified.* Manchester, 1910, University Press.

DAVENPORT, CYRIL. *English Heraldic Book Stamps.* London, 1909, Archibald Constable & Co.

FITE, EMERSON DAVID and FREEMAN, ARCHIBALD. *A Book of Old Maps Delineating American History.* Cambridge, Mass., 1926, Harvard University Press.

FLETCHER, W. Y. *English Armorial Book Stamps and their owners.* London, 1897, Bibliographica.

FORDHAM, SIR HERBERT GEORGE. *Maps, their History, Characteristics and Uses.* Cambridge, 1921, University Press.

Fox-Davies, Arthur Charles. *Complete Guide to Heraldry.* London, 1925, T. C. & E. C. Jack.
————. *Fairbairn's Book of Crests.* Edinburgh, 1892, T. C. & F. C. Jack.

Galbreath, Donald Lindsay. *A treatise on ecclesiastical Heraldry.* Cambridge, 1930, W. Heffer & Sons.
————. *Handbüchlein der Heraldik.* Lausanne, 1948, Spes-Verlag.
Grant, Francis J. *The Manual of Heraldry.* Edinburgh, 1948, John Grant.

Hope, Sir William Henry St. John. *Heraldry for Craftsmen and Designers.* London, 1913, J. Hogg.
Humphreys, Arthur Lee. *Old Decorative Maps and Charts.* London, 1926, H. & T. Smith.

Jomard, Edme Francois. *Les Monuments de la Geographie.* Paris, 1842–1862.

Lehmann, Edgar. *Alte Deutsche Landkarten.* Leipzig, 1935, Bibliographisches Institut.
L'Isle, Guillaume de. *La France.* Paris, 1703.
Lynam, Edward. *British Maps and Mapmakers.* London, 1944, W. Collins.
Lynch-Robinson, Sir Christopher. *Intelligible Heraldry.* London, 1949, McDonald.

Magny, Ludovic Viscomte de. *Nobiliaire Universel.* Paris, 1854–1880, Institut Héraldique.
Merian, Matheus. *Topographia Galliae.* Basel, 1555, Caspar Merian.
Münster, Sebastian. *Cosmographey, oder beschreibung aller Länder, herrschafften und fürnembsten Stetten des gantzen Erdbodens.* Basel, 1578, Henric Petri.

Nordenskiöld, Adolf Erick. *Facsimile-Atlas to the early History of cartography.* Stockholm, 1889.

Ortelius, Abraham. *Theatrum orbis terrarum.* Antwerpen, 1570–1584.
Ortroy, F. van. *Remarkable Maps of the XV., XVI., and XVII. century.* Amsterdam, 1894–1897, F. Muller.

Paris. *Atlas des anciens plans de Paris.* Paris, 1880, Department de Seine.
Parker, John H. and James. *The Annals of England.* Oxford, 1855–1857.

Rothery, Guy Cadogan. *The A.B.C. of Heraldry.* Philadelphia, 1915, G. W. Jacobs & Co.

Speed, John. *The Theatre of the Empire of Great-Britaine.* London, 1612.
Ströhl, Hugo Gerard. *Heraldischer Atlas.* Stuttgart, 1899, Julius Hoffmann.
Stückelberg, Ernst Alfred. *Das Wappen in Kunst und Gewerbe.* Zürich, 1901.

Tooley, R. V. *Maps and Mapmakers.* London-New York, 1949, B. T. Batsford.

Warnecke, Friedrich. *Heraldische Kunstblätter.* Görlitz, 1877–1891.
————. *Heraldisches Handbuch für Freunde der Wappenkunst.* Frankfurt a.M., 1893, Heinrich Keller.
Weller, Ernst. *Roland—Archiv für Stamm- und Wappenkunde.* Kahla i.Th., 1902–1921, Gebr. Vogt Papiermühle.
Wieder, Frederik Caspar. *Monumenta cartographica.* Den Haag, 1925–1934, Martinus Nijhoff.
Wyon, Alfred Benjamin. *The great Seals of England.* London, 1887, Chiswick Press.

Zieber, Eugene. *Heraldry in America.* Philadelphia, 1895, Bailey, Banks & Biddle.